VISUAL & PERFORMING ARTS

Medieval

Mischief

VISUAL & PERFORMING ARTS

This book is dedicated to my parents,
Lillie Frankel Rebold (1912–2000)
and
Joseph Rebold (1909–2000).

Medieval Mischief

Wit and Humour in the Art of the Middle Ages

JANETTA REBOLD BENTON

SUTTON PUBLISHING

First published in the United Kingdom in 2004 by
Sutton Publishing Limited · Phoenix Mill
Thrupp · Stroud · Gloucestershire · GL5 2BU

British Library Cataloguing in Publication Data
A catalogue record for this book is available from the British Library.

ISBN 0-7509-2773-9

Typeset in 12/17 pt Perpetua.
Typesetting and origination by
Sutton Publishing Limited.
Printed and bound in England by
J.H. Haynes & Co. Ltd, Sparkford.

Contents

Acknowledgements

My sincere appreciation is owed to Pace University, Pleasantville, NY, for numerous grants to support my research and for providing sabbatical leave to complete this book. I want to thank the Metropolitan Museum of Art, New York, especially Hilde Limondjian of the Department of Concerts and Lectures who has for many years given me the opportunity to present my research at the Museum.

Extreme gratitude goes to my intrepid readers – those dear and generous friends who courageously read the typescript, Nona C. Flores, Ph.D. (medieval literature) and Stephen Lamia, Ph.D. (medieval art). To all those who have bravely accompanied me on research trips abroad – Elliot R. Benton, Helene Bergman, Faye Harwell, Robyn L'Allier and Claudine T. Parisot – and to those who permitted me to publish their photographs – Elliot R. Benton, Phillips Alexander Benton, Claudine T. Parisot and Adriaan de Roover (de Rooy) – I extend a great many thanks.

Introduction

The significant mischief created by medieval artists has been largely overlooked by scholars. Because the sculpture and painting of this era were primarily in the service of the Church, levity is unexpected among the traditional repertoire of subjects. This study is thus intended to demonstrate that, although medieval art is fundamentally religious in subject, it is not always solemn in presentation. Witty, clever, or humorous imagery has a long history in art and the Middle Ages were no exception. Rather than induce audible laughter, the entertaining images examined here were likely to elicit a small inner chuckle, a knowing smile, a pleasurable response in the viewer consistent with the restraint and sophistication characteristic of medieval art in general. It is probable that these images appeal to us today in much the same manner as they engaged their original audience, but they offer additional interest for today's viewer by providing a revealing insight into the medieval mentality not found in more traditional subjects.

Amusing activities, at first glance seemingly irrelevant and even irreverent, take place with surprising frequency where they are least expected on and in churches and cathedrals – possibly striking the modern viewer as coarse and inappropriate. The images chosen for this study suggest that medieval western Europe in general, and the medieval Church in particular, were less serious than is widely believed today. There was no firm division between Church and State and correspondingly little separation between sacred and secular, for the Church was the guiding force in all aspects of daily life.

It is probable that there was more medieval mischief than we recognize today. In addition to the fact that only a small portion of the works of art created during the Middle Ages survive, certain aspects of extant medieval art that were intended to be humorous may well go unnoticed: today's viewer fails to *get the joke*. While visual puns are accessible to anyone who stops to look, this is not necessarily true of verbal puns, nor of literary and political allusions, nor of references to specific customs or

people of the time. Conversely, were all aspects of medieval art that we find witty today regarded as such during the Middle Ages, or are we imposing our sense of humour on an earlier era, and thus laughing *at*, rather than *with*, the medieval artists?

The didactic value of humour in religion today is explained by the Reverend Robert Martin Walker of Greenwich, Connecticut, author of *Politically Correct Parables and Politically Correct Old Testament Stories*, who says, 'humor has greater power in the pulpit . . . than we realize. Humor can be a vehicle for the truth . . . Humor engages us. You get five minutes of listening for every joke or funny story you tell. Why? Because people are anticipating the next joke.' Simply put, 'humor surprises and delights'.[1]

Much has been written to demonstrate that wit and humour were abundant in medieval literature.[2] We should therefore not be surprised to find humorous images created in the visual arts during the same era. Instead, what should surprise us is that relatively little investigation has been made into this subject.

LOCATION

Witty medieval imagery is geographically widespread in western Europe. While there are regional preferences in subjects and styles, given that similar types of clever motifs are found in sites separated by great distances and that imitation is the highest form of compliment, such imagery must have been favourably received. The works studied in the following pages were created in the countries known today as Austria, Belgium, the Czech Republic, England, France, Germany, Italy, The Netherlands, Spain, and Switzerland. I have attempted to organize the material by subject and to establish various categories of mischievous medieval images: those that amuse; those that instruct; and those that surprise, amaze, or offend. Within certain categories there may be several examples that are similar, but I know of no two that are truly identical.

These odd antics occur in a variety of locations both outside and inside churches. Some are in inconspicuous locations — unexpected and non-canonical imagery tends to be small in scale and located in out-of-the-way places, such as high on exterior roof corbels, or on interior ceiling bosses or capitals hidden by the gloom of the church interior. Some gargoyles are best viewed with the aid of modern field glasses or a telephoto lens. Alternatively, many are to be found not by looking up but by looking down — some surprisingly bawdy examples are tucked away below the bottoms of the clergy as they rest on choir seats with misericords beneath. Comparison might be made to some of the

minuscule inhabitants of medieval manuscript margins, equally out of sight, whose behaviour is often no better.

Other examples intended for a more public audience are readily noticed by the visitor. These differ in purpose and meaning and are prominently placed on church and cathedral façades, on tympana and archivolts above entryways, on clearly visible column capitals, and in stained-glass windows.

MEANING AND THE MEDIEVAL CHURCH

Throughout the Middle Ages the Church was the major source of artistic patronage. Consequently, we may wonder to what extent this venerable institution commissioned the artists' wit for instructional purposes. Is this meaningful mischief? Mischief as message? Given the dominantly didactic nature of medieval art in the service of disseminating religious beliefs through illustration – especially when teaching the illiterate faithful – some of the clever images also served to bring a moral message to mind. Sermons were to be seen as well as heard. There is significant validity to the old expression 'a picture is worth a thousand words' and it is probably worth still more to people unable to read those words. It may be argued that a picture can convey information with less ambiguity than a written description, and certainly can do so with greater speed. Clarity of presentation was valued, as evidenced by, for example, the depiction of the weighing of the souls at the Last Judgement at Autun Cathedral (II.18); with angels and devils vying for one's soul, no questions remained as to what lay ahead. Which specific types of behaviour would give the devil an advantage in this competition are made clear by the many cases of crime and punishment depicted in medieval art, for instance the grape stealers at Wells Cathedral (II.4–7). Thus while some examples seem to be purely engaging and charming, others were, in addition, used by the Church to illustrate teachings, to strengthen the impact of sermons, and to make the Church's moralizing messages more memorable by the ingenuity and appeal of the visual presentation. Wit was an effective vehicle for social and religious commentary, with clever imagery used as a pedagogical device to enhance religious teachings and to make the Church's messages both more accessible and more notable. Witty depictions warn those who might go astray and admonish those who already have.

Images and ethics have long been allies, and medieval art abounds with advice and warnings.

'The truest things are said in jest' during the Middle Ages as now. Humour has often been used as a means of approaching subjects with which we are uncomfortable if they are dealt with more directly. Although the Last Judgement, sin and salvation, and the eternal fate of the soul were serious concerns to the medieval faithful, what causes fear can also amuse, what intimidates can also entertain.[3]

Several of the images included here make clear that not only did the public need correction, but the clergy also. Satirical art is used to parody the paradigm, to mock the model, employing seemingly irreverent activities and images to achieve its ends. For example, a monster wearing a bishop's mitre has a dragon tail that ends in a young woman's fashionably coiffed head looking at him, as depicted in early fourteenth-century stained glass in the Lucy Chapel of Christ Church Cathedral in Oxford.

ARTISTS

Artists active during the Middle Ages worked within restraints unfamiliar to their counterparts today. The Church as patron customarily stipulated the subject to be depicted, and conventions of religious representation determined the way in which that was to be done. What is praised today as 'artistic freedom', and taken almost for granted, was not part of the medieval approach to aesthetics. Those people who would today be called artists were instead regarded as craftspeople or artisans, their work judged largely on the basis of technical skill and its degree of conformity to accepted models. An artist was not expected to create a uniquely individualistic style and was certainly not encouraged to display personal proclivities or propensities. Further, use of art as the 'picture book of the illiterate', and the consequent concern for visual clarity, well-served by the familiarity achieved through repetition, was unlikely to encourage an interest in innovative presentation.

Those amusing works that are located in peripheral and inconspicuous places, however, were evidently less rigidly bound by the customary iconographic inhibitions. When creating the mischievous medieval images seen in the following pages, the artist's imagination was aided by the work of his predecessors, literary sources, folklore and fables, aspects of daily life, and an innate sense of what entertains the viewer. The multiplicity of possible sources of inspiration and influence magnify the difficulty encountered when attempting to study examples in which fancy and fantasy play such an important part. While some of

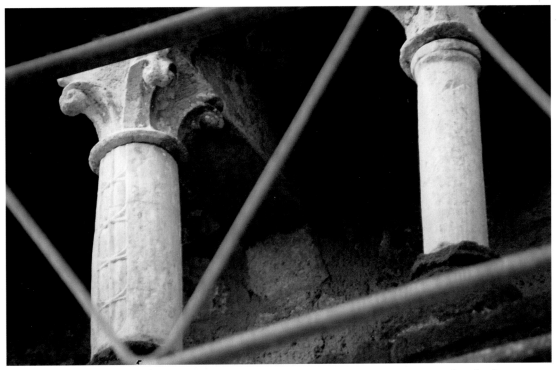

The widest column in the loggia wearing a corset: façade, twelfth–thirteenth century, church of Sta Maria Maggiore, Tuscania.

the subjects examined here are found throughout medieval western Europe, others appear to be unique. This may be due to the loss of additional examples, or a work may truly be one-of-a-kind, fitting into no category, revealing an individual artist's personal creativity. The clever anecdotes created, perhaps antidotes to the surrounding seriousness, are the exceptions to the rule in the art of the Middle Ages for they reveal unfettered individualism.

Perhaps an indication of the medieval attitude to amusement in the Church is offered by two grids of nine holes each, carved into benches in the north aisle of Winchester Cathedral, used in the game of Nine Men's Morris which was played here with marbles during the Middle Ages.

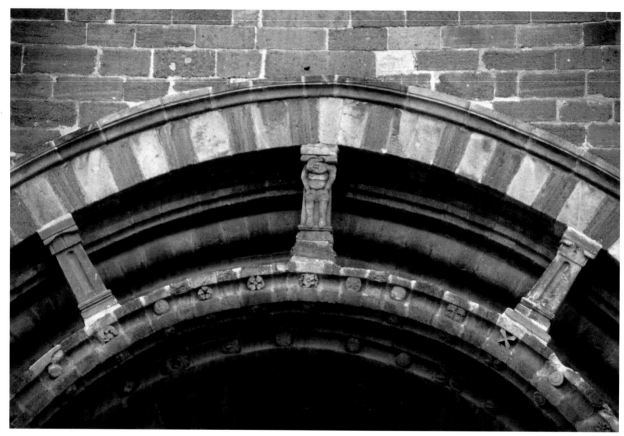

A tiny atlas supporting an arch: back porch, cathedral, Le Puy-en-Velay.

CHAPTER I

The Amusing

VISUAL PUNS

Medieval art, especially that created by clever carvers, includes a variety of visual puns that are readily understood because the meaning is equally accessible to everyone, no matter what the viewer's origin, language, or level of education may be. One needs only to look, for no former familiarity or prior knowledge is required to *get the joke*.

This is especially true of images that may be described as clever in context, the humour dependent upon the image's location — that is, if the image were placed in different surroundings, the joke would be lost. The element of wit in many of these examples relies upon the relationship between sculpture and architecture, the sculptor capitalizing upon the location of the carving on the building. These site-specific examples of medieval mischief appear to be of several types, of which there are variations. Most often, carved people or animals are shown to act as real people or animals might. The interplay created between sculpture and architecture involves an element of surprise, since we are not accustomed to seeing figures of stone or wood behaving as if they are animate and able to engage in the activities shown.

SCULPTURE PLAYS WITH THE ARCHITECTURE — AND THE VIEWER

Among the sculpted figures who relate to the medieval buildings on which they are located, as well as to the viewer (or to another sculpted figure), are those that appear in loggias, on balconies, and on rooflines, as if over-seeing the visitors to churches and homes; those on top of towers, as if defending a city; those leaning out of windows, as if to engage the passer-by; those peeking out from behind mouldings, as though spying on visitors; or those playfully threatening to douse the unwary walker with water.

King Charles IV of Bohemia, crowned emperor of the Holy Roman Empire in 1355, is

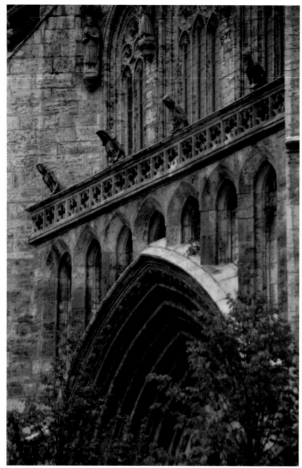

I.1. Charles IV of Bohemia and Blanche de Valois: balcony, *c.* 1370–80, south transept façade, Marienkirche, Mühlhausen.

accompanied by his wife, the French princess Blanche de Valois and his courtiers as he continuously addresses his subjects from the balcony on the south transept façade of the Marienkirche, Mühlhausen (I.1). Carved in about 1370–80, the stone has been made to look, and even act, like flesh and blood. If these figures trick our eyes, deceiving even momentarily, the sculptor has succeeded. The result is simultaneously amusing, intriguing, surprising and perhaps even slightly unnerving, for the unreal and the real are intertwined, the juxtaposition of sculpture and architecture linking imagination and reality. The novelty of the unexpected interplay between sculpture and architecture is noteworthy.

A stone figure appears on a balcony in the right transept of Our Lady of Strasbourg Cathedral Church. This unidentified but deceptively real late fifteenth-century man leans on the balcony of the *cantoria* to admire the celebrated Angels' Pillar before him in the transept.

A timeless scene from daily life is played out on a balcony on the Hôtel de Ville in Bruges, where a fashionably attired young woman, made of stone and paint, has positioned herself to attract the attention of the handsome knight standing guard here, also beneath a Gothic canopy (I.2). Her efforts are to no avail, for he has long remained indomitable, with eyes front, attentive to duty, eternally able to resist her charms.

carving and their effective use of the space in which they stand as they grasp the tiny columns, seem concerned about descending from their location high on the left side of the cathedral.

Visitors to the Sicilian cathedral of Palermo cross the large piazza to enter through the south porch, constructed between 1426 and 1430 (I.4). The lintel of this porch is entirely carved with figures of members of the nobility and clergy who appear to

I.2. A young woman attempting to attract the attention of a handsome knight: balcony, Hôtel de Ville, Bruges.

A whimsical example is offered by a man and woman at Parma Cathedral – too tiny to trick the viewer into thinking they are real – who stand in an arched loggia cleverly formed by a pier capital (I.3). This couple, charming in the naïve style of their

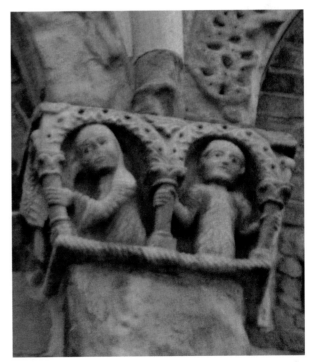

I.3. A man and a woman in an arched loggia: pier capital, exterior, left side, Parma Cathedral.

I.4. Many people in an arched loggia: south porch, 1426–30, Palermo Cathedral.

stand in the arches of a loggia, watching all that transpires in the piazza below, taking note of each person who enters the cathedral, as if to make certain that the people of Palermo attend church regularly. While these relief figures, less than life-size, are not capable of genuinely deceiving the visitor, they subtly imply that your attendance is being monitored. Indeed, many sculpted figures and faces invigilate the interior and exterior spaces in medieval churches – the visitor is rarely alone with his or her actions or thoughts.

The plethora of watchers at Palermo Cathedral have carved comrades in the stone figures standing in the crenellations on the west façade of Exeter Cathedral, dated 1346–75, surveying everyone who comes or goes (I.5). An entertaining variation on the crenellation figures at Exeter is offered by a fireplace in the Gruuthuse Museum in Bruges, the mantel made to mimic a medieval turreted castle, with men

I.5. Many people in crenellations: west façade, 1346–75, Exeter Cathedral.

I.6. Men blowing horns in crenellations: fireplace, Gruuthuse Museum, Bruges.

standing in the crenellations and blowing horns, as if to announce the visitor's arrival (I.6).

A practical purpose is served by the stone figures on crenellated towers, positioned as guardians, ever vigilant, seemingly ready to defend the city of York against unwanted visitors or would-be assailants. Guards stand atop the two massive cylindrical towers of the medieval gate known as Monk's Bar, missiles in hand, threatening to hurl them at anyone who would enter here (I.7). Bootham Bar, another of the several medieval gateways to York, is also guarded by similarly positioned soldiers. Sculpture performs a practical function at York: these stalwart sentries are perpetually ready to protect the city, performing their jobs with complete reliability, requiring neither sleep nor food, never complaining about working conditions, never once asking for a pay rise or a holiday. Late in the day, when the shadows diminish our visual acuity, an unsuspecting assailant might hesitate before entering the city through one of these gates. Elsewhere, sentinels are found on medieval churches, such as those positioned high on the corners of the back bell tower of the cathedral of Le Puy-en-Velay.

I.7. Soldiers standing guard: Monk's Bar, York.

I.8, 9. Jacques Coeur and Macée de Léodepart: street façade, 1443–51, palace of Jacques Coeur, Bourges.

Perhaps the most genuinely deceptive stone people are those (now partially restored) on the luxurious palace built by Jacques Coeur in Bourges between 1443 and 1451 (I.8, 9). A wealthy French spice and textile merchant active also in paper-making and mining, Coeur served as the superintendent of finance to Charles VII and was manager of the Paris Mint. In 1451, when the palace was almost finished, Coeur was arrested, exchanging palace life for prison life due to his debts and the charge of 'financial irregularities', and his palace was confiscated by Charles VII. On the street façade are life-size and highly realistic figures of Jacques Coeur and his wife, Macée de Léodepart, each looking out of a second-storey window. Husband and wife lean away from each other as they appear to try to engage in conversation the people who pass by. Today's visitor can only imagine how

much more effective these figures were when they still retained their original paint. Now, even without colour, the level of realism remains so high it seems certain that visual trickery was intended.

Although the interior of the palace has been greatly damaged and restored, the medieval mischief continues here. In the largely renovated Galerie des Marchands, small stone figures look out from windows over one fireplace and stand in crenellations on a second fireplace that is made to look like a medieval building with a crenellated roof line and high roofs in the French style.

A clever variation on the stone figure who leans out of a stone window is found in a religious setting on the pulpit in the cathedral of St Stephen in Vienna. Members of the religious hierarchy – a bishop, a cardinal – rest their forearms on books as they lean out of windows beneath the flamboyant Gothic canopies of the pulpit created by Anton Pilgram in 1510–15, as if attempting to communicate with the visitors.

The behaviour of these full-scale gregarious people contrasts with that of the shy diminutive figures at the twelfth-century Romanesque church of Ste-Foy in Conques, for the visitor studying the celebrated sculpture of the west portal tympanum is simultaneously scrutinized by a series of tiny, timid

I.10. Two of several tiny people peeking out around the tympanum archivolt: twelfth century, church of Ste-Foy, Conques.
(Photo: Claudine T. Parisot)

people who peer curiously over the archivolt moulding (I.10). In a sense, they have turned the tables, inverting the usual relationship between sculpture and viewer, for at Conques visitors are unlikely to notice that the *sculpture is watching them*. The pastime of people-watching from this vantage point was perpetuated by descendants of the Conques figures on the thirteenth-century west façade of the Gothic cathedral of Notre-Dame in

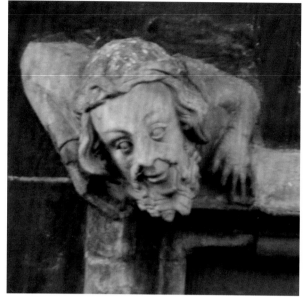

I.11. One of several figures peering down: fourteenth century, Maison Tavel, Geneva.

Paris, where angels (restored) peer over the archivolt moulding of the central tympanum.

Equally as subtle, but far fewer in number, are the several small figures who emerge over the mouldings high on the fourteenth-century Maison Tavel in Geneva. Included is a bearded man, evidently slightly amused by what he sees, as he peers down on the pedestrians from his perch above the second-storey windows (I.11).

Gargoyles, those characteristic medieval gutters carved in fanciful forms, may actually achieve a

specific kind of physical interaction with visitors. In the thirteenth- to fourteenth-century cloister beside the former cathedral of St-Etienne in Toul, some of the gargoyles are positioned so low that they are able not only to eavesdrop on the monks' conversations in the cloister, but also to douse the monks absorbed in meditation with the rainwater that issues from their mouths and even from a barrel held over the shoulder (I.12). Thus these gargoyles threaten those below, not fiercely with missiles as at York, but playfully with water — the apparent threat at York is much less real than the hidden one created by the gargoyles. A pair of fifteenth-century gargoyles on the Chain Gate at Wells Cathedral is also less likely to damage than to dampen. Located high above the visitor's head, each gargoyle is carved

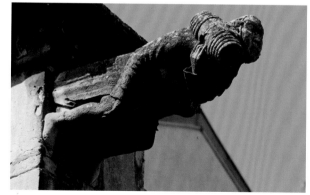

I.12. A gargoyle carrying a barrel on his shoulder: cloister, former cathedral of St-Etienne, Toul.

in the form of a man with a barrel over his shoulder through which rainwater pours onto the unsuspecting or inattentive passer-by below. Similar barrel-bearing gargoyles appear on Bern Cathedral and on San Marco in Venice.

On a much smaller scale, and located on the landing between the two flights of steps up to the pulpit of *c.* 1485 in the nave of Strasbourg Cathedral, is a tiny stone dog that represents the canine companion of Geiler of Kayserberg. The preacher's dog is said to have turned away those members of the congregation who might approach the pulpit in anger when their names were mentioned in public censure for certain behaviour. However, carved in miniature, the preacher's creature is so endearing, so far from fierce, that he is more likely to have served to amuse than to scare the irate parishioner.

CLIMBING ON BUILDINGS

Medieval sculptors created many individual figures and, less frequently, groups of figures who appear to scale structures. Carved with varying degrees of realism and in a great variety of inventive forms, this witty interaction between sculpture and architecture is found throughout western Europe. In each case, the impact of the image's ingenuity depends upon the specific architectural context in which it is seen – the element of humour hinges on location. The same figure, seen in a different context, would not be notable.

At the former cathedral of Notre-Dame in Embrun, halfway up a slender column on the north porch, one diminutive column-climber uses his arms and legs to cling to the column, and another sticks his head out between two columns (I.13, 14). These figures – tiny and barely noticeable – may seem surprisingly out of context in a religious setting, yet is it possible that they carried a religious or symbolic connotation to the people of medieval Embrun? They could be interpreted as clinging to the Church for spiritual protection and salvation, but the fact that they are so very small, not prominently located, and that no similar figures are known on other churches all argue against the possibility that these figures were intended to convey a didactic message. Is it possible, however, that these whimsical cartoon-like figures reveal the medieval Church's attitude to have been less austere and severe than is believed today? The man ostensibly imprisoned here in stone is said to be the chapter provost/rector who underpaid the workers; they had their revenge with these caricatures, believed to be the work of an Italian sculptor.

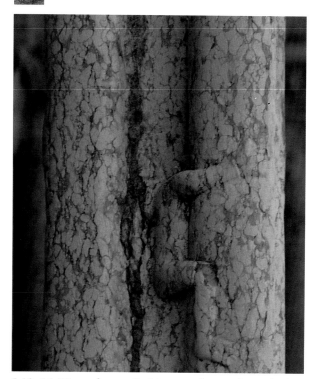 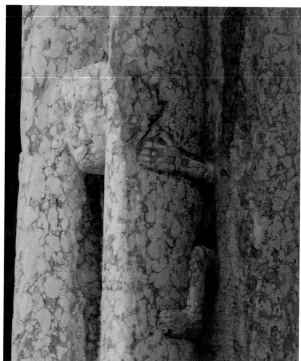

I.13, 14. Tiny column-climbing people: north porch, former cathedral of Notre-Dame, Embrun.

Caught in mid-ascent as he attempts to climb up the late fifteenth-century Maison d'Adam in Angers (I.15) is a wooden man, much larger in size and more readily seen than those in Embrun. Given his location on this fine half-timbered home, perhaps he is a struggling 'social climber'. Or could he be trying to climb in a window on an upper level (or to make a quick escape from a bedroom window)? He is one of several wooden figures on this house, and it

is probable that similar figures existed elsewhere but no longer survive due to the vulnerability of wood.

Evidently successful in his efforts to scale a column is the barefoot man at the church of Notre-Dame in Semur-en-Auxois who has reached his goal and now sits complacently on top of a column on the right side of the north porch (I.16). This figure is positioned to mask a misalignment between the capital and the column, the transition achieved by

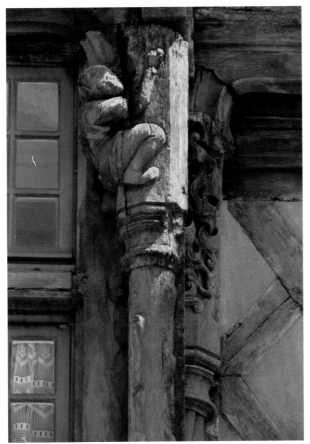

I.15. A man climbing up a column: Maison d'Adam, Angers, end of the fifteenth century.

his seated posture with his head dropping forward beyond his torso.[1] Similarly, at Southwell Minster, a little man perches uncomfortably on top of an engaged column, hiding an awkward juncture in the structure of the fourteenth-century pulpitum

between the choir and nave (I.17). An additional example of the sculptor saving the mason, at Wells Cathedral, is discussed below.

More than columns were climbed by the sculptors' creations: at the parish church of St John the Baptist in Thaxted stone people try to edge their way up the raking moulding just below the roof line

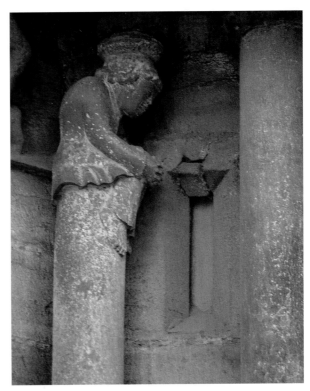

I.16. A man sitting atop a column, hiding a misalignment: north porch, church of Notre-Dame, Semur-en-Auxois.

I.17. A man masking the transition between arches and columns: Southwell Minster, fourteenth-century.

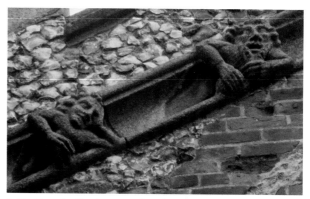

I.18. People climbing up the church: parish church of St John the Baptist, Thaxted.

I.19. A man on the moulding: church of St Andrew, Heckington.

or to rest there from their arduous ascent (I.18). A diminutive crouching relative, with his head supported on his left hand, calls out from his perch on the moulding on the church of St Andrew in Heckington (I.19). While the activities of such sculptures suggest that they have come to life, they are far from realistic in their carving and cannot actually have been intended to deceive the viewer. Instead, they amuse.

Others, although successful in their ascent, seem to regret the situation in which they now find themselves. Small-scale figures cling to corbels and brackets, as on the churches at Anzy-le-Duc (I.20) and

I.20. A man clinging to the corbel: church of the Assumption, Anzy-le-Duc.

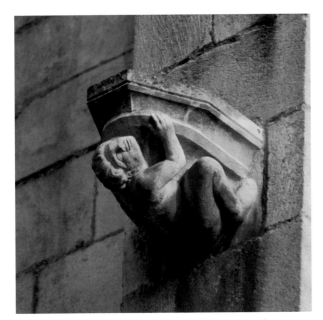

I.21. A man hanging from the bracket: church of Notre-Dame, Semur-en-Auxois.

Semur-en-Auxois (I.21). Although the stone from which these figures are carved serves to support the architectural projection above, the figures are not posed to look as if they reinforce the architecture; instead, they hang from the corbel or bracket, giving the impression that they are trying to avoid falling. At St-Etienne in Cahors a mournful little thirteenth-century monk sits on the façade moulding (I.22). A precariously perched young man clings to the moulding on the church of St Mary in Fairford, glancing over his shoulder as if to see where he would land if he were to fall (I.23).

It might be argued, with some persuasiveness, that these figures have a religious meaning and represent those who cling to the Church for guidance and salvation. But so profound an

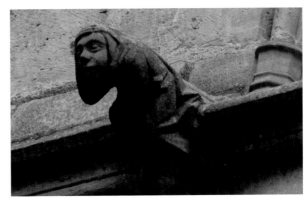

I.22. A sad monk sitting on the façade moulding: thirteenth-century, church of St-Etienne, Cahors.

13

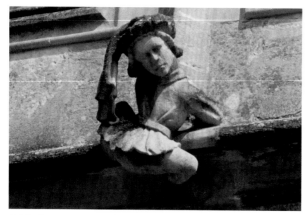

I.23. A young man clinging to the moulding: church of St Mary, Fairford.

I.24. A smiling dog perched on the moulding: church of St Mary, Fairford.

interpretation is undermined by discovering animals in the same situation, such as a smiling dog on the church of St Mary in Fairford (I.24), showing no more distress than does a doglike animal on the church of St Peter in Winchcombe. A lion climbs on the moulding on the north side of Winchester Cathedral (I.25); this animal features so frequently in medieval art as a symbol of Jesus, the Resurrection, and much more, that iconographic significance might be claimed here. This interpretation, however, is weakened by the frightened felines in much the same predicament high on the roof line of the chapter house of York Minster, using their claws to cling to the edge of the ledge, behaving much as a real cat would in such uncomfortable circumstances.

I.25. A lion climbing on the moulding: Winchester Cathedral.

I.26. People straddling the flying buttress: *c.* 1500, Sint-Janskathedraal, 's-Hertogenbosch (Den Bosch).

Additional problems are endured by sculpted figures on medieval buildings. Many highly realistic stone people, dressed in the costumes current in the carver's day (*c.* 1500), appear to have scaled the walls and now straddle the flying buttresses of Sint-Janskathedraal in 's-Hertogenbosch (I.26). They certainly have reason to regret their efforts to attain so lofty a location, for at the top of each buttress a fierce open-mouthed gargoyle blocks their path of ascent and lunges threateningly toward them, causing them to recoil in fear. Similarly positioned figures are found on the buttresses of the Eusebiuskerk

15

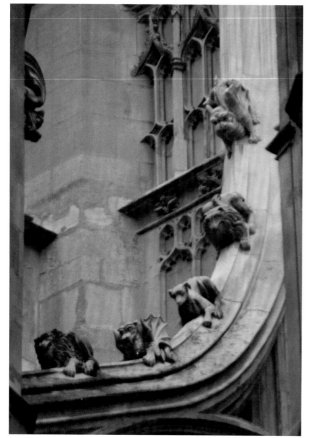

I.27. Creatures sliding down the buttresses: chapel of Henry VII, Westminster Abbey, London.

of Henry VII at Westminster Abbey, London (I.27). Intent on preventing a similar descent, a tiny wooden figure holds on tightly as he straddles a handrest on the fifteenth-century stalls in the cathedral of St-Pierre, Geneva (I.28).

An especially intriguing interplay between architecture and sculpture is seen at St-Etienne in Cahors, on the twelfth-century north portal and north flank of the church. The patient visitor who examines

I.28. A man straddling the handrest: stalls, fifteenth century, cathedral of St-Pierre, Geneva.

(Grote Kerk) in Arnhem, which was built in the fifteenth century and rebuilt after the Second World War, although without the fierce gargoyles. And animals, real and imaginary, reverse the direction as they seem to slide down the buttresses on the chapel

I.29, 30. A woman and a man in circular openings on the soffit: twelfth century, north side, St-Etienne, Cahors.

the details will be well rewarded here: between the corbels supporting the cornice a clever carver has created a series of small animated women and men whose lower legs are visible through circular openings – as if there are holes in the soffit – and whose upper bodies emerge above, as they gyrate in and out of these openings (I.29, 30). Such figures are surprising here and possibly unique. Do they deserve a symbolic religious interpretation? Or was the sculptor playing with the architecture by carving little figures who now find themselves captives of the edifice?

If one example of visual punning is discovered at a specific site, more are likely to be found there, suggesting that a sculptor – or sculptors – active there came equipped with a sense of humour. Thus, in the sixteenth-century cloister of St-Etienne in Cahors, a monk seems to have thrust his fist through a pier. In a similar predicament is the roaring lion on the north side of the new cathedral of Salamanca who appears to have stuck his head through a pier and now tries to extricate himself (I.31). Truly stuck in the architecture is a little man carved on the pulpitum in Southwell Minster who has been trying without success to squeeze himself out through a small opening since the fourteenth century (I.32).

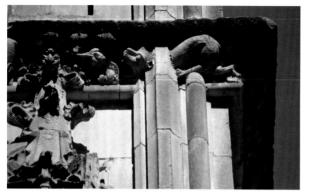

I.31. A lion with his head stuck through a pier: new cathedral, Salamanca.

EATING THE ARCHITECTURE

An especially curious interaction between sculpture and architecture is seen in heads, more often monstrous than human, that appear to consume parts of buildings – tracery, column tops, column bases, mouldings, ribs, and beams, offering gastronomic variety to the medieval monsters' menu.

At the little rural church of Barfreston, built in the last quarter of the twelfth century, the radiating tracery on the east window attracts no unusual attention – until one notices that fantastic animal heads are biting the ends of the stone bars (I.33). A 'well-rounded meal' may be had by consuming columns – dining is done with great enthusiasm by a monster with large eyes and many pointed teeth who replaces a more traditional

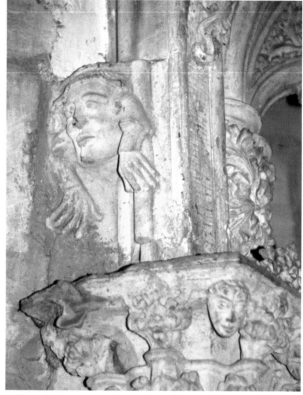

I.32. A little man stuck in the pulpitum: fourteenth century, Southwell Minster.

capital on the upper left arch of the façade of St-Nicolas in Civray (I.34). Similarly, at Chadenac a Romanesque creature with bulging eyes and flame-like vertical hair consumes a column, while another Romanesque head at the church of Notre-Dame in Avénières looks surprised by what he finds in his enormous mouth. More human and

I.33. Monsters biting the tracery: last quarter of twelfth century, east window, Barfreston Church.

equally as hungry is the toothy person devouring a column at León Cathedral; evidently dissatisfied with the menu are the human heads carved on capitals in the thirteenth–fourteenth century cloister here, who open their mouths so wide as to consume the columns that support them (I.35). In the Gothic portion of Southwell Minster, capitals carved in the form of monstrous heads have pairs of slender colonettes in their mouths, as if they were sucking on straws (I.36)! Also at Southwell, and atypically realistic in this context, is the head of a bull biting a column. Column-consumers are widespread in location and varied in physiognomy: they include an animal in the cloister of the

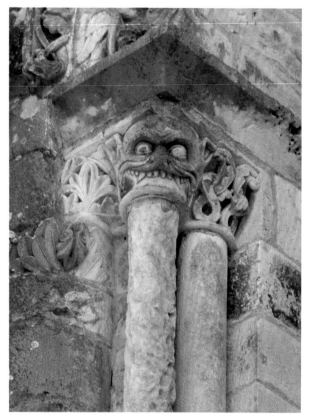

I.34. A monster consuming a column: façade, church of St-Nicolas, Civray.

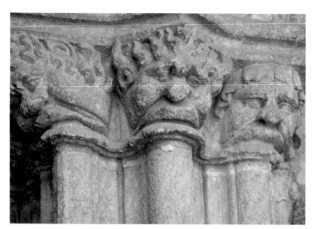

I.35. Heads devouring columns: thirteenth–fourteenth centuries, cloister, León Cathedral.

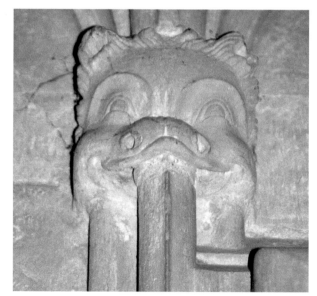

I.36. A monstrous head with slender columns in its mouth: Southwell Minster.

Benedictine monastery of Millstatt; an impressive example high on the interior wall of Parma baptistry; small column-biters on the right side of the façade of Parma Cathedral; and the monstrous capital eating the column on the façade of Notre-Dame in Echillais.

I.37. A little monster eating the base of a column: twelfth century, cloister, Monreale Cathedral.

Rather than the top of the column, it is the base that provides nourishment in the twelfth-century cloister beside Monreale Cathedral, where the moulding on several column bases is being eaten by little monsters who open their mouths wide like boa constrictors (I.37). The menu is similar in the north, for small dragons inside the north porch of Wells Cathedral gnaw on the horizontal mouldings just beneath the column bases.

In France, long lauded for the quality of its cuisine, several beam-biters survive, carved of wood rather than of stone, voraciously devouring

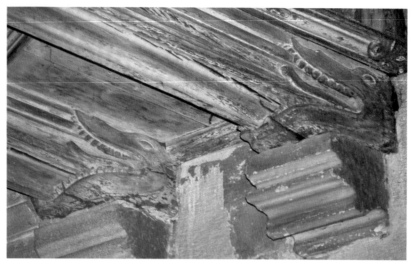

I.38. Monsters biting beam ends: wood, early sixteenth century, nave, cathedral of St-Lazare, Autun. *(Photo: Claudine T. Parisot)*

wooden beams; one such is found in the former cathedral of Notre-Dame in Embrun, now brightly repainted. Just inside the entrance to the cathedral of St-Lazare in Autun, up in the shadows of the north aisle, pairs of early sixteenth-century wooden monsters gnaw the ends of wooden beams which are part of the organ (I.38).

The motif appears also in a secular setting in the Hôtel-Dieu in Beaune, built by Nicolas Rolin, chancellor of Philippe-le-Bon, duke of Burgundy. In the Great Hall of the Poor, which opened in 1452, is a series of brightly painted dragon heads, one at each end of every beam. Although they have been called the monsters of hell, some wear clothing akin

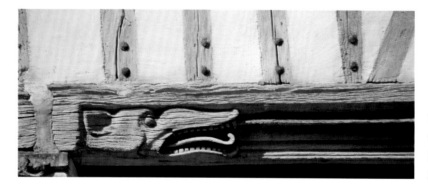

I.39. A monster biting the end of a wooden beam: courtyard, former Palais des ducs de Bourgogne, now Musée du Vin de Bourgogne, Beaune.

to monks' habits and some look like caricatures of human heads. The sculptors are thought to be Flemish/Burgundian. The same type of animal heads are found in the church of St Catherine in Honfleur, where two vaults are of the inverted ship hull type seen at the Hôtel Dieu. Similar wooden dragon heads, again at the ends of the horizontal beams of an inverted ship hull ceiling, are found in Brittany in the sixteenth-century chapel of Lezurgan in Plescop. Wooden beam-biters with impressive tongues appear out-of-doors in secular surroundings in the courtyard of the Palais des ducs de Bourgogne, now the Musée du Vin de Bourgogne in Beaune (I.39), and there is more than one such creature at the late fifteenth-century Maison d'Adam in Angers, equally as equipped with menacing teeth.

The notion of a sculpted monster eating parts of the architecture was cleverly used to mask an error made around 1320 during construction of the retrochoir of Wells Cathedral. On either side of the processional way, three ribs were started but were found to be superfluous, having no place to go. Rather than ripping out these incomplete ribs, a dragon head was placed at the end of each, so that the monsters appear to be eating away the extra ribs with the gastronomic gusto of a gourmand, the sculptor

I.40. A monster eating superfluous ribs: *c*. 1320, retrochoir, Wells Cathedral.

cleverly turning an error into an entertainment (I.40). These little creatures are members of an enormous group of monstrous animals having a wide range of physiognomies in medieval art. Many are

I.41. A stone rope reinforcing the arch: 1396, *pandhof*, Utrecht Domkerk.

referred to as dragons, traditional Western symbols of evil, and are routinely shown menacing, if not actually eating, their victims. In each of the examples noted, if they had been portrayed dining on their usual diet, the impact and import would be very different. It is the oddity of eating architecture that accounts for the arresting aspect of these animals – the incongruity of this relationship between sculpture and architecture amuses.

STONE KNOTS AND
OTHER ARCHITECTURAL ANOMALIES

Several medieval buildings appear to be reinforced by ropes or cords made not of hemp or jute but instead carved of the same material as the building.

An amusing story explains the highly realistic example in the *pandhof* beside the Utrecht domkerk, carved in 1396 (I.41). Various master builders were employed successively here; during the time Jacob van den Borgh was in charge, one of the delicate arches bordering the cloister was thought to be too weak – the bishop remarked that it looked 'rather unstable'. Van den Borgh's solution to the problem was to have the arch reinforced with a rope – of stone, and therefore certain to last as long as the Gothic tracery of this arch. By carving the shape of a rope, made permanent in stone, not only are structural effectiveness and durability increased but also the visitor's confidence. Equally realistic is the stone rope in the cloister beside the Cathedral of Le Puy-en-Velay that ties two columns together and even includes a knot in the rope between the columns. A more subtle variant on the stone rope is seen on another capital in the cloister of Le Puy, where two lions are held by a leash that is looped over the moulding above their heads. In each case, the appeal is due to the novelty of the change in medium used for reinforcement; it simultaneously surprises and amuses. On one hand, a stone rope is illogical because the material cannot be bent or twisted to form a knot. Yet, on the other hand, a rope of stone is more effective than one of hemp or

are the knotted columns of about 1100 on the back of the Broletto (town hall) in Como. The four columns flanking the south transept porch of Modena Cathedral are the twelfth-century work of Master Wiligelmo, carefully carved to look as if

I.42. Master Wiligelmo, knotted columns: twelfth century, south transept porch, Modena Cathedral.

jute in stabilizing the structure and alleviating the concerns of the bishop of Utrecht.

A variation on this idea is the knotted column in which four small columns appear to be tied together by another column looped around them, seemingly to strengthen the structure. This is found in several locations and seems to have been especially popular in Romanesque Italy. Thus, simultaneously decorative, structural, and amusing

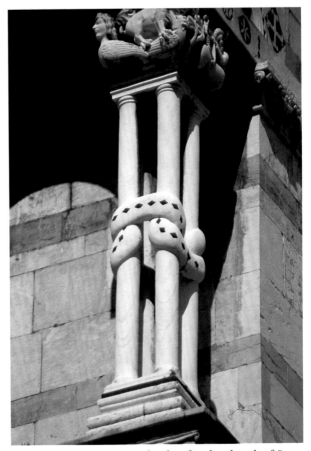

I.43. Knotted columns with inlay: façade, church of San Michele in Foro, Lucca.

they have been tied together for reinforcement (I.42). Knotted columns are seen in Lucca on the façades of the duomo and of San Michele in Foro, where there are five levels of columns, the second and fourth having four knotted columns at either side, the loops emphasized by inlay (I.43). At the collegiate church of San Quirico in Orcia the portal is flanked by late twelfth-century knotted columns, four on either side. The central portal of Ferrara Cathedral of about 1135, signed by Niccolò, is flanked by pairs of columns, each with the slenderest of attached colonnettes, all tied together by stone ribbons. At the twelfth-century Pieve di Sta Maria in Arezzo, a thinner rope is used on a bundle of slender colonnettes, the size of the rope corresponding to the width of the columns. A stone rope ties two columns together in the cloister arcade of San Zeno in Verona. Pairs of columns look as if they have been tied in a knot in the twelfth-century cloister of Sta Sofia in Benevento. The motif appears also outside Italy, as on the north porch of Notre-Dame in Embrun, where the especially slender columns are given two knots – one above and one below – for added strength.

It is notable that knotted columns are found in several Cistercian foundations: the Cistercians, to whom decorative sculpture was forbidden, seem to have taken special pleasure in this form of non-figurative carving, which was still within the bounds of their restrictive rules of visual austerity. Thus, a knot ties four columns together in the south-east corner of the cloister of the Cistercian abbey of Chiaravalle della Colomba at Fidenza. Among the examples outside Italy are the two small columns tied together in the chapter house of the Cistercian monastery at Osek in northern Bohemia.

In each instance, masons and sculptors experiment with the potentials of their medium, blurring the division between architecture and sculpture. Which profession is responsible for giving a sculptural form to an architectural support? As a display of technical skill, the knotted columns are evidence of the absence of a firm division between sculpture and architecture, as well as of a blending and merging of media.

Additional architectural anomalies are found in columns that deviate from the usual cylindrical shape established in antiquity. Among the various clever columns on medieval buildings, the author's absolute favourite is found on the façade of the Romanesque basilica of Sta Maria Maggiore in Tuscania, built between the end of the eleventh and the first half of the twelfth century (see page xiii). Positioned between the portal and the wheel window is a dwarf loggia formed by nine small columns. The penultimate column on the right side is wider in diameter than the

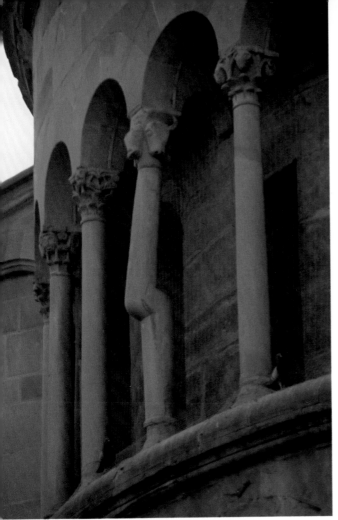

I.44. A monolithic column with a bulging abdomen:
Pieve di Sta Maria, Arezzo.

dimensions, thereby making the corseted column as slender and svelte as its neighbours.

One column also deviates from the shape of its neighbours in Arezzo on the back of the Pieve di Sta Maria, in this case by the capital carved with bull heads and the monolithic column below shaped like a long tubular body with a bulging abdomen, possibly the result of one mason working on the top and another on the bottom of the shaft without having agreed on its axis (I.44).

Although columns that twist are not unusual in medieval architecture and have a lineage that goes back to antiquity, two mid-twelfth-century columns from the Benedictine abbey at Coulombs, now in the Musée du Louvre, Paris, take the idea of the spiral to an extreme; one appears to be the result of twisting together four slender spiral columns carved with geometric patterns, while the other is composed by entwining four spiral columns. Further, the sculptor has embellished both columns with a variety of little climbing men and dragons. Several unusual column shafts are found in the crypt of Canterbury Cathedral, where no obligation was felt to make the classical fluting run vertically in accord with the axis of the column. And while a simple twisting column may not be noteworthy, twisted piers most certainly are, as those flanking

other eight. Rather than chipping away at the column to make it conform to the contours of the others, the sculptor cleverly used his chisel and hammer to carve a corset on this column, which, the sculptor implies, can simply be laced tighter in order to diminish its

the portal to the Landoechsstube of the 'Wladyslaw Hall' of the Hradschin in Prague.

Equally at odds with the simple traditional form of an architectural support is the treatment of stone vault ribs carved in the form of branches with the new growth neatly trimmed. This is first seen in Germany at the end of the fifteenth century and there is a good example of about 1520 in the west chapel of the parish church in Golstadt, Swabia. The curving flamboyant Gothic ribs in the choir vault of the church of St Mary in Pirna are accompanied by unattached ribs cleverly carved to resemble tree limbs and the sculptor, taking full advantage of this novelty, even provided hairy wildmen climbing on them.

Each of these cases demonstrates medieval sculptors' appreciation of visual puns. The joke is readily understood by each viewer – no words are needed to explain the humour and the impact is immediate. The sculptors' wit is equally accessible to everyone – no matter which language they speak, their country of origin, their level of education or range of experience.

RELIABLE HELP
SUPPORTING ROLES

A multitude of people, sculpted of stone or wood with varying degrees of realism, serve as structural supports on medieval buildings. A playful and human element is thus added to the architecture by the figures who hold up columns, arches, lintels, brackets, and corbels, usually posed as if labouring to keep the building from collapsing, the sculpture thereby

I.45. 'Right hand man': façade, church of St-Nicholas, Civray. *(Photo: Claudine T. Parisot)*

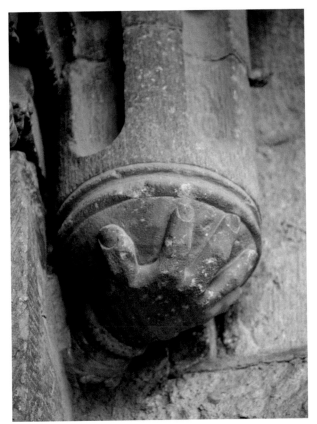

I.46. A hand supporting a column: eleventh–twelfth century, back porch, cathedral, Le Puy-en-Velay.

interacting with the architecture. To create this effect, sculptor and mason must have collaborated closely. This is in contrast to the division usually assumed between the various visual arts during the Middle Ages, raising questions about on-site working relationships between sculptors and masons.

ON BUILDINGS

Among the most amusing interactions between sculpture and architecture is that created by sculptors who quite literally lend a helping hand. On the façade of St-Nicholas in Civray, beside a relative of the column-consuming head just mentioned, is his 'right hand man' (I.45). The same sort of assistance is offered by a sculptor to a mason at the Cathedral of Le Puy-en-Velay. On the back porch, just below the vault rib, an engaged column ends abruptly midway down the wall. Contrary to rules of construction and to structural logic, this column is not supported from the ground below. But the visitor need not worry about the stability, for a sense of security is provided by an eleventh- or twelfth-century hand (albeit carved of stone) holding up the bottom of the column (I.46). Theologically, this is interpreted as the hand of God the Creator supporting the dome of heaven represented by the vault above. This hand is not prominently located and is thus easily overlooked; it is not on the façade but on the back porch and the visitor must peer under the column to discover it. Here, as is true also of many other visual puns in medieval art, the images have largely gone unnoticed and unappreciated because they are not located in plain view.

In Le Puy a sculptor offered several helping hands on another medieval monument, but the close observation required to see them must be preceded by the physical stamina necessary to reach them. Perched on top of a stone outcropping so vertical that it is known as 'the needle', is the eleventh-century chapel of St-Michel d'Aiguilhe, with several stone hands supporting the corbels at the top of the façade.

Perhaps the most blatantly humorous use of stone hands is found on the base of the central column in the chapel of the Holy Cross in the abbey church of Mont-Sainte-Odile. The Romanesque sculptor carved a pair of hands grasping the rounded moulding on each of the four sides of the base – the implication is that this is all that remains visible of four people, their bodies now down below the floor.

Sometimes more than merely a hand was needed. Extremely subtle is the tiny carved man who supports an arch of the back porch of the cathedral of Le Puy. Inquisitive eyes are required because, while at first glance the visitor may see three miniature piers, the centre one is actually a miniature atlas – seated, hands on knees, head bent under the weight he bears. The compressed body of the Le Puy figure contrasts with that of an extremely slender figure on the façade trumeau of the church of St-Pierre in Beaulieu-sur-Dordogne,

who strains to support the capital with both his hands and his shoulders, causing him to bow his head under the weight in a similar manner. This ethereal, immaterial figure, hardly more substantial

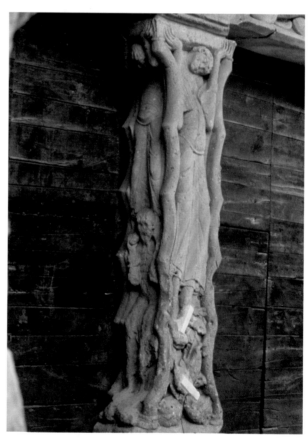

I.47. An elongated man, helped by a figure on the shoulders of another, struggling to support the capital of the trumeau: façade, church of St-Pierre, Beaulieu-sur-Dordogne.

than the scalloped columns that edge the trumeau, requires the assistance of a smaller man standing on the shoulders of yet another on the side of the trumeau (I.47).

Certain burdens are so heavy that pairs of sculpted figures are required to support them. Two men, back-to-back, bear a column on their heads, hands, and shoulders at the entry to the church of Ste-Marie in Oloron-Ste-Marie. Dressed as Saracens and bound together by a chain encircling their waists, these prisoners of war were commissioned by viscount Gaston IV the Crusader (1090–1131) after his conquests in Spain.

More often, the pair of supporting figures is divided up, one on either side of a portal, their identity unknown. The weight-bearers on the north porch of Notre-Dame at Embrun sit as they hold up their columns (I.48). Given the difficulty of the task performed, the evident exertion of effort is understandable; although carved of stone, these men suffer visibly under the weight they bear on their heads and shoulders. The impression created is that real people, who were to serve only very briefly as architectural supports while the porch was being constructed, were never relieved of their task by their fellow workers and were instead abandoned to become frozen in stone over

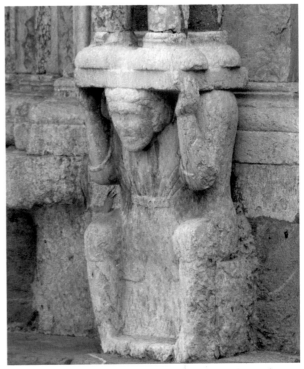

I.48. A seated man supporting columns: north porch, former cathedral of Notre-Dame, Embrun.

the ages. The Embrun figures are members of a large supporting cast, for similar sculpted figures are found in a significant number of clever variations throughout medieval western Europe. At Sta Maria Maggiore in Bergamo, the better preserved of the pair of crouching figures supporting the porch knits his brow mournfully, deprived even of a seat, the cushion over his head

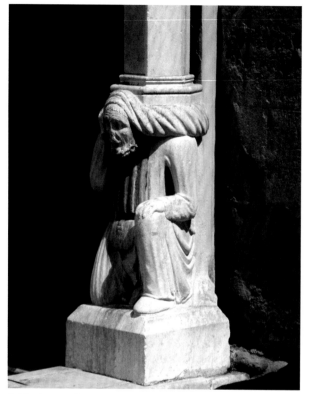

I.49. A crouching man supporting a column: porch, church of Sta Maria Maggiore, Bergamo.

and shoulders evidently insufficient to protect him from pain (I.49).

Pairs of small relief figures, carved into the fabric of the wall and posed as if to provide support, may flank church portals. This is the case on the façade and north porch of the duomo of Modena, where one little figure, skirt whirling, seems to

dance but another struggles under the weight he carries (I.50).

Pairs of weight-bearing figures also appear above porch columns, supporting the ends of the spanning arch. On the east porch of the duomo of Verona, two carved men of about 1135 to 1140 are determined in their efforts to 'support the Church', for they hold up the arch with their hands and shoulders (I.51).

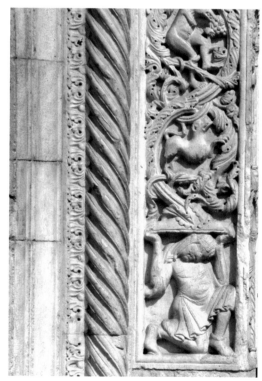

I.50. A small kneeling man providing support: relief, façade, Modena Cathedral.

carved in relief has been using his arms, legs, and possibly even his hair, to keep the flanking arches in place since the end of the twelfth century.

Corbel brackets that support lintels above doorways were frequently reinforced by little carved people. Such figures are seen crouching as atlantes, one on either side of the entry portal of the church of St-Croix-et-Ste-Marie in Anzy-le-Duc (I.52). At St-Hilaire in Semur-en-Brionnais, in

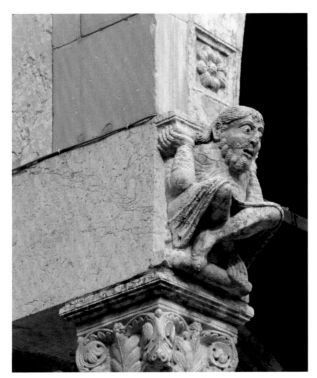

I.51. A seated man supporting an arch: east porch, Verona Cathedral, *c.* 1135–40.

Expressively carved, they are, as if proclaimed by unwritten medieval law, similar but not identical in their appearance. Tiny people support brackets that in turn support arches, from the little monks in the chapel of St Barbara in the new cathedral of Salamanca to the small figures on the façade of the fifteenth-century house of the porters' guild in Bruges. In the former abbey of St-Aubin in Angers a crouching man

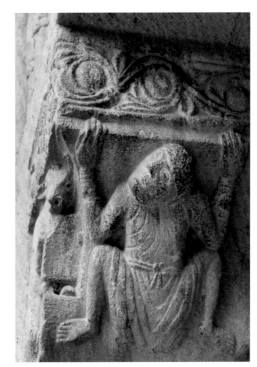

I.52. A crouching man holding up a lintel bracket: left side of portal, church of St-Croix-et-Ste-Marie, Anzy-le-Duc.

addition to corbel figures at the entrance portal, figures appear inside the church on either side of the crossing arch, reinforcing the brackets on which it rests. While the demon on the left struggles with the weight he bears and sticks out his tongue (its tip and one horn are broken), the smiling man on the right side needs only one hand to do the same job. At the collegiate church of Notre-Dame in Huy a crouching monk on a corbel manages to provide support for the church with his hand and shoulder.

I.53. A 'head-strong man' supports a column while grasping the colonnettes: church of St John the Baptist, Cirencester.

Related supporting figures appear on corbels on the façade of St-Pierre in Parthenay-le-Vieux, and elsewhere. Even capitals sometimes required additional structural support, as provided by a late twelfth-century atlas at St-Aubin in Angers.

Figures support columns, as does the bearded man in the parish church of St John the Baptist in Cirencester who sports one on his head as if wearing a tall hat, firmly grasping the flanking colonnettes to brace himself under the weight (I.53). Another example shows a man whose large hat is the base of a column in the right transept of Lincoln Cathedral. Similarly, in the nave of St Sebalduskirche in Nuremberg, a diminutive man, toes curling over the edge of the ledge on which he crouches, frets under the weight he bears on his head (I.54). Unusually dextrous is a small monk on the staircase leading up to the chapter house of Wells Cathedral; he faithfully and tirelessly holds up the column base with one hand as he simultaneously spears a dragon with the other.

Piers also pose problems: a little man emerges on the south side of Westminster Abbey in London, knitting his brow as he obviously struggles beneath the weight of a massive pier, pushing down with his right hand and up with his left, as if trying to avoid being crushed (I.55).

I.54. A disgruntled man supporting a column on his head: nave, St Sebalduskirche, Nuremberg.

Figures ranging from human to monstrous support piers at the church of Notre-Dame in L'Epine. There are a great many variations of small figures cast in these important supporting roles, including those in media other than stone sculpture; for example, the crouching figures who perform the role of atlantes in the mosaics inside the baptistery of Florence. Their pose recalls the orant prayer position in which the arms are raised to heaven; this gesture could refer to the act of prayer as well as support for the Church, both literal and symbolic. Such an interpretation, moreover, would be in accordance with the medieval affection for layered

meaning, maximizing the symbolism and instructional benefits of a single image.

Occasionally group effort is required to ensure architectural integrity. Inside the former cathedral of Notre-Dame in Embrun, several small, nearly nude figures, each in a different pose, struggle to prevent the collapse of an engaged capital that threatens to crush them (I.56).

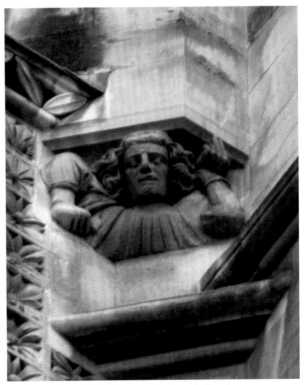

I.55. A man struggling in a pier: south façade, Westminster Abbey, London.

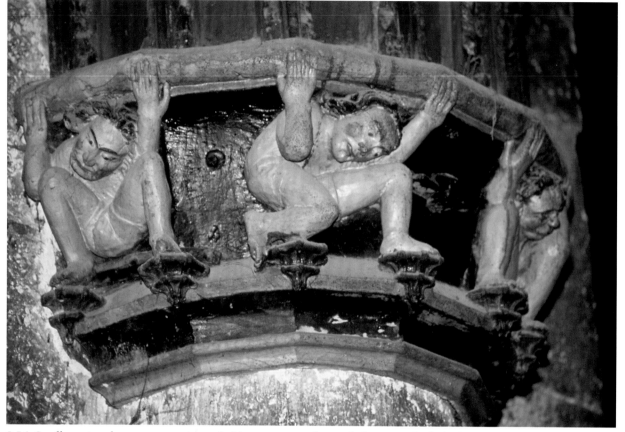

I.56. Small semi-nude men attempting to hold up an engaged capital: former cathedral of Notre-Dame, Embrun. *(Photo: Claudine T. Parisot)*

Support of an arch may require the help of many more people. At St-Pierre in Aulnay-de-Saintonge, on the south transept portal, a visitor may admire the complex iconography carved on the voussoirs, but only by looking directly up under the archivolts will the numerous supporting cast members that have kept this structure standing for centuries be discovered (I.57). A similar situation is encountered on the north transept portal of Notre-Dame in Vouvant, where

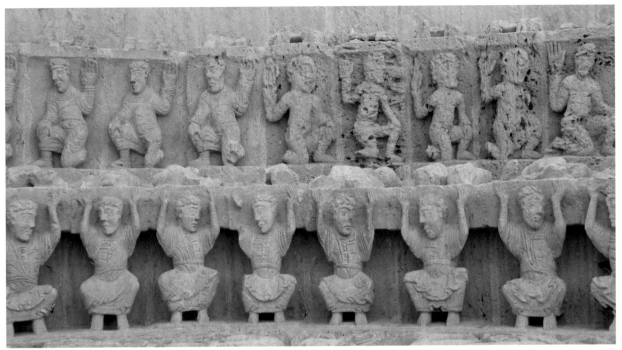

I.57. Supporting cast of many tiny people beneath archivolts: portal, south transept, church of St-Pierre, Aulnay-de-Saintonge.

a multitude of little stone people literally help support the church.

It seems worth noting that the supporting figures are not realistically depicted. This is not surprising among Romanesque examples, for a degree of distortion is characteristic of the art of this era, but the Gothic examples are barely more believable. There can be no possibility of visual deception. In this, the supporting figures differ from the highly realistic figures that appear on balconies and in windows, as in Mühlhausen and Bourges (I.8 and I.9 above), that interact overtly with the viewer and truly intend to trick our eyes – even if for only a brief moment.

Groups of sculpted figures, posed as if holding up buildings, hardly make their first appearance in the Middle Ages. Their ancient lineage can be traced back at least to the early fifth-century BC Greek

Temple of Zeus (Jupiter) in Agrigento, where enormous nude male figures over 65 feet (20 metres) tall once supported the entablature on their heads and raised arms. Such figures are called telemones or atlantes (atlas, singular) – in ancient Greek mythology Atlas supports the world. On the 'porch of the maidens' of the Erechtheum, a late fifth-century BC Greek temple on the acropolis in Athens, clothed female figures known as caryatids perform the same function, supporting the entablature on their heads. These substantial ancient Greek men and women passively carry out their jobs without evidence of physical exertion. In contrast, their medieval descendants are greatly diminished in scale and far less stoical, performing their tasks with evident difficulty. Kenaan-Kedar interprets the supporting figures as sinners punished, and discusses the ancient origin of this iconography going back to Vitruvius's *Ten Books on Architecture*.[2]

ON CHURCH FURNITURE

In addition to sculpted figures who seem to assist in supporting a building or actually do so, as at Beaulieu (I.47 above), medieval art includes figures of stone and wood who support church furniture, appearing where a non-figurative, and certainly non-animate, form of support is routinely expected. The seat of the marble throne of Bishop Elia in the church of San Nicola in Bari, dated *c*. 1100, rests on three struggling servants who grimace under the weight they bear. The two outer figures act as if they carry most of the weight, whereas the smaller central man, identified as a pilgrim by his staff, is believed to be a reference to the faithful who walked the pilgrimage route to this church, thereby 'supporting' the bishop and the city. Less effort is exerted by the pair of atlantes who hold up the armrests of the cathedra seat in Parma Cathedral, carved by Benedetto Antelami (documented 1178–1233).

Related imagery, although in wood, on a smaller scale, and far less obvious in location, appears on misericords – 'mercy seats', from the Latin *misericordia* meaning 'mercy' or 'pity'. With the exception of the old and infirm who might sit on stone benches lining the walls inside the church, the faithful originally stood during medieval services. Monks, canons, priests, and the choir were also obliged to remain on their feet during the long Latin services – the divine offices of Matins, Lauds, Prime, Terce, Sext, Nones, Vespers, and Compline lasting several hours each day. From the twelfth century on, however, references are found to hinged seats with a carved corbel bracket on the underside that

supported a little ledge which, when tipped up, would permit members of the clergy to rest at least some of their weight on this ledge while still appearing to stand. Medieval misericords may seem rather low to the ground for many of today's visitors, but were appropriately positioned for our generally shorter medieval ancestors. Is there not something amusing about the very purpose of the misericord, which is a type of trick or deception designed to make it appear as if one is still standing and suffering when, in fact, one is resting quite comfortably?

Although a simple bracket would suffice to stabilize the seat, the medieval predilection for ornamentation found a new focus here and misericords developed into a Gothic speciality, particularly during the fourteenth and fifteenth centuries. Curiously, in spite of the fact that the misericords are located inside the church, close to the altar, and intended for use only by the clergy, the subjects carved on them certainly were not exclusively religious. Because of their location in the choir, thus hidden from the eyes of the public, and because they are barely visible even when the seat is tipped up to expose the wooden carving, misericords varied widely in subject, ranging from sacred reverence to secular ribaldry. Although some subjects were selected for their religious significance, the great majority of subjects are secular. In addition to the occasional religious themes, the wide range of subjects on misericords includes classical mythology, Old Testament scenes, fables, folk tales and legends, customs and pastimes of everyday life, the signs of the zodiac, labours, seasons, people, animals, monsters, grotesques and foliage, as well as satire and humour.[3]

It would be interesting to know who selected the subject matter to be carved on the misericords, for this person was not necessarily the sculptor, who was likely to be a lay person employed by the church. The subjects of some misericords seem to be unique, while other motifs appear in several locations, similar in presentation but never identical, suggesting that misericord carvers worked from drawings and model books and/or travelled from one job to another. The sculptor may have known the original occupant of the seat, and it is possible that the subject on each misericord was intended to relate in some manner to a characteristic of this person. The image selected would have been especially familiar to the occupant in those churches where it was customary for the clergy to kneel facing the seat, which then served as a little desk. While the style in which certain misericords are carved is highly elegant and sophisticated, more

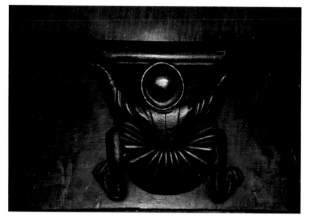

I.58. A man (seen from the back) supporting a seat: late fifteenth century, misericord, abbey church of La Trinité, Vendôme.

often it is popular and naive, even crude in both style and subject.

The theme of the supporting figure was a natural match with the purpose of misericords. It was especially popular at the cathedrals of Exeter and Wells, for several misericords in each are carved with figures, or parts thereof, positioned as if to support the seat. Exeter's misericords, most of which were probably carved in the mid-thirteenth century, include a crouching 'strongman' who strains under the weight he supports, arms spread wide to better perform his job. On another misericord at Exeter the human body is abbreviated to only a pair of hands

gracefully holding up the little ledge. At Wells one misericord depicts a man in a semi-reclining position supporting the seat with his hands and one foot, while on another, also of about 1330–40, a bust-length man supports the seat with his hands and head. The design of each misericord at Exeter and Wells, carved from a single piece of wood, accommodates its function as a structural support.

Similar subjects are found on misericords located on the continent, such as that of a man seen from the back who supports the seat with both hands, on a late fifteenth-century example in the abbey church of La Trinité in Vendôme (I.58). The image becomes especially amusing in this context,

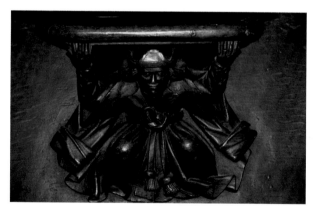

I.59. A man (seen from the front) supporting a seat: late fifteenth century, misericord, abbey church of La Trinité, Vendôme.

I.60. A man ringing a bell: interior façade wall, church of St-Hilaire, Foussais-Payré.

Related imagery appears on a still smaller scale in manuscripts. For example, in Jean Pucelle's depiction of the 'Entombment of Jesus' in the *Hours of Jeanne d'Evreux*, now in the Cloisters, New York, two miniature marginal grotesques work hard to hold up the frame in which the main scene appears.[4] But in a manuscript the notion of a fictive figure stepping in to provide actual physical assistance is not included, nor is the element of surprise.

I.61. Mason monks building a column capital: twelfth century, cloister, church of Ste-Foy, Conques.

for he stretches his arms wide — the distance between his hands perhaps indicating the girth of the clergyman to whom this seat was assigned. Facing forward is his presumably older companion (I.59), fashionably dressed, his arms emerging through the openings in the sleeves of his *gardcorp*, a practical style of the time, perhaps making him more comfortable as he labours under his burden.

I.62. A hand grasping a leafy vine: façade, church of Notre-Dame des Marais, Villefranche-sur-Saône.

LOYAL EMPLOYEES

In addition to providing structural support or reinforcement, figures created by medieval sculptors were helpful in several other ways. Among the most appealing is the half-length stone man inside the church of St-Hilaire in Foussais-Payré, seen in the left corner of the façade wall, who pulls a stone rope, as if to ring a bell above, and can be absolutely counted on never to miss a day's work – although pulling the rope on time is beyond his ability (I.60).

In the cloister of Ste-Foy in Conques miniature monks work as masons and are in the process of building the column capital on which they appear (I.61). Thus the column and capital are treated as if

they are a tiny tower capable of accommodating accordingly small inhabitants.

Other sculpted figures work with nature. In the left transept of Strasbourg Cathedral, a man begins to trim the vines at the left end of a long horizontal frieze of foliage; when he gets to the right end of the vines and has finished the task, he sleeps. Elsewhere, a helping hand, minus the rest of the body, appears – in unlikely places. On the façade of Notre-Dame des Marais in Villefranche-sur-Saône, a hand holds onto one end of a leafy vine (I.62). At Notre-Dame in Semur-en-Auxois, on the fourteenth-century Flamboyant Gothic façade with fifteenth-century statues, are two examples of equally realistic hands grasping snails, one on either side of the top of a buttress (I.63). Further, there are snails in the vines

I.63. A hand grasping a snail: fourteenth–fifteenth century, façade, church of Notre-Dame, Semur-en-Auxois.

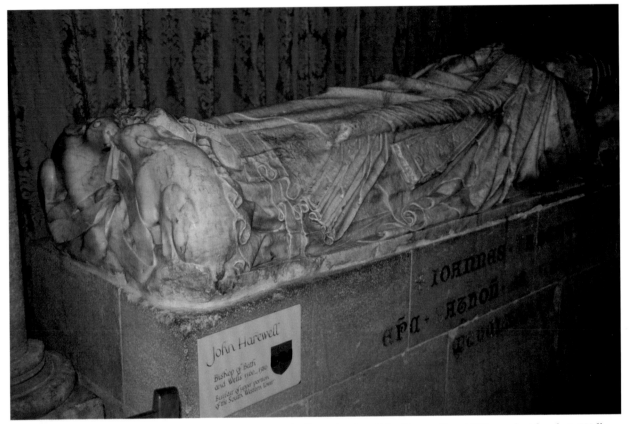

I.64. Hares drinking from a well at the foot of the funeral effigy of Bishop John Harewell: *c.* 1386, south aisle, choir, Wells Cathedral.

on a small façade capital, and on the north portal three snails (one broken) climb up the left columns. Snails grow to be especially large here in Burgundy where they are a culinary speciality – *escargots* cooked with butter, parsley, and garlic. Does the sculptor display pride in a product of his region while simultaneously providing publicity? This is contrary to the Bible, in which snails are listed among the 'unclean' creatures not to be eaten, along with weasels, mice, tortoises, ferrets, chameleons, lizards, and moles – 'creeping things' that live under the earth (Leviticus 11: 29–31). Viewed positively, snails

43

represent birth and the dawn as they emerge from their shells, and their spirals imply the eternal nature of life. However, it is unlikely that they carried these connotations during the Middle Ages, for snails are not among the many creatures in the medieval bestiary (book of beasts), a popular encyclopedic compilation of animal lore, fantasy, and symbolism.

VERBAL PUNS MADE VISUAL

In addition to visual puns, medieval art includes various forms of verbal puns that challenge the viewer to solve pictorial puzzles. Less immediately understood than the visual puns, these rebuses, homonyms, and other kinds of word play in art, test the viewer's ability to deduce the correct meaning. For example, in the depiction of Satan carrying a soul at Shibden Hall in Halifax, the soul is represented as a big dead sole fish – being taken to the frying pan, thereby clearly indicating the doomed future of its spiritual counterpart. This pun was painted on glass, perhaps in the late fifteenth century.[5]

Certain family names were readily given visual form. Consider the marble funeral effigy of John Harewell (I.64), bishop of Bath and Wells (1366–86) and builder of the upper portion of the south-western tower of Wells Cathedral. Located in the south aisle of

I.65. A 'long tun' (barrel): wood relief, for Bishop Langton, Winchester Cathedral.

the choir, Harewell's monument lacks the lion usually found at the feet of the deceased which, in this context, is a symbol of watchfulness and the resurrection. Instead Harewell is identified by two hares drinking from a well at his feet. A similar example is offered by the chapel of Bishop Alcock, founder of Jesus College, Cambridge and Chancellor to Edward IV. Built in 1488 in the north aisle of Ely Cathedral, the chapel has stained-glass panels flanking its entry that include images of a cock standing on a globe – the globe for 'all' and the cock for the second syllable of the bishop's name. Further, the Gothic architectural elements that thoroughly decorate Alcock's chapel include many carved stone cocks. And in Winchester Cathedral, Bishop Silkstede is

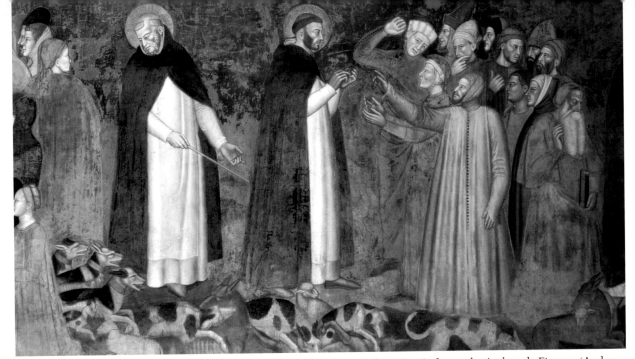

I.66. Dominican monks represented as dogs ('*domini canes*'), *Triumph of the Church*, fresco, by Andrea da Firenze (Andrea di Bonaiuto), c. 1366–68: Spanish Chapel, church of Sta Maria Novella, Florence. *(Photo: © The Bridgeman Art Library)*

referenced by a representation of a skein of silk and Bishop Langton by a 'long tun' – a barrel, also carved in wood relief (I.65).

In addition to being witty and amusing, the use of rebuses was extremely practical for the simple reason that the great majority of people were illiterate, making the indication of a family name through an image especially useful. Rebuses are key to medieval heraldry. For example, the emblem of the de Vere family is the boar, which might seem to be an undesirable association but was selected because *verres* means 'boar' in Latin.

Another Latin-based play on a name, admittedly more complex, appears in the depiction of the members of the Dominican order in the fresco by Andrea da Firenze (Andrea di Bonaiuto, active c. 1343–77) of the *Triumph of the Church*, in the Spanish Chapel of Sta Maria Novella in Florence, c. 1366–68 (I.66). The faithful Christian flock is shown to be guarded by the Dominicans, represented by dogs with black and white fur – the colours of the Dominican habit. Thus, the Dominicans are depicted literally to be '*domini canes*' – dogs of the Lord, the story linked to a dream

Dominic's mother had during her pregnancy of a dog holding a torch in its mouth. The same visual pun is seen in the margin of a mid-fourteenth-century French Gothic version of 'Le Roman de la Rose' written by Guillaume de Lorris and Jean de Meun(g).[6]

A play on a name – similarly two-part, extremely subtle, and highly sophisticated, but, in contrast to the preceding examples, certainly not meant as a riddle to be solved by the general public – is found in certain manuscripts commissioned by Jean, duke of Berry, one of the brothers of the French king Charles V (reigned 1364–80). Jean de Berry was captivated by a certain Lady Ursine. The prayer book, *Les Très Riches Heures*, which he commissioned from the Limbourg brothers, Pol, Herman and Jean, dated 1413–16 and now in the Musée Condé in the château of Chantilly, includes a folio devoted to each of the twelve months of the year. In that of January, the background pattern of alternating bears (*ours*) and swans (*cygnes*) is a play on the name of the duke's lady love.[7]

While the various visual puns discussed here may be assumed to be only a minute fraction of those created during the Middle Ages, many that do survive probably go unnoticed. Today, after centuries have elapsed, the names, events, customs, and relationships to which medieval signs and symbols refer are often forgotten. Thus, because these clever medieval rebuses require prior knowledge or an explanation to be understood, the modern viewer misses the meaning. Perhaps new documents and sources of information will provide clues to overlooked examples of medieval mischief. . . .

CHAPTER II
The Instructive

The art of the Middle Ages abounds with advice and warnings, the moralizing messages made more memorable by the ingenuity of their presentation. Wit and even humour were used intentionally in the visual arts by the medieval Church as effective didactic devices. Images and ethics have long been allies, pictorial preaching being particularly appropriate in view of the widespread illiteracy among the medieval audience.

Parables, moralizing tales, fables, proverbs, and sayings well known to the residents of medieval western Europe were frequently depicted on the exteriors and interiors of their churches. For example, the expression 'putting the cart before the horse' is depicted literally on a misericord in Beverley Minster, and 'urging on a slow horse' is represented on a misericord in Bristol Cathedral as a snail with a package on its back, encouraged by two men. The variation in the animals used to illustrate the latter example (and the snail certainly makes the point more obvious than does a horse) raises the possibility that certain images originally had special meanings that are no longer readily understood today.

While parables are intended to illustrate broadly applicable moral lessons referring to truths of everyday life, the instruction offered elsewhere is intended for a specific person and may be more practical than moralizing. A charming example of advice offered is seen in the spandrels on the south nave wall (although originally under the organ) of Wells Cathedral, where an angel whispers into a bishop's ear to tell him which key to strike on the organ – which only played seven notes.

IMAGES AND ETHICS: THE DEADLY SINS

Retribution for sin is usually shown to be swift and often severe in medieval art. For example, on the Stonyhurst Chasuble, embroidered around 1470, the devil receives immediate and humiliating

II.1. St Dunstan tweaking the devil's nose with his tongs: the Stonyhurst Chasuble, *c.* 1470, silk, gold, and silver thread on velvet (*opus anglicanum*), Stonyhurst College, Stonyhurst. *(Photo: © Courtesy of the Trustees of Stonyhurst College)*

punishment for bothering St Dunstan (909–88).
Archbishop of Canterbury and the patron saint of
English goldsmiths (on the continent the patron
saint of goldsmiths is usually St Eligius or St Eloi),
jewellers, and locksmiths, Dunstan is said to have
been at once a painter, embroiderer, bell founder,
and metalworker. Legend holds that while working
in his shop he received a visit from the devil; when
the devil mocked him, Dunstan defended himself by
using his goldsmith's tongs to tweak the devil on one
of his noses, whereupon the devil stuck out his
tongue (II.1).

A pinched proboscis may be both painful and
embarrassing, but it is not permanent – unlike the
punishment suffered by another devil, known as the
Lincoln imp (II.2). Only about 12 inches (30.5
centimetres) high, once brightly painted, he has sat
in a spandrel in the Angel Choir of Lincoln
Cathedral since the thirteenth century. The story
goes that when the devil sent his imps out to play,
one came into this cathedral through an open
window. Once inside, he was a notable nuisance,
causing all sorts of problems – he attempted to trip
the bishop, to knock down the dean, and to pester
the vergers and members of the choir. All this was
tolerated, but when the imp began to break the
cathedral windows he had exceeded what even

II.2. The Lincoln imp: thirteenth century, Angel Choir,
Lincoln Cathedral.

generous tolerance permitted. To the angels' request
that he cease, the imp retorted, 'Stop me if you
can!' And this they certainly did – by turning him to
stone. Now he must sit, through the ages, in the

Angel Choir, literally looked down on by the angels above. However, a friend of this imp is claimed to be flying around the cathedral looking for him – thus is explained why it is always so windy in Lincoln Cathedral even today.

But what about other forms of misbehaviour more common to ordinary earth-bound humans than to airborne imps? What was considered improper and what was considered proper punishment provide a revealing insight into the medieval Church's view of crime and punishment. Several of the various types of possible transgressions were succinctly summarized for the medieval populace as the seven deadly sins. Lust or Luxury (*libido* or *luxuria*) and Greed/Avarice (*avaricia*) were, according to the medieval clergy, the major failings of the populace, whereas Lust and Gluttony (*gula*) were, according to the populace, the primary flaws of the clergy. The remaining four deadly sins are: Pride/Vanity (*superbia*); Anger/Wrath (*ira*); Envy (*invidia*); and Sloth (*acedia*). Seven was a favoured number during the Middle Ages as evidenced, for example, by the seven sacraments; the seven joys and seven sorrows of Mary; the seven gifts of the Holy Spirit and the seven liberal arts.[1]

Medieval artists tended to personify each specific sin by a guilty individual portrayed as both suffering and remorseful. For example, in the chapel of St Bernard in Roure in the Tinée Valley, a late fifteenth-century fresco represents the sin of **Lust** and its ramifications with a depiction of a local priest who had sex with a woman in his parish, now expressing regret as his halo is taken from him by a devil. A misericord in Léon Cathedral is carved so that the entire bracket is a bath tub in which a pretty young woman and a tonsured young monk are found. Another misericord, this time in Bristol Cathedral, depicts an unchaste woman as nude, ushered into the mouth of hell by a devil; following her, with ropes around their necks, are some of her lovers now transformed into apes. (The sin of lust is discussed at greater length in the following chapter in connection with depictions of nude men and women.)

Greed is represented frequently by the miser who values his wealth above all else. On a cloister capital from the southern French monastery of St-Guilhem-le-Desert, dated *c.* 1150, now in the Cloisters, New York, a miser is shown with his heavy sack of coins around his neck, which pulls him down into the mouth of hell, represented as a fierce monster with a continuous row of pointed teeth and fiery breath.

A problem encountered in daily life was that of the greedy merchant who asked too high a price for

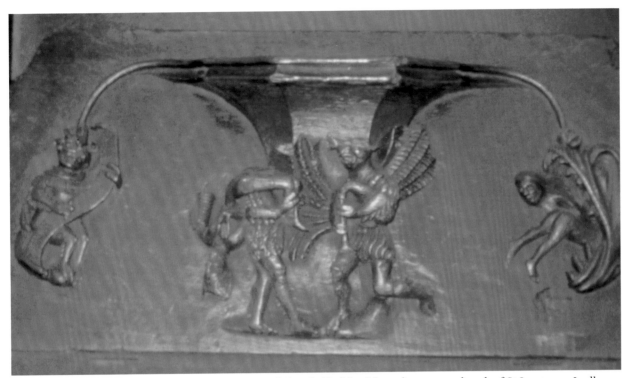

II.3. A false-measuring barmaid (Greed): misericord, first half of the fifteenth century, church of St Laurence, Ludlow. *(Photo: Phillips Alexander Benton)*

his or her goods, or who charged the customer for a larger quantity of goods than was actually received. A misericord in the parish church of St Laurence in Ludlow, carved in the first half of the fifteenth century, depicts this subject as one of the evils of tavern life (II.3). The false-measuring barmaid portrayed here is an identified resident of Ludlow known to give short measure. The sculptor clearly

and cleverly shows what happened when she died. Other than her horned headdress, a sign of vanity and a style that was denounced from the pulpit, the barmaid is nude, implying that taverns were not very different from brothels.[2] Now hoisted over the shoulder of one of the demons the devil has sent to fetch her, she still clutches the fraudulent tankard in her hand – a *tot* measure used for liquids, specifically

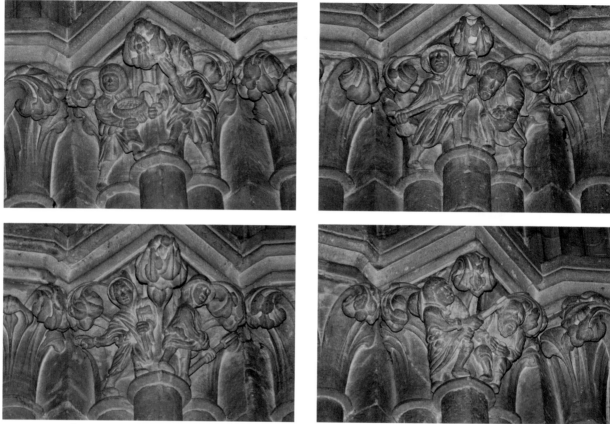

II. 4, 5, 6, and 7. Grape stealers (Greed): a thief taking grapes as a young accomplice holds the basket; the farmer informed of the theft; the farmer grabbing the thief by the ear; the farmer hitting the thief on the head with a pitchfork: capitals, thirteenth century, right transept, Wells Cathedral.

for alcoholic beverages. The demon on the right within this central group plays a bagpipe, a musical instrument associated with sin (more is said about bagpipes in the following chapter). The story continues on the left supporter where the devil reads from a very long scroll listing the barmaid's sins. On the right supporter she receives her punishment when she is pitched head first into the mouth of hell. This imagery derives from the Last Judgement play in the Chester mystery cycle,

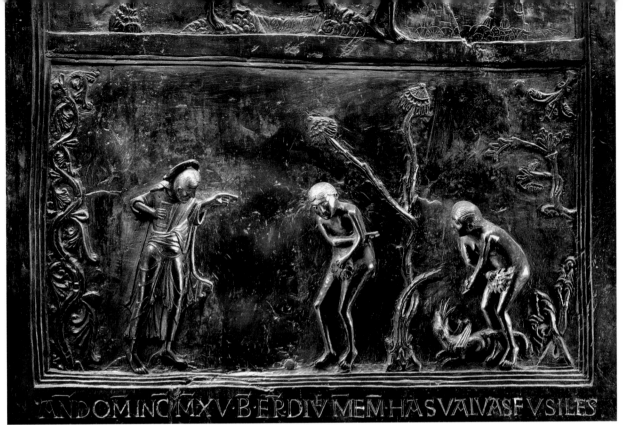

II.8. Adam and Eve Reproached by God for Eating the Forbidden Fruit, 1011–15, bronze relief door panel made for St Michael's, Hildesheim, now at Hildesheim Cathedral. *(Photo: Hildesheim Cathedral)*

suggesting that perhaps other such stories also were connected with the plays frequently performed during the Middle Ages. It seems worth noting that not one of Ludlow's misericords has a theological subject; instead, all relate to life in Ludlow in the first half of the fifteenth century.

Medieval artists repeatedly associated the sin of Greed with theft. This sin and its consequences were carved in the thirteenth century at Wells Cathedral on four capitals of a pillar in the south transept. While often referred to as the 'apple stealers', the stolen fruits are, in fact, grapes. On the first capital, a bearded thief grasps a bunch of grapes in his left hand and brandishes a sickle in his right as he glances over his shoulder to see if anyone is watching, while a young accomplice holds a basket already filled with fruit (II.4). On the second capital, the farmer, carrying a two-tined pitchfork, is told of the theft by

II.9. A man drinking from a barrel (Gluttony): corbel, church of St-Hilaire, Foussais-Payré.

a man holding a hatchet (II.5). On the third capital, the thief is caught carrying the incriminating grapes in his apron by the farmer who, armed with his pitchfork, grabs the thief by the ear (II.6). And on the fourth capital, the farmer whacks the thief on the head with his pitchfork, the thief's legs buckle under the blow, and he loses the fruit (II.7). Thus the thief's fate shows that crime does not pay and, further, has painful consequences.

The depiction of the theft of fruit appears in a much earlier story, with far more universal ramifications. The bronze reliefs on the doors made between 1011 and 1015 for Bishop Bernward – originally installed at the church of St Michael's in Hildesheim and subsequently moved by Bernward's successor to Hildesheim Cathedral – include the familiar story of Adam and Eve. The sequence of scenes shows God creating Eve, God introducing Adam and Eve, and then Adam and Eve doing the *one thing* they have been told not to do in the Garden of Eden – eat the forbidden fruit – only to be caught in the act and reproached by God (II.8). It would be difficult to depict this scene with greater narrative clarity or more astute understanding of human nature – although not of accurate human anatomy. God, identified by his clothing, halo, and especially by his large size, points the accusatory finger at Adam. Having eaten from the Tree of Knowledge, and therefore now aware of his nudity, Adam covers himself with one hand and points to Eve with the other, passing the blame to her. Eve, in turn, covers herself with one hand and points to the serpent with the other, as if claiming 'the devil made me do it'. Thus no one takes responsibility for their own actions, each denying complicity in the crime. The same imagery, each person implicating another, appears in the glittering twelfth-century mosaic cycles at the Palatine Chapel in Palermo and at Monreale Cathedral in Sicily, and elsewhere.

The sin of **Gluttony** as depicted by medieval artists often involves alcoholic beverages rather than solid food. On a façade corbel of the church of St-Hilaire in Foussais-Payré, a man is shown to have by-passed the cup and is drinking directly from the barrel which he grasps with both hands (II.9). A similar gluttonous man, unable to wait another moment for his beverage, guzzles directly from the cask on a console bracket on the apse of the former Chartreuse of Notre-Dame at Hastingues-Arthous, as does a barrel-drinker on a corbel on the north side of the church of St-Juste in Pressac.

Related subjects appear on misericords, like, for example, one at León Cathedral which depicts a drunken man sucking on a full wineskin. The choirstalls at Plasencia Cathedral include a monk who sits with his book open but with a wineskin between his knees, and a woman who is drinking from a pigskin. Especially clever is the representation on a misericord at Ciudad Rodrigo of three monks whose bodies are wineskins, gathered around an open book from which they sing the music to 'Vino Puro'. Another of the misericords at Ludlow, now on the south side of the chancel, shows an ale or wine seller filling his pitcher. While one interpretation holds that the tapster consumes too much of his own goods too often and is a drunkard, an alternate explanation maintains that this misericord depicts a popular medieval moralizing tale about the servant or monk who is entrusted with the wine but takes advantage of his situation and becomes addicted. In fact, the position of cellarer in a monastery was one of high responsibility – the Rule of St Benedict comments on the correct character of the person selected for this job. A far more generous interpretation claims that this man is watching carefully as he fills the pitcher, the process controlled by his foot on a spring-loaded mechanism, thereby ensuring that he will not end his days like the dishonest barmaid across the choir.

A gargoyle on the church of Notre-Dame in L'Epine, built between 1405 and 1527, is carved in the form of an excited man who seems to prefer wine to his usual beverage of water, for he holds a pitcher in one hand and a cup in the other. That he has already had too much to drink is suggested by the head of a fool below, identified by the cap and ass's ears. And, as he is a gargoyle, the result of his over-consumption becomes clear when it rains and he performs his function as a water spout (II.10).

While the drunkard is usually shown to be male, both sexes partake simultaneously on a misericord of the late thirteenth to early fourteenth century in

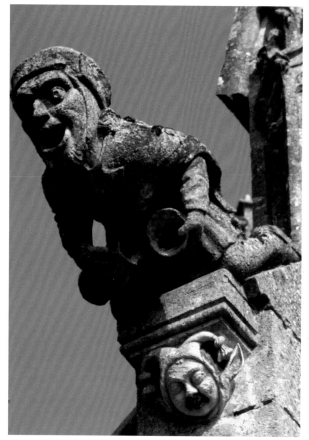

II.10. A man holding a pitcher and cup (Gluttony): gargoyle, church of Notre-Dame, L'Epine.

pitcher identify him as a drunk, and although presumably too inebriated to walk, he is *still* drinking on a misericord of 1492–1500 from the destroyed abbey of St-Lucien-de-Beauvais, now in the Musée National du Moyen-Age (former Musée de Cluny), Paris. The same subject is seen on a misericord in Hoogstraten, the wife presumably fetching her besotted husband. Gender roles reverse as a drunk woman, her condition indicated by the flask she holds, is pushed in a wheelbarrow by a man in an engraving by Master bxg, as also on a misericord in Ripon Cathedral and on a stall-end in the parish church of Baden-Baden.

The sin of **Pride**, or one of its manifestations as vanity, is the subject of another of the misericords in St Laurence at Ludlow, carved in the first half of the fifteenth century, which depicts a woman wearing a

II.11. A woman wearing a horned headdress (Pride): misericord, first half of the fifteenth century, church of St Laurence, Ludlow. *(Photo: Phillips Alexander Benton)*

the church of St Mary in Fairford, the man and the woman both smiling, flanking a barrel from which he fills his cup. Elsewhere, one is drunk and is cared for by the other. A woman (wife?) pushes a man (husband?) in a wheelbarrow – his tankard and

horned headdress, a style popular at the time and referred to above (II.11). This feminine fashion is depicted also on a misericord at the church of St Mary in Minster-in-Thanet where a woman wears a horned headdress so enormous that the devil is accommodated between the horns, making the moralizing message clear. While these misericords mock the fashion of the horned headdress in particular, they may be seen as criticisms of feminine vanity in general. Those who wear this style are not depicted as beautiful; instead, extremes in fashion are paired with physical distortions, and the Ludlow example, in particular, has been interpreted as a representation of the ugliest or grouchiest hag living in town. The medieval Church expressed strong and repeated objections to exaggerations in female attire, the horned headdress receiving especially stern criticism. The bishop of Paris offered indulgences to people who would insult women wearing this fashion, and a Carmelite monk, Thomas Couecte, encouraged children to shout insults at the wearers.[3] The Ludlow misericord, in fact, includes heckling children.[4]

The clergy also disapproved of other specific items of feminine attire, such as the 'sideless gown', which was worn by Jeanne de Bourbon, queen of France and wife of Charles V (reigned 1364–80), recorded clearly on the Parement of Narbonne, a long

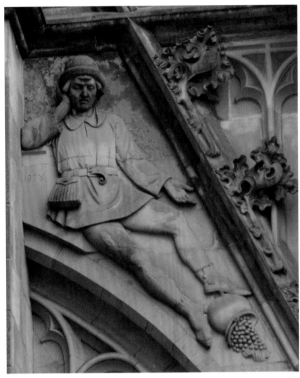

II.12. A rich master builder who considered a pot of peas beneath his status and threw it down (Pride): stone relief, north side, Sint-Janskathedraal, 's-Hertogenbosch (Den Bosch).

piece of silk painted with India ink grisaille, c. 1375, now in the Musée du Louvre, Paris. A sort of open surcoat or sleeveless tunic with oval openings on the sides that revealed a tight-fitting undergarment (and the wearer's form), the 'sideless gown' was denounced from the pulpit and the side openings

referred to as the 'windows of hell'. Long trains on dresses, a subject of sumptuary laws, were also denounced in church. The train, complained one Cardinal Latino, got dirty in the mud and, further, 'dirtied' men's thoughts – the train was regarded at the time as a seductive element of attire. The same cardinal sought to require all women to wear veils, but the dismaying result was that they looked even more alluring this way.[5]

While the Church objected to flamboyant attire for what were perceived to be moral reasons, the nobility objected to excess in dress for other reasons (and for those other than themselves). The intent of sumptuary laws passed by the nobility was to maintain obvious visual distinctions between social classes by regulating personal display. For example, under the rule of Philip the Fair of Burgundy (1285–1314), the size of certain garments, the amount of fabric a person could own, and even the width of trimmings on garments were dictated by law. Specific segments of society might be targeted, as was true of a law passed in England in 1355 that governed the garb of prostitutes: fur was prohibited, only striped hoods were permitted, and clothing was to be worn inside out. The law was intended to make prostitutes easily distinguishable, although the sceptic might ask why

this was necessary, and whether this law censured or, in fact, advertised the profession.

The display of a different sort of pride, not of physical appearance but of personal importance, is scorned in the story of the master builder of Sint-Janskathedraal in 's-Hertogenbosch (II.12), who had become rich (indicated by his large purse) and, believing that the pot of peas his wife prepared for his meal was beneath his dignity, threw it down. A permanent public record of his arrogant behaviour is carved in stone on the north side of this cathedral. His mournful expression as he gestures to the spilt pot of peas would seem to indicate that he regrets his display of pride.

Anger or wrath is repeatedly associated with tavern life in medieval art, where tavern gambling is shown to lead to hostility and then to fighting. This theme appears on misericords as in the chapel of St George at Windsor Castle, where two men quarrel over a card game – they pull their knives as a cat, ears back in fear, crouches on a chest. On a lower-stall side-relief at León Cathedral, men who gamble, in spite of their noble status indicated by their clothing, are soon to be taken to hell by a demon. Medieval Church morality considered games involving gambling to be contrary to religion, work, and good order.

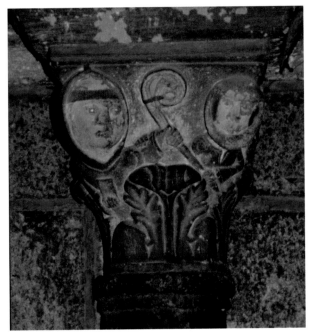

II.13. An abbot and abbess fight for a crozier (Anger): capital, cloister, cathedral, Le Puy-en-Velay.

Members of both the secular and the sacred domains succumbed to the sin of anger: its effect within the Church is shown on a capital in the cloister of the cathedral of Le Puy-en-Velay, which depicts a tonsured abbot and an abbess both tugging on a crozier (II.13). An ornate staff carried by bishops, abbots and abbesses, the crozier in this context represents the Church. Because the crozier is always held with the crook curving outward, so as to draw souls to God, this must be the abbot's

crozier that the abbess now grasps. Such an image may be viewed as having a broadly applicable meaning, alluding to the ongoing battle between good and evil, while simultaneously referring to local events and even specific individuals. Does the abbot fear the abbess will take control? Is this a conflict between monastery and convent?

Those who gossip or slander, connected with the sin of **Envy**, are punished in various ways in medieval art. On a nave capital in the church of Bois-Ste-Marie a demon gleefully pulls out a man's tongue with tongs, bracing himself with his clawed foot on the condemned man's feet, while the demon's accomplice holds the man's head still. Similarly, the slanderer's tongue is torn out on a nave capital in the church of Ste-Madeleine in Vézelay. Emphatically clear in meaning is the sixteenth-century misericord of a woman with a lock on her mouth so she can no longer gossip, on stalls that were moved to the church of St-Maurille in Les-Ponts-de-Cé after the Revolution (II.14).

A similar woman, mouth locked shut, appears on a corbel now in the Gruuthuse Museum in Bruges. Two smiling young women who gossip while in church are shown straddled by a hairy bat-like demon on a misericord of the late fourteenth century in the Royal Foundation of St Katherine, Stepney, London.

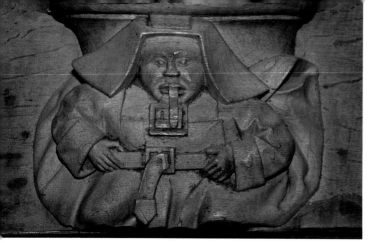

II.14. A woman (gossip) with a lock on her mouth (Envy): misericord, sixteenth century, now in the church of St-Maurille, Les-Ponts-de-Cé.

A misericord in Ely Cathedral also depicts two women who gossip in church – one holds a book, the other a rosary – while the devil Tutivullus inserted between them embraces both; on the supporters he writes down what they say on his long scrolls. A sculptor carved eavesdroppers high on the walls, nearly under the eaves of the Ridderzaal in The Haage – the proper place for them – who seem to listen clandestinely to private conversations in this large Knights' Hall.

Sloth is represented, on an oak bench end in the late medieval church of the Holy Trinity in Blythburgh, by a man comfortable under the bedcovers. He sits up but is too lazy to get up and out of bed; the pillow included in this relief, a symbol of indolence, emphasizes the point. Elsewhere, Sloth is likely to be represented by sleeping pedlars or even members of the clergy.

More generically, sloth is symbolized by a sleeping cat or dog, as on a fifteenth-century misericord at Notre-Dame des Grands Andelys in Les Andelys, or one from the early sixteenth century in the church of St-Denis in Coulanges.

Having looked at several individual representations of the seven deadly sins, the collective compendium in the Last Judgement carved on the twelfth-century tympanum of the church of Ste-Foy in Conques may hold special interest (I.15). Literally a sermon in stone, the rhymed inscription carved on bands that separate the scenes translates:

The assembled saints stand before Christ their judge, full of joy. Thus are given to the chosen, united for the joys of heaven, glory, peace, rest, and eternal light. The chaste, the peaceable, the gentle, the pious are thus filled with joy and assurance, fearing nothing. But the depraved are plunged into hell. The wicked are tormented by their punishments, burnt by flames. Amongst the devils, they tremble and groan forever. Thieves, liars, deceivers, misers, and ravishers are all condemned with criminals. Sinners, if you do not reform your ways, know that you will have a dreadful fate.

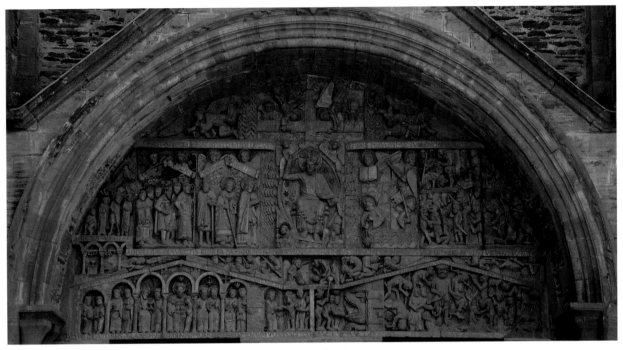

II.15. The Last Judgement: tympanum, twelfth century, church of Ste-Foy, Conques.

To Jesus's left, on an angel's shield is inscribed, 'The angels will come forth and separate the wicked from the righteous.' Further to the right are three monks ensnared in a net pulled by a devil: holding a crozier is Etienne II (940–84), simultaneously abbot of Conques and bishop of Cleremont, who connived with his two nephews, shown with him, to rob the church treasury. In front, with his head bent down, is Bégon II, abbot of Conques, who was appointed fraudulently, mismanaged finances, and now has a devil gnawing on his back. Below, the damned are shown to be literally 'eaten by remorse'. The written threats, combined with the activities of many of the 117 figures carved on this tympanum, make clear that medieval art sought to mould public behaviour through visual intimidation. It was said that, if love of God would not deter people from sin, perhaps fear of hell would be more effective.

In hell, on the tier below, people who have sinned now endure the consequences of their

61

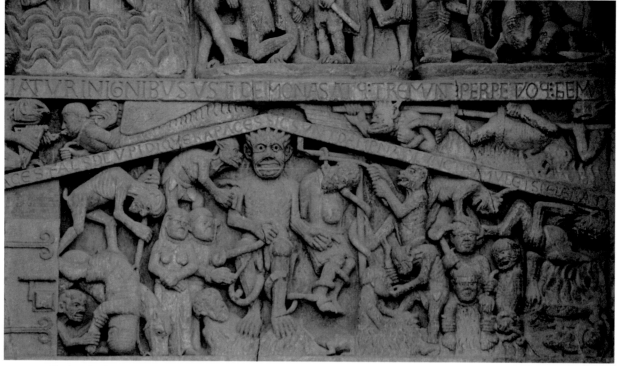

II.16. Hell: detail of II.15.

transgressions, the punishment suffered shown to accord with the specific sin committed (II.16). Moreover, greatly enhancing the impact of what is today called 'cognitive behaviour modification', the deadly sins are represented by *specific people* living in twelfth-century Conques who were guilty of these sins. As a comment on human nature, it may be worth noting that Conques is a tiny town today and was still smaller during the twelfth century, yet this portion of the tympanum is packed full – clearly the sculptor did not lack subjects.

Beginning on the left, Pride is represented by a neighbour of the abbey who coveted its wealth. A proverb says 'Pride goes before a fall' – he falls from his horse, or more precisely is pulled down by one devil as another stabs him in the back. This man is Rainon, seigneur d'Aubin, who attacked the monks of Conques, was excommunicated, and in fact died

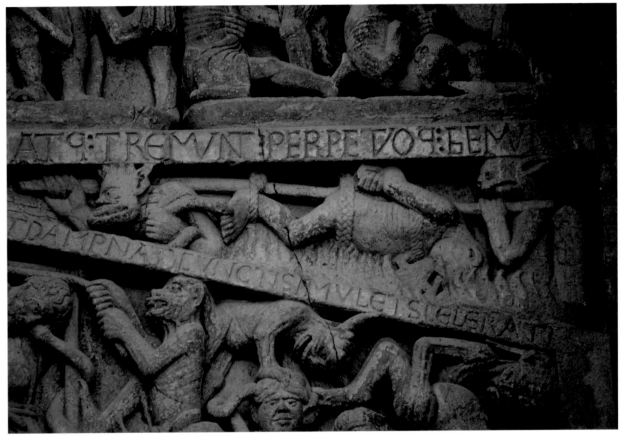

II.17. A poacher tied to a pole and roasted like a rabbit – by a rabbit: detail of II.15.

from a fall from his horse. Lust is represented by an adulterous couple, partly naked, tied together at their necks; above them, a devil asks Satan what their torture should be. The man is Hector, seigneur of the château of Belfort, punished for committing adultery on Ste-Foy's day. Satan, the main figure in the centre of this section, welcomes the damned. Lying idle under Satan's feet is Sloth, a sluggard enveloped by the flames of hell and approached by a frog, a standard symbol of sin. Further to the right, Greed is represented, as is customary, by the miser with a sack of coins around his neck – he hangs by its cord.

A serpent, another traditional symbol of evil from the Garden of Eden onward, wraps itself around the miser's legs. Envy is represented by the slanderer whose tongue is torn out by a devil. Just above is the author's personal favourite – a poacher who hunted in the abbey's woods is tied to a pole and cooked over an open fire (II.17). One end of the pole is held by a demon and the other by a rabbit who, now as cook, retaliates. A frog is at the poacher's mouth and a serpent bites his foot, making his association with evil clear. Typical of twelfth-century Romanesque sculpture, the carving has the exaggerated quality of a cartoon or caricature; the goal is dramatic, emphatic narrative, not visually deceptive naturalism.

Whether one's final eternal destination would be heaven above or hell below was decided – according to medieval art and literature – by weighing one's soul. The belief that people are judged after death by placing the deceased's soul in a balance goes back at least as far as ancient Egypt, and is found in about 1400 BC in the *Book of the Dead*. A papyrus fragment of *c.* 1300 BC now in the British Museum, London, depicts Anubis, Egyptian god of the dead, weighing the heart of the deceased against the feather of truth on a balance. Similar concepts are found in Eastern religions. In Greek literature and art, either Hermes or Justice is in charge of the balance. The task of Hermes, messenger of the gods, was often assigned in Christian art and literature to the Archangel Michael, God's messenger who weighed the soul of the deceased, represented as a tiny human that issued from the mouth at death. Based upon the *Enchiridion* of St Augustine (354–430), it was determined that the chosen would go to paradise and the damned to hell. The concept of purgatory, neither heaven nor hell, appears in the mid-twelfth century.

Medieval artists depicted souls literally 'hanging in the balance' at the Last Judgement, the outcome of the weighing affected by competing angels and devils. On the tympanum at Ste-Foy the devil cheats by carefully pushing down on his bowl with one finger; nevertheless, this soul is saved and will go to heaven, shown below on Jesus's right, rather than to hell, shown below on Jesus's left. On the façade of the Münster (Cathedral of Our Lady of Love) of Freiburg-im-Breisgau, an angel holds the scales and, although a demon goes so far as to hang from his bowl, the devil loses this soul – to the lament of another curly-tailed demon to the right. At Bourges Cathedral a thirteenth-century stained-glass window of the Last Judgement includes a depiction of the weighing of the souls in which, predictably, the furry

blue and horned devil cheats – he menaces the angel with a weapon in one hand and pushes down on the balance beam with the other, while a small green furry imp hangs from the bowl. It should also be noted that angels were not without their defences, for on a capital at the church of Saujon an angel pushes on a devil's head to prevent him from tipping the scales against a soul.

In these cases and others, the devil attempts to cheat in order to gain a soul for hell. But *neither the devil nor the angel* is honest when the souls are weighed at the Last Judgement depicted on the tympanum of the cathedral of St-Lazare in Autun, dated *c*. 1130–45, for the devil hangs on the balance beam while the angel pulls on the basket (II.18).

The thorough portrayal of the deadly sins carved in the twelfth century at Conques may be compared with the way in which this subject was painted in the church of St Ethelbert in Hessett. The figures' costumes are of the late fourteenth century (presumably when this mural was painted), suggesting that specific people are portrayed here – as at Conques. Although the clarity of the imagery is diminished now by damage, the sins are arranged on the branches of a tree, recalling a family tree intended to establish an impressive lineage, only here the tree grows from a hellmouth supervised by

II.18. Detail of the weighing of souls, Last Judgement: tympanum, *c*. 1130–45, cathedral, St-Lazare, Autun.

two demons. Pride is at the top, represented by a young man dressed in the peak of fashion with his flaring sleeves and a feather in his cap; Pride is given prominence because this sin led to Lucifier's fall

from heaven. Below, the remaining sins are represented three on either side. Each figure, already standing in the mouth of a monster, will be swallowed imminently, presumably descending through the long branch-like necks of the monsters, down the trunk of the tree, into the gaping hellmouth below. On the upper left a kissing couple represents Lust. Opposite is Wrath holding a dagger in his left hand and a whip in his right. On the left middle level, Sloth leans back, as if to recline. Opposite is Envy, dressed in green – a person may still be described today as 'green with envy'. On the left side of the lowest tier Avarice holds a bag, presumably of coins, the usual identifying attribute of misers. Opposite is Gluttony – the image is deteriorated yet the figure appears to be eating something quite large. At Hessett all seven sins are included, but in this restrained English representation their punishment in hell below is only implied.

In striking contrast, although probably contemporary in date, is the painting by Taddeo di Bartolo of 1396 on the walls of the duomo (collegiata) in San Gimignano. Here Satan presides over hell, supervising the many devils who torment the damned. The punishments are horrifying and the figures rather realistic, making the message still more emphatic. Thus Lust is tormented by three demons simultaneously, one a horned hag who grotesquely violates her. The adulterous couple is bound and beaten, as a demon embraces, gropes and kisses a woman. Envy endures a non-anatomical disembowelling. Greed is identified by his sack of coins; two demons use its cord to strangle him. Just below, a demon defecates gold coins into the mouth of an obese man. Another, in spite of being reduced to a skeleton, is fed by two demons as he hangs by the neck. The gluttonous, including a fat tonsured monk, cluster around the dinner table. Sullen Sloth sits still, unresponsive to the surrounding events.

Although the torments of hell at San Gimignano are more varied, complex, and graphically depicted than earlier at Conques, perhaps San Gimignano's hell is also less readily understood, more chaotic and confusing to the viewer, lacking the immediacy of Conques's cartoon-like exaggerations and humorous inclusions – remember the hare who roasts the hunter. At San Gimignano some of the sinners are labelled with names such as Simon Mago (Simon Magus) and Erode (Herod), and thus represent specific people, but they are traditional examples of evil rather than individuals residing in late fourteenth-century San Gimignano; this depiction lacks the impact of seeing your neighbours depicted

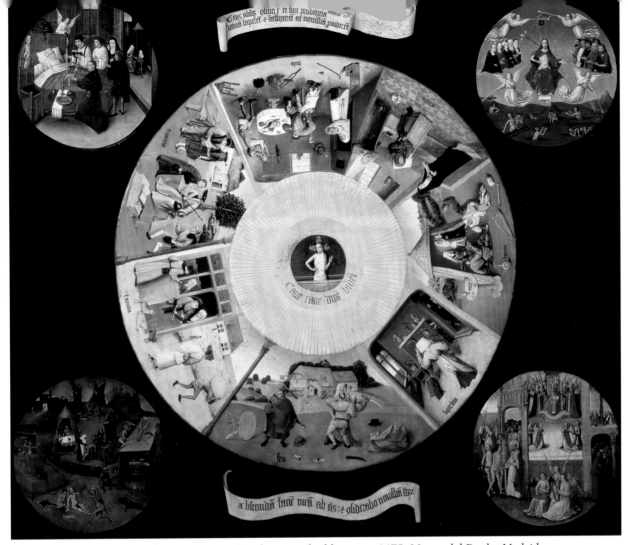

II.19. The seven deadly sins by Hieronymus Bosch: painted table top, *c.* 1475, Museo del Prado, Madrid. *(Photo: © The Bridgeman Art Library)*

in hell and knowing that you, too, could be portrayed there for all to see for eternity.

Differing from the representations of the deadly sins in France, England, and Italy just discussed is one created in yet another country, and in another medium. The Netherlandish artist Hieronymus Bosch painted the seven deadly sins on a table top, *c.* 1475, now in the Museo del Prado, Madrid (II.19). Anger

is represented by a domestic dispute. Pride is shown as a woman in fancy attire admiring herself in a mirror held by a demon – who sports a similar headdress. Lust is displayed by lovers inside a tent as a fool is beaten with a large spoon – a symbol of sexual desire and illicit love. The scene includes food, drink, and musical instruments – the last relates to the Flemish proverb that music-making is a likely prelude to love-making. Sloth sleeps, his eyes closed to the offer of a rosary. Food is the sole interest of Gluttony. Avarice is portrayed by a judge who listens to one person while taking a bribe from another. Envy is represented by a dog who has two bones, but wants another held just out of reach, and by a man labouring under the burden he carries on his back, envious of the man who does not work.

Bosch depicted not only the seven deadly sins on this table but also their results, for the circles in the four corners depict the 'four last things'. On the upper left is Death – a man is in bed, an angel and devil hover on his headboard (waiting to contest possession of the soul) and a skeleton enters with the arrow of death. On the upper right is the Last Judgement – the destinations possible thereafter are shown below to be hell or paradise. But Bosch's focus is on sinful behaviour rather than on its punishment in hell, which contains generic torments, unlike the concept of hell carved at Conques or painted at San Gimignano, which focuses on specific punishments for specific sins.

Bosch is praised for the unusual and clever presentation of his visual sermons, as in his paintings *The Haywain* of *c*. 1490–95, one version in the Prado in Madrid, another in El Escorial near Madrid (scholars debate which is the original); *The Ship of Fools* of *c*. 1495, perhaps as late as *c*. 1500, in the Louvre; or *The Garden of Earthly Delights* of *c*. 1505–10, in the Prado. Bosch bridges the Middle Ages and the Renaissance. His approach has antecedents in the Romanesque Middle Ages – as evidenced at Conques where it is seen that what warns can also entertain and what induces fear can also amuse. An element of shock

II.20. A little dog (Verona) biting a big lion (Venice) on the bottom: south porch, Verona Cathedral.

may simultaneously engage, for there is an innate human compulsion to look at what we find frightening or repulsive, before turning away in horror or disgust, perhaps feigned. The medieval Church used such evocative imagery to illustrate sermons, thereby strengthening their impact and making their messages to the masses more readily recalled.

THE WORLD UPSIDE DOWN (*INVERSUS MUNDI*)

The theme of the 'world upside-down', a sort of perversion by inversion of the natural order of life, was very popular during the Middle Ages and is seen in many variations. The notion of the 'topsy-turvy world' has ancient origins and can be found as early as Egyptian depictions of animals engaged in activities normally reserved for humans. The basic concept of the *monde renversé* amuses and entertains. Its appreciation in medieval western Europe is perhaps linked to the belief that Satan sends demons of temptation to reverse God's plan – hence God's name is reversed to Dog, obscenities are venerated, and lewd songs are sung. The *inversus mundi* is seen as an earthly reflection of Satan's hell below, itself the world upside down. The customary manner in which various things are done in daily life was

inverted at a medieval winter celebration, and the Feast of Fools was celebrated in various forms. On St Stephen's day, a choir boy was elected bishop – the so-called Boy Bishop – and reigned with the Lord of Misrule. While presumably the official Church disapproved of such activities, they were certainly carried out in at least some local churches, as evidenced by representations of the Boy Bishop and the Lord of Misrule carved on the bench ends of the choir stalls in St Laurence in Ludlow. Many other depictions of role reversal are found in medieval art.

ANIMALS IN HUMAN ROLES

Medieval artists frequently depicted animals behaving as humans and less often humans acting like animals. When the laws of nature and of common sense are thus inverted or revoked in subjects involving animals, the theme usually relates to who has power, dominates, scares, hunts, eats, or preaches. Animals are used as vehicles for satire: one of the best – and subtlest – uses of animal imagery to make a political point is seen on the south porch of the duomo of Verona, which, as is common on porches in northern Italy, uses lions for supports. But here, curiously, a small dog bites the lion from behind. The lion is the symbol of Venice; this dog represents Verona coming from behind to bite Venice (II.20).

Animals were frequently used to mock human follies and foibles – our myriad frailties and failings – by performing activities normally restricted to humans. Although certain subjects recur, their presentation is never identical. Thus, the rabbit's revenge on the hunter carved on the Conques tympanum (II.17, above) also appears in the guise of a nude man hanging upside down from a pole over the shoulder of a huge hare in hell on the right panel of Bosch's painting, *The Garden of Earthly Delights* just mentioned. A minutely detailed engraving by the Flemish artist Israhel van Meckenem (d.1503) portrays 'The Rabbits' Revenge' in which the hunted become the victorious hunters, the point made emphatic since the man is even turned on a spit like a rabbit – by a rabbit – and hunting hounds are simmering in caldrons. In this revolt by role reversal, the usual victim is doubly victorious, becoming not only the hunter but even the cook! This subject was given a political meaning in a hand-coloured woodcut broadsheet by the German artist Georg Pencz, 'Hunters Caught by Hares', dated *c.* 1534–35, for the government is represented by the hunters and the peasants are symbolized by the unusually large hares who boil dogs in kettles. Special meaning seems to be attached to this role reversal when inserted below an illumination of 'St George and the Dragon' in a manuscript in the Bodleian Library, Oxford, showing two hares armed with weapons attacking a dog; thus in both pairs (hares and hound as well as saint and dragon) the tables are turned and the intended victim is victorious.[6]

Among the instances in which the hound and hare – usual roles reversed – appear carved in wood is the frieze on the late fifteenth-century choir stalls of Toledo Cathedral, where a very large smiling rabbit cooks a dog in a pot over an open flame. Another kind of comical inversion appears on a misericord at Worcester Cathedral, where a hare rides on the back of a hound, as if riding a horse.

Other animals beside hares turn the tables and take their revenge on humans. At the little rural church of Sts Mary and David in Kilpeck, built *c.* 1145, a pig eats a tiny person (II.21) and another person struggles out of a big bird's beak. Interpretation of these corbel figures is difficult because of the inversion between human and animal of both their relationship and their relative scale. Have these familiar creatures metamorphosed into enormous monsters who will devour anyone who chooses to remain outside the Church? That these animals at Kilpeck, in spite of their cartoon-like style, were meant to frighten is supported by the

II.21. A pig eating a tiny person: *c.* 1145, church of Saints Mary and David, Kilpeck.

appearance elsewhere of mortal meals consumed, not by animals that humans normally eat, but by overtly monstrous beasts that represent the dangerous temptations and sins to which the faithful must not succumb. Medieval art includes countless depictions of devouring monsters, frequently dragons or dragon-derivatives shown dining on people, their diet made obvious by the

remaining body parts still protruding from their mouths. These include the dragon who eats a man, head first, on a lintel on the south side of the duomo of Verona (II.22). This victim has been interpreted as Jonah swallowed by the whale, routinely depicted as a dragon-like creature in medieval art. On a mid-fourteenth-century misericord at Gloucester Cathedral a monster holds a human's head in his mouth, variously interpreted as Jonah and the whale, Judas in the mouth of hell, or St Margaret swallowed by a dragon. On a corbel at Notre-Dame in Vouvant a crude and comical carving depicts only the plump buttocks and legs of a hungry monster's meal still visible – as two animals above smile approvingly (II.23). Etiquette among medieval monsters evidently dictated that the meal must be eaten head first, since frequently the victim's legs are seen sticking out of the monster's mouth. A façade corbel at Notre-Dame in Echillais offers an exception, for all that remains in the smiling monster's mouth is one human hand, still trying to escape an inevitable fate (II.24). And only the upper half of a monk remains visible as he struggles to free himself from the jaws of a dragon that functions as an aquamanile, made of bronze in Germany between the late twelfth and early thirteenth century, now in the Cloisters, New York.

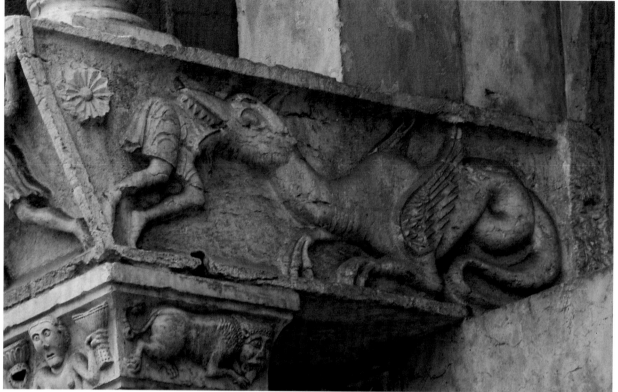

II.22. A dragon devouring a man head first (Jonah and the whale ?): relief on lintel, south side, Verona Cathedral.

Among the many animals depicted by medieval artists, monkeys and apes appear with notable frequency, mimicking human behaviour as they wear clothes, ride other animals, teach, study, fish, juggle, joust and game. Although commonly kept as pets during the Middle Ages, monkeys and apes were routinely given negative connotations in art and literature, their ability to 'ape' human behaviour making them natural subjects for the 'world upside down' theme. The ease with which a monkey can make a fool of man is demonstrated in a spandrel relief in the Romanesque nave of Bayeux Cathedral: the buffoon kneels before the monkey which, although chained, is elevated on a pedestal above

II.23. A monster devouring a small human (buttocks and legs visible) to the satisfaction of the animals above: corbel, twelfth century, church of Notre-Dame, Vouvant.

carrying his produce on his back on a misericord of 1337–39 at Wells Cathedral. The monkey as thief is seen on a seat carving at Bristol Cathedral where he steals bags of grain and rides away on horseback, and at Beverley Minster, again on horseback, followed by the angry owner. Eight apes rob a sleeping pedlar on a misericord at Manchester. On the outside of a painted enamel beaker, probably made in the southern Lowlands *c.* 1425–50, now in the Cloisters, New York, a multitude of monkeys act like lowly thieves as they relieve a sleeping pedlar of his wares. On the inside, in contrast, the monkeys mock the aristocracy by aping their fondness for stag hunting, the favoured pastime of the upper class. Monkey are used to satirize people who try to do things for which they have no ability

him. Obviously satirical, it would be interesting to know if such images are meant to ridicule a specific individual or the general customs, practices, and beliefs of the time.

Monkeys are repeatedly shown to mock through mimicry. Thus a monkey appears as a pedlar

II.24. A monster with a human hand remaining in its mouth: corbel, church of Notre-Dame, Echillais.

– a subject that was given various forms in the Middle Ages. Thus in a German window made of colourless glass with silverstain and vitreous paint, of 1480–1500, now in the Cloisters, New York, three apes build a trestle table with no more legs than there are carpenters.[7]

Doctors are a special target for medieval satirists: public opinion of the medical profession is revealed by witty depictions of animal physicians – often apes shown holding up for inspection the distinctively shaped urine flask, just as human doctors do in medieval medical illustrations. During the Middle Ages it was customary for doctors to analyse urine, based upon its appearance, smell, and even taste, to make a diagnosis; doctors had so much confidence in this source of information that they might not even examine the patient.[8]

This subject appears repeatedly on English misericords. Thus on a misericord in the church of St Mary in Beverley a running Barbary ape holds up a urine flask for inspection in his right hand, and points to it with his left. An ape physician sits on a supporter at Beverley Minster, looking contemplatively at his flask. A monkey mocks medical practices by holding a urine flask on a misericord supporter in Manchester Cathedral, a commentary on the fallacies of fraudulent physicians. The ape doctor is on a misericord at Bristol Cathedral. A misericord in St Botolph, Boston, portrays an ape holding up the urine flask and, in this instance, his patient is a fox – is the usually sly fox now at the mercy of the ape doctor?

Such ridicule occurs also on the continent. The image appears in French manuscript marginalia, for example – the ape holding up a urine flask, presumably brought by the attendant owl, in an early fourteenth-century book of hours from northern France, now in the Musée Condé at the château of Chantilly.[9]

ANIMALS IN RELIGIOUS GUISE

Among the professions open to the satirists' attack was that of the monk, manifested in a series of depictions of monkeys dressed as monks. Rather than targeting the entire religious structure, it is likely that such ridicule is aimed at specific individuals, much as the seven deadly sins were depicted using individuals as negative exempla.

A vault boss near the Slype door in the cloister of Canterbury Cathedral is carved with a caricature of a monkey wearing the monk's identifying cowl (II.25). Although this head is small in size and subtle in location, its mockery is absolutely clear.

II.25. A monkey wearing a monk's cowl: vault boss, cloister, Canterbury Cathedral.

A monkey monk sits comfortably on a handrest of the stalls at the church of St-Maurille in Les-Ponts-de-Cé (II.26); should there be any doubt about this monkey's ability to 'ape man's behaviour' or of the mockery made of the monk's 'monkey business', his companion on another handrest here is a fully-attired monk in the same pose with a monstrously distorted face. An ape dressed as a bishop arguing with another ape appears in the *Smithfield Decretals*,

an English manuscript of *c.* 1330–40, in the British Library, London,[10] and another ape dressed as a bishop is seen in a book of hours from the early fourteenth century, today in Trinity College, Cambridge.[11] Monkeys mimic the behaviour of monks singing over a draped coffin in the margin of the text for the 'Office of the Dead' in a French book of hours from the 1320s, now in the British Library, London.[12]

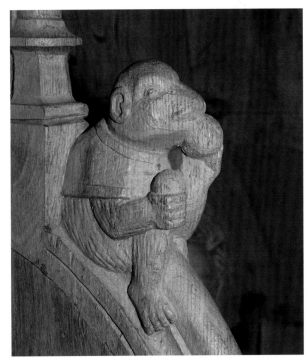

II.26. A monkey monk: choir stall handrest, church of St-Maurille, Les-Ponts-de-Cé.

The story of the sly fox in the role of a bishop, monk, or other ecclesiastic was popular during the Middle Ages. Most frequently the fox is dressed as a monk and is preaching from the pulpit to a congregation of geese; the fox may have already caught one or more members of his audience, some being attentive although others are put to sleep by his sermon. The satirical subject derives from tales ascribed to that most famous of storytellers, Aesop (*c.* 600 BC). It appears in the story of Reynard (Reinard) the fox, in particular in that of Reynard's son, Reinardine/Reynardine, also very popular during the Middle Ages, and is connected with the poem, the 'Roman de Renart' (History of Reynard the Fox), especially the later versions. Although the sequel, 'Shifts of Reynardine', was written in the seventeenth century and printed in 1684, it derives from earlier tales and provides the basis for the scene of a fox in monk's or priest's clothing preaching to geese with the intent of eating them. The tale is told also by Chaucer in his 'Nun's Priest's Tale'.

It is probable that this satire on clergy who mislead innocent parishioners does not refer to the Church as a whole, nor is it meant to criticize the clergy of the church in which the subject is shown, but targets instead the wandering friars either as a group or even as individuals. These itinerant preachers addressed the common people and criticized the regular monks and clergy as corrupt and wealthy, while the regular monks and clergy satirized the itinerant preachers as rapacious hypocrites who took advantage of their simple congregations. The wandering friar is portrayed as the 'sly fox' – an expression still in use today, and the gullible congregation is portrayed as geese – one may still hear someone being called a 'silly goose'.

The preaching fox appears repeatedly on misericords with amusing, if sinister, variations. In Beverley Minster, among the commentaries found here on religious conflicts of the time, is a portrayal of friar fox in the pulpit preaching to his feathered audience, while another fox runs off with one goose, and an ape accomplice has another goose over his shoulder. The Beverley misericord has been linked to the minster's concern that the faithful were listening not to their own preachers but to the Dominican friars in their city. The canons cautioned the good people of Beverley, specifically comparing those who listened to the Dominicans to unsuspecting geese lured by a predatory fox, warning that this would lead to their spiritual and secular ruin. A misericord in the Benedictine church in Etchingham depicts a fox dressed as a Franciscan priest haranguing a congregation of geese – it has been observed that

misericords in Benedictine churches are inclined to criticize the Franciscans.[13] In St Laurence in Ludlow a misericord of the first half of the fifteenth century portrays a fox dressed as a bishop, preaching to geese until they fall asleep, whereupon he will pounce on them. Another at Wells Cathedral, carved *c.* 1330–40, depicts a fox sermonizing to four geese; the one closest to him already asleep. When portrayed in Ludlow and Wells, this variation on the popular medieval moralizing tale demonstrating that the foolish are seduced by fair but false words was perhaps also intended to warn people about the Lollards – Wycliffe's followers.

Many other examples of this subject survive, underscoring the prevalence of the concern as well as the popularity of the Reynard stories. A misericord supporter at Ely Cathedral, carved between 1339 and 1341, depicts Reynard dressed as a bishop carrying the crozier and deceiving his attentive congregation of a cock and two geese. At Ripon Cathedral a misericord shows a fox preaching from the pulpit, flanked by two attentive birds – a cock and a goose. Another misericord, dated between the late thirteenth and early fourteenth centuries at St Mary in Fairford, portrays the fox to have killed at least one goose, its neck in his mouth and lying limp over his shoulders. Bristol Cathedral

has an unusual number of misericords with this theme. Related depictions of Reynard, so popular during the Middle Ages, are on misericords at St Mary in Beverley, the church of St Botolph in Boston, the church at Nantwich, and Sherborne Abbey, and in a wooden quatrefoil on the choir stalls of Lincoln Cathedral.

In France the preaching fox is seen on misericords from St-Taurin, now in the Municipal Museum, Evreux; the church at Bletterans; St-Claude Cathedral (Jura); the chapel at Château l'Hermitage; in the former collegiate church of St-Martin in Champeaux; and an example from the chapel of St-Lucien-de-Beauvais is now in the Musée National du Moyen-Age, Paris.

Reynard's popularity extends far beyond British and French misericords, to other countries and other media. A fox wearing a monk's habit lectures to a group of geese and has already stuffed several fowl into his cowl in the marginalia below the 'Presentation of Jesus in the Temple', in a missal produced before 1381 in lower Germany, probably Hamburg, now in the Pierpont Morgan Library, New York.[14] The fox as cleric and the fox preaching to fowl appear in the margins of other Gothic manuscripts.[15] A fox in a monk's habit, preaching to geese, some already in his hood while another fox

II.27. A fox preaching to geese: spoon bowl, second quarter of fifteenth century, silver, enamel, and gilt, Museum of Fine Arts, Boston (51.2472). *(Helen and Alice Colburn Fund. Photo: © Museum of Fine Arts, Boston)*

bites a goose's neck and another goose flies away, is exquisitely painted in enamel and gilded on a silver spoon, a Flemish work of the second quarter of the fifteenth century, perhaps *c.* 1430, now in the Boston Museum of Fine Arts (II.27).

In each case Reynard is shown to be sly and crafty as he achieves his unethical goals; we should scorn

his behaviour but his cunning is impressive and, in fact, admirable. Ultimately his victims seek to hang him: in literature he gets a reprieve at the last moment, but medieval artists are less forgiving and Reynard less fortunate. Thus, while Reynard may be shown to be successful in his deceptive preaching, he may also be found hanged on the gallows by vengeful geese, as on a misericord at Bristol. And on the façade of San Zeno in Verona, two roosters strut as they carry the captured fox, tied to a pole and hanging upside down, for all to see (II.28).

The fox in ecclesiastical garb appears in roles other than preacher. Clearly satirical is the ceiling boss of the late fourteenth to early fifteenth century in the nave of Winchester Cathedral showing a fox

II.28. A captured fox hanging upside down from a pole carried by two roosters: relief, façade, church of San Zeno, Verona.

wearing a cowl and flanked by monks, the animal using his paw to mark a place in the book held open by the monks. This carving is so high in the vault that it cannot be seen clearly from the floor – could this be the sculptor's joke, made without the knowledge of the Church authorities? Tantalizingly subversive though this theory may be, such sculpture was carved in the studio, rather than up *in situ*; thus it is unlikely that the sculptor hid his work from his patron. Instead, the medieval Church was quite comfortable with humour, even that which might be self-deprecating. Overt satire of the clergy is seen on a misericord in St George's Chapel at Windsor Castle where the mouth of hell opens wide to receive three monks in a wheelbarrow pushed by a demon and steered by a fox.

MUSIC-MAKING ANIMALS

Animal imagery was used to mock human behaviour in a great many ways by medieval artists; a recurring subject is that of the animal musician, especially in the twelfth century.[16] This may be linked to the importance of music at this time, for it was studied with arithmetic, geometry, and astronomy as part of the *quadrivium* in monastic and cathedral schools during the so-called renaissance of the twelfth century. The appeal, popularity, and variety of music-making

animals and instruments is demonstrated in St Gabriel's chapel in the crypt of Canterbury Cathedral, where several examples are found on a column capital of *c.* 1115–25; one side displays a donkey playing a cornet and a monstrous animal a harp, while another face shows a goat performing on a flute and a ram bowing a violin. The species of animals vary as do their musical instruments, the most common combination being an ass or donkey standing on his hind legs and playing a harp or lyre, an image especially popular in the stone sculpture of twelfth-century France. This is seen on a voussoir of the south transept portal of St-Pierre at Aulnay-de-Saintonge, of the first half of the twelfth century, where the donkey's animal companions dance to his music (II.29). Similar performances are provided on capitals by a curly-haired lyre-player in St-Nectaire; an ass plucking a lyre at St-Parize-le-Châtel; a donkey duet on the lyre at St-Julien in Brioude; a goat playing the lyre as a lion rings a bell in Notre-Dame in Beaune; and an ass strumming a lyre on a corbel in La Plaisance-sur-Gartempe. Much the same subject appears in other geographical areas and media: for example, a donkey performs on a lyre as a fox and goat dance to his tune in a Spanish fresco of *c.* 1220 from San Pedro de Arlanza, now in the Cloisters, New York, and in Germany a horse

II.29. A donkey playing the harp: voussoir relief, first half of the twelfth century, portal, south transept, church of St-Pierre, Aulnay-de-Saintonge.

performs on a lute on the stalls of the church of St Martin in Emmerich.

But it is likely that this music-making is more than mere fun, perhaps relating to ideas found in early fables such as that attributed to Aesop about the donkey who found a lyre but could not play it. Medieval artists tended to portray the donkey

standing up on two legs and trying to make music as a person would, but, having hooves instead of fingers, he cannot. The tale suggests that we humans, too, sometimes think we have abilities that in fact we do not. From classical mythology comes the Phaedra fable of the 'Ass Musician', in which the ass finds a lyre and tries to play it but is unable, admitting 'I know nothing about music. If anybody else had found this lyre, he would charm ears with his divine harmonies.' In this satire on futility the donkey recognizes his own limitations as well as the abilities of others. Or might the animal musicians derive from the words of the Roman Boëthius (AD 475–525), author of *De consolatione philosophiae* (*Consolation of Philosophy*), widely read during the Middle Ages, that are spoken by the personification of Philosophy to her uncomprehending disciple, 'Do you hearken to my words or are you like an ass with a lyre?'

This negative connotation is supported by the harp-playing sow at Notre-Dame in L'Epine, for the pig is a symbol of Lust and Gluttony (II.30). Although able to stand up like a human, dress like a human (she wears a belt), and play a harp, she is still a sow suckling her hungry offspring. The meaning is made clearer by a misericord at Ripon Cathedral that depicts a sow playing the bagpipe as two piglets dance, for bagpipes were made from pigs' bladders,

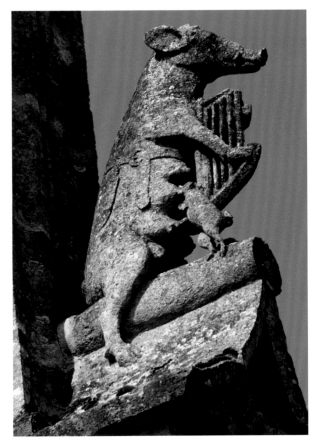

II.30. A sow (with piglets) playing the harp: church of Notre-Dame, L'Epine.

making them low-class instruments associated with the peasantry and animal lust. That bagpipes were played at fairs further diminished their status. In Beverley Minster a misericord depicts a sow playing the bagpipe to the delight of her dancing piglets, and in Melrose Abbey as in Manchester Cathedral there is a pig with a bagpipe. In Spain a pig plays a bagpipe on a misericord at Ciudad Rodrigo. The bagpipe appears in Hieronymus Bosch's painting of hell on the right wing of his *Garden of Earthly Delights* triptych, mentioned above.

The link between the pig and lust is made clear on a misericord in the chapel of Henry VII in Westminster Abbey, where little subtlety is involved as an older man reaches into his purse while putting his arm around the waist of a young woman in a low-cut dress, as she holds her purse in one hand while extending her other to receive his money. On the right supporter a pig stands and plays the flute for them, while a dragon, traditional symbol of evil, coils on the left supporter. On the stalls of Oviedo Cathedral a relief depicts one razorback pig standing on its back legs to play the bagpipe for two others in the process of copulating, similarly standing on their hind legs.

The animal musicians' unsavouriness is seen at Notre-Dame in L'Epine where a monkey (whose unfavourable qualities – according to medieval beliefs – were discussed above) plays the bagpipe (II.31). A monkey dressed as a man plays the fife and drum, instruments associated with carnivals in the Middle Ages, on an elbow rest of the

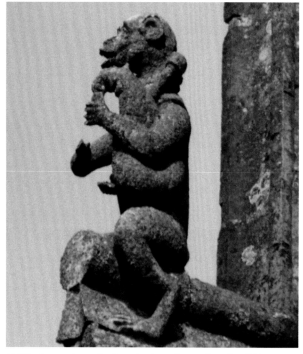

II.31. A monkey playing the bagpipes: church of Notre-Dame, L'Epine.

sixteenth-century stalls at the collegiate church of St Catherine in Hoogstraten.

Emphasizing the Church's disdain for secular music are music-making monsters, such as that carved on a misericord in the church of Sts Peter and Paul in Lavenham. A composite creature with the upper body of a woman plays a gittern while, beside her, a monster with the upper body of a man mocks her by holding a bellows under his chin as

one would a violin, and playing this pseudo instrument with a crutch as if it were a bow. It is worth noting that animals with positive connotations – for example, the lion – are not shown playing musical instruments.

Not all music-making animals in medieval art do so willingly, for on an oak misericord in the same church in Lavenham a crucial step in making bagpipes seems to have been omitted, for a man is playing a pig as if it were a bagpipe, holding the pig under his arm and compressing the unfortunate animal with his elbow to produce a squeal. On a misericord at Beverley Minster a monkey uses a cat as a bagpipe by biting its tail. And an ape plays a dog like bagpipes on a misericord in Norwich Cathedral by blowing on the hapless animal's tail and pressing on its legs!

Although music played an important role in religious rituals, the Church opposed music thought to incite its listeners to lust – hence the association with the pig and the ape, themselves symbols of sensuality. The bestiary links boars and country pigs to things wild and rude – hence 'boorish' – and the ape/monkey to base sin and lustfulness. In defence of the animal musicians, however – given that so many are found in choirs on stalls, such as the sows playing a double flute at Winchester or a harp at

Beverley, or the cats playing fiddles at Wells and Beverley as mice dance – perhaps they might also be more generously regarded as happily and helpfully providing musical accompaniment, at least visually, for the singers in the choir.

WAR OF THE SEXES

The conflict between men and women started with Adam and Eve, and art offers little evidence of domestic bliss or even tranquillity during the Middle Ages. Rare is the depiction of a happy couple whose relationship is romantic and affectionate. A notable exception is a misericord of *c.* 1330 at Chicester Cathedral which shows a man turning his head from his musical instrument to kiss a woman as she dances nearby. Instead, the norm was to portray men and women as fundamentally adversarial, their conflict shown either by a physical altercation or by a symbolic tugging at trousers.

Such a hostile view of married life is probably linked to the fact that misericords were commissioned by and for male clergy; perhaps this is the impression held by the celibate medieval priests – or what they were led to believe conjugal life would be like, were they to leave religious life and marry. This misogynistic attitude is revealed clearly on a misericord of 1492, in the former Augustinian abbey of St-Martin-aux-Bois, of a sculptor (or God) and a devil working together to create a woman: a proverb explains, 'God cannot create woman without the aid of the devil' or 'It takes the help of the devil to make a woman'.

When a man and a woman are depicted together as husband and wife, the woman is frequently shown attacking the man, her weapon often associated with household chores – a washing paddle, a distaff, spindle, spoon/ladle, or even a small piece of furniture. She may grab him by the hair or beard, thus attacking his virility. The battle of the sexes is especially common on English misericords; in each of the fifteen extant examples, the wife dominates her husband. However, such a depiction of domestic dispute is itself 'topsy-turvy', the very opposite of the actual situation. The woman may be shown to be physically larger than the man – unlikely to be the case, making the 'world turned upside down' theme more apparent.

Although it is unusual for misericords to be paired by subject, this is found in the cathedral church of Hereford, dated *c.* 1380 or earlier. On the first misericord a seated young couple holds hands, while the second shows the couple when older and fighting furiously, he seemingly attempting to defend himself as she throws an object (now

damaged and unidentifiable) at him and kicks him. Another pair having to do with the battle of the sexes, this time from Spain, is seen among the late fifteenth-century misericords in León Cathedral. On the first a woman 'wearing the pants' and holding her spindle threatens to strike her husband, while the second shows him spinning thread. It is an example of the norm inverted, for she strikes him and he does 'woman's work'.

These subjects are combined into a single scene on a misericord of 1509 in the chapel of Henry VII in Westminster Abbey, on which an unhappy man winding wool – routinely regarded as 'woman's work' – is birched on his bare bottom by a smiling woman. Another example of the 'natural' hierarchy inverted is seen on a misericord of *c*. 1520 in Bristol Cathedral showing a man lifting the lid of the cooking pot as a woman grabs his beard. On a misericord in Ely Cathedral a woman bites a man's thumb as they fight. In Lincoln Cathedral a misericord of the second half of the fourteenth century depicts a domestic brawl in which the woman has the upper hand, for she rushes toward him, grabs him by the hair, and flings his body upward, ready to strike him in the next instant. A woman beats a man miserably on a misericord in Tewkesbury Abbey: he is on the ground, she

restrains him by his hair, and is about to club him with her washing paddle. The same subject appears at the church of St Mary, Fairford. The conflict between the sexes takes a more humorous (and chivalrous) turn on a misericord in Bristol Cathedral that portrays a man and woman jousting, he riding a pig, a symbol of lust and gluttony, and she, armed with a broomstick, riding a goose, a symbol of the female sex and foolishness.

While the subject of the war of the sexes appears with notable frequency on English misericords, it is found elsewhere at various times, demonstrating the widespread and enduring nature of this human conflict. It was already noted in León; another Spanish example in Plasencia Cathedral shows a man being spanked on his bare bottom by a woman. The theme also appears in different media, for an amusing version is found on a copper plate from the south Netherlands, probably Dinant or Malines, *c*. 1480, now in the Metropolitan Museum of Art, New York. It depicts a woman who sits facing backward astride a man, lifting his garment with one hand and raising her weapon in her other to strike his exposed bottom. The tools he holds indicate that he has been spinning wool, the task perhaps not performed to her satisfaction.

Rather than this sort of physical fight, the struggle between the sexes is represented more

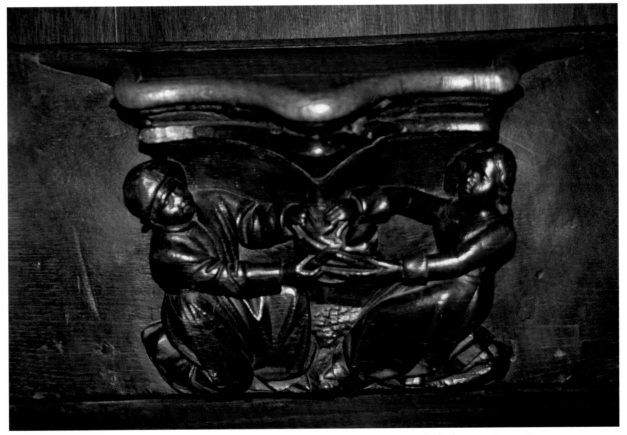

II.32. The war of the sexes (battle for the breeches): misericord, 1457–70, cathedral of Notre-Dame, Rouen.

often on the continent, especially in the Low Countries and France, by a symbolic battle over the breeches; the early English expression, 'to wear the trousers in the family' still carries the same connotation today. This is seen in Belgium carved on a mid-sixteenth-century misericord in the collegiate church of St Catherine in Hoogstraten, where a man and woman tug on opposite sides of his trousers which, the carver makes clear, he is no longer wearing. In France, the subject of the *combat pour la culotte* is carved on a misericord of 1457–70 in the cathedral of Notre-Dame in Rouen (II.32),

the man and woman both leaning backward to tug as hard as possible on the trousers. Age does not seem to mellow the combatants, as evidenced by an older couple seen fighting for the pants on a misericord in Villefranche-de-Rouergue. A misericord from the stalls of the destroyed abbey of St-Lucien-de-Beauvais, now in the Musée National du Moyen-Age, Paris, also depicts the battle over the breeches. Not limited to misericords, the same subject is seen in the cathedral of St-Etienne in Auxerre on a fourteenth-century south transept capital, as well as in the margin of a Franco-Flemish mid-fourteenth-century manuscript now in the Morgan Library, New York, where a man and woman struggle over the trousers she holds in her right hand while restraining him with her left as he is about to strike her.[17]

Both forms of the war of the sexes are combined in engravings by Israhel van Meckenem. In 'The Battle for the Breeches' a woman is about to strike a man with her distaff; his trousers are already on the ground. And in 'The Hen-pecked Husband', of 1480, van Meckenem shows the woman putting on trousers with one hand while raising her spindle in the other to strike the man who now does the spinning.[18]

The dangers of feminine charm were made clear by the story of Aristotle and Phyllis (Campaspe),

popular during the late Middle Ages and Renaissance. According to this tale, young Alexander the Great was so enamoured of the lovely Phyllis that he paid insufficient attention to his work. Old Aristotle, the wisest man in the world and formerly Alexander's tutor, attempted to persuade Alexander to forgo Phyllis's charms and return to his duties. Phyllis, as a consequence, sought her revenge on Aristotle by so thoroughly enticing and entrancing him that he agreed to her request to ride on his back. When Alexander questioned this conduct, Aristotle explained, 'If a woman can make such a fool of a man having my age and wisdom, how much more dangerous must she be for the younger ones?' This story was considered a warning for men to beware of women's wiles – and if the number and variety of visual and literary forms this story was given by artists and authors working in different locations is any indicator, worry over this peril must have been widespread.

Aristotle's seduction by Phyllis was portrayed in many ways. Those carved of wood include a misericord of 1457–70 in the cathedral of Notre-Dame in Rouen with Phyllis wearing a horned headdress – a fashion scorned by the Church – as she seems to slide off the back of a disproportionately large Aristotle (II.33). This

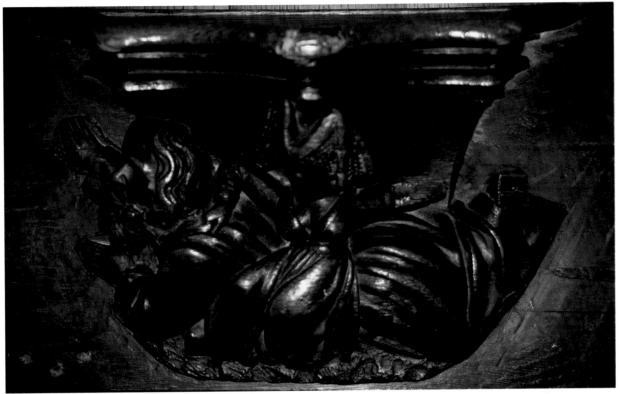

II.33. Phyllis and Aristotle: misericord, 1457–70, cathedral of Notre-Dame, Rouen.

subject appears on a sixteenth-century stall panel in the former abbey of Notre-Dame in Montbenoît, where Phyllis truly rides Aristotle like a horse, even using reins to direct her would-be steed. Aristotle and Phyllis appear twice on the armrests of the fifteenth-century stalls in the former abbey of St-Pierre in Vertheuil. Similarly, in the cathedral of Notre-Dame in Lausanne, Switzerland, the thirteenth-century stalls include seductive Phyllis riding on the back of bearded Aristotle. The sculptor carved Aristotle and Phyllis in ivory, rather than wood, on the front panel of a Parisian casket with scenes from romances, c. 1320–40, now in the Cloisters, New York,[19] and the same subject is seen on the front of a Flemish ivory casket of c. 1350, in the Museo Nazionale del Bargello, Florence. It was

carved in stone beside a window in the north aisle of York Minster where Phyllis, whip in hand, rides on Aristotle who even wears the horse's saddle and bridle. However, the opposite situation is depicted beside the next window, where a man rides on the back of a woman and raises a club to strike her. The subject was depicted in sculptural media in addition to those that are carved. Phyllis riding side-saddle on Aristotle's back was cast in bronze to create an unusual aquamanile, the brilliant man now humbled and humiliated on hands and knees in this Mosan Netherlandish work of *c*. 1400, in the Metropolitan Museum of Art, New York.[20] The story of Phyllis and Aristotle appears in the margins of Gothic manuscripts[21] and in German prints, such as an engraving by Master MZ (possibly Matthäus Zaisinger), *c*. 1500, and in a woodcut by Hans Burgkmair the Elder, *c*. 1519. The subject of Phyllis riding Aristotle, both shown nude (with the sole exception of her headdress), is depicted in a woodcut by Hans Baldung Grien (d. 1545).

The clever nature of women – female wit able to solve any puzzle the male mind can devise – is demonstrated by the old Norse tale of Disa. In return for her open criticism of the royal council, the king presented Disa with a seemingly unsolvable problem: to appear before him neither walking nor riding, neither out of the road nor in it, neither dressed nor undressed, neither with shoes nor without and bearing a gift that is not a gift. Disa's ingenious solution is to come to him riding a goat but keeping one foot on the ground, wearing an open net and sandals (or one shoe), and carrying a rabbit – a 'gift' that will hop away when presented. The king was so impressed by Disa's ingenuity that he married her, making her his queen. This story, also referred to as 'the clever daughter' or 'the clever peasant girl', appears on misericords in Worcester Cathedral, 1379; St Mary in Beverley, *c*. 1445; Norwich Cathedral, 1480; and elsewhere. In fact, this story challenges us to solve the king's puzzle, and then impresses us with Disa's ingenious solution (as well as by the difficulty artists face in depicting it).

The same story is told in various forms. In each case, the humbler person is ordered to come before the more powerful one to perform a feat similar to Disa's. In one version, the riddle is posed by a king who offers anyone who solves it their weight in gold. The same riddle is solved by a man in the story of Marcolf, who responds to the puzzle posed by Solomon.[22]

The perils of love and marriage are made clear on an ivory statuette base carved in the early sixteenth

II.34, 35. The perils of love, courting lovers on one side, their conflict on the other, the fool ever-present: statuette base, early sixteenth century, northern French or Flemish, ivory. *(Photos: © The Metropolitan Museum of Art, The Cloisters Collection (1955.55.168)*

century in either northern France or Flanders, now in the Cloisters, New York (II.34, 35). On one side are the courting lovers: he offers a ring, a symbol of marital fidelity, and she offers a pomegranate, a symbol of fertility – but between them is the smiling fool, identified by his cap. The event takes place in an enclosed garden, perhaps representing a garden of love or the Garden of Eden – if it is the latter, an idea reinforced by the ape eating an apple, the story told here is symbolic of the Fall of Man. On the other side of the base is the artist's commentary on the result of romantic love, for now the man, sword in hand like the avenging angel of the Garden of Eden, drives away the woman who puts her hand to her head as she turns from him.

Again, the fool, omnipresent symbol of human folly, stands between them, scowling at the husband, and the ape is angry.

A similarly negative view of romance is suggested by a kissing couple carved by the sculptor Arnt van Tricht on a polychromed oak towel rack, from Kalkar on the north Rhine in Westphalia, *c.* 1540, now in the Städisches Museum Haus Koekkoek, in Cleves (Kleve). The bar for the towel is held in the hands of a woman wearing a revealing dress who is embraced and kissed by a man. But his costume shows him to be a fool, there are small music-making fools on their shoulders (the link between music and lust was discussed above), and a tiny figure peers out of his sleeve.

II.36. A man kissing a woman on one corbel, a person winking on the next: north side, church of St-Etienne, Cahors.

Finally, on a corbel on the north side of St-Etienne in Cahors, as a man sporting an impressive mustache kisses a woman, the face on the next corbel winks knowingly, slyly indicating how others perceive their romance (III.36).

ARTISTS' SELF-PORTRAITS; PATRONS' PORTRAITS

The assumed humble anonymity of the generic 'medieval artist' is based upon the survival of only a few names and fewer signatures. However, certain artists marked their work as their own in ways other than their written name. At Santiago de Compostela, Master Mateo (Matthew), sculptor of the elaborate

triple doorway to the Porch of Glory (1168–88), 'signed' his work by including a figure of himself at the base of the trumeau. His image does not face the approaching visitor who ascends the staircase to enter, but is located instead on the inside, facing toward the altar, kneeling modestly in prayer.

In Wells Cathedral the head of a bearded man wearing a mason's cap is perhaps a portrait of Adam Lock (d. 1229), the master mason responsible for the north side of the west end of the nave, where this head is found (to be close to the west door is a position of prestige). In contrast, an unflattering portrait carved in the north transept here is that of a worker disliked by the stone masons. In the right transept of the abbey church of La Trinité in Vendôme is a charming and almost child-like representation of Régnault, the founder and first abbot of this church, identified also as the architect by his unusually large compass (II.37). In the cathedral of St-Pierre in St-Claude, Jehan de Vitry of Geneva, the master sculptor of the choir stalls, dated 1449–65, carved his own image kneeling humbly before St-Claude on the north stalls.

An arresting self-portrait was carved by the German sculptor Adam Kraft (II.38) at the base of the unusually tall Holy Sacrament House he created of sandstone, in about 1493–96, in the

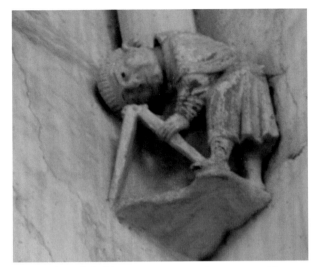

II.37. Régnault holding a compas: south transept, abbey church of La Trinité, Vendôme. *(Photo: Elliot R. Benton)*

St Lorenzkirche, Nuremberg. Accompanied by two other people presumed to be his assistants, Kraft appears to support this tabernacle as he crouches on one knee. Dressed in work clothes, he holds the tools of his craft – the mallet and chisel. These identifying attributes ensure that there will be no doubt as to who created this shrine for the reserved host. Indeed, life-size, painted, and startlingly real, this self-portrait is the ultimate form of an artist's signature on a work of art.

Equally intriguing is the relationship between church furniture and a self-portrait created by the sculptor Anton Pilgram in Vienna's Stephansdom,

for he depicts himself pulling back a shutter and peering out from a *trompe-l'oeil* window in the base of the large Gothic pulpit he designed between 1510 and 1515. By treating the stone self-portrait as if it were a living person, Pilgram guarantees his artistic immortality. The concept of 'putting yourself into your work' is thus given visual form. Another

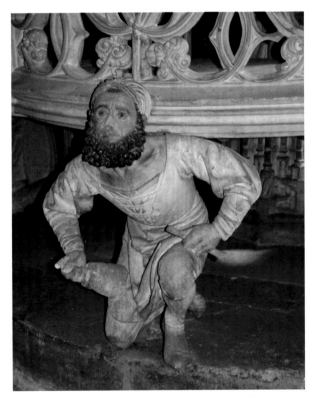

II.38. Adam Kraft, self-portrait: the base of Holy Sacrament House, *c.* 1493–96, St Lorenzkirche, Nuremberg.

likeness of this sculptor appears in the late Gothic organ base he designed in 1513 against the north aisle wall of this cathedral, for here he leans out of the bottom of the structure, holding the tools of his trade. An actual likeness of the artist is far more personal and revealing than the letters of a name, and far more effective in an era when the great majority of people were illiterate.

Among the limited number of written signatures that survive from the Middle Ages, among the best known and earliest is that of eleventh-century Unbertus on the porch tower at St-Benoît-sur-Loire. Additional recorded names of Romanesque artists include Bernard at Ste-Foy in Conques, Bernardus Gelduinus at St-Sernin in Toulouse, Gilabert at St-Etienne in Toulouse, Gislebertus at Autun Cathedral, Godefridus at St-Pierre in Chauvigny, Guinamond at St-Front in Périgueux, Isembard at Bernay, Niccolò at Ferrara Cathedral, Rotbertus at Notre-Dame-du-Port in Clermont-Ferrand and Wiligelmo at Modena Cathedral, as well as the metal and enamel artists Renier of Huy and Nicholas of Verdun. A much larger number of Gothic architects, sculptors, and painters are known by name. Signatures of scribes and/or illuminators of medieval manuscripts are, understandably, less rare.

In addition to self-portraits of medieval artists, several portraits of medieval patrons of the arts survive. The patron may go so far as to be shown with the actual work of art or architecture sponsored, thereby ensuring appropriate recognition for his generosity – if not from God, at least from the public. An early example is Bishop Ecclesius, portrayed carrying a model of the church of San Vitale, which he offers to Jesus and St Vitale, in a mosaic dated before 547 in the Byzantine church of San Vitale in Ravenna. Later, Abbot Desiderius of Montecassino – the builder of Sant'Angelo in Formis and the future Pope Victor III – was likewise memorialized, this time in fresco, on the lower wall of the apse of Sant'Angelo in Formis, painted between 1072 and 1087, where he, too, cradles a diminutive version of this church in his hands, as if to present it to Jesus above. Abbot Suger, who rebuilt the royal abbey church of St-Denis just prior to the mid-twelfth century, was doubly certain that his generosity would not be forgotten, for he had himself shown in a stained-glass Tree of Jesse window, presenting the sleeping Jesse with the very window in which he is depicted (II.39), as well as in stone relief on the façade. Not long after, the Norman king, William II, also had himself depicted both inside and outside Monreale Cathedral, the

II.39. Abbot Suger presenting the sleeping Jesse with the window in which this appears: Tree of Jesse window, shortly before the mid-twelfth century, royal abbey, St-Denis.

beneficiary of his largess, for he is seen in a nave mosaic of the later twelfth century offering a model of the cathedral to Mary, and the same subject is carved in stone on a cloister capital. In the early fourteenth century, the Florentine genius Giotto portrayed the donor of the Arena (Scrovegni) Chapel in Padua, Enrico Scrovegni, in the process of offering this very chapel to Jesus at the Last Judgement, thereby seeking to secure his salvation in expiation for his family's usury. In each of these

several cases, the patron is shown humbly donating the building or work of art to a member of the sacred hierarchy.

Such patron portraits cleverly serve both to document and to publicize an individual's contributions. While there are many early images of donors, most tend to be small in scale, ancillary in location, secondary to a sponsoring name saint, and symbolic in representation rather than realistic. In contrast, the notable novelty of the examples mentioned here is that the donors have become full-scale participants in the scenes in which they appear, are shown without the support of saints or family members, and are as individualized as the works of art they donated.

CHAPTER III

The Surprising,
Amazing or Offensive

ANATOMICAL ANOMALIES

Some amusing (and physically implausible)
modifications were made to the human body by
medieval artists. Little evidence of interest in the
accurate portrayal of anatomy is found in medieval
art. Neither artists nor doctors studied directly
from life during the Middle Ages, and neither
performed dissections of the human body to
increase their knowledge, as would be done during
the Renaissance, for example, by Leonardo da Vinci.
Instead, sacred figures were shown to have physical
beauty according to the ideal canon of the time, the
paradigm of feminine beauty being Jesus's mother
Mary. Therefore, certainly unusual is a German
sculpture of the Visitation (III.1), dated *c.* 1310–20,
now in the Metropolitan Museum of Art, New York,
for the abdomens of Mary and Elizabeth are covered
with rock crystal, this transparent stone permitting

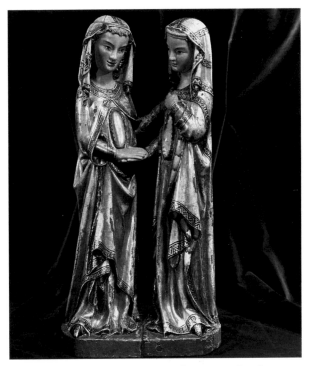

III.1. The Visitation: *c.* 1310–20, walnut, crystal, poly-
chromy, and gilt, German. *(Photo: © Metropolitan Museum of
Art, New York, gift of J. Pierpont Morgan (17.190.724))*

tiny figures of Jesus and John the Baptist, respectively, to be seen in their mothers' uteruses. This subject is traditionally portrayed with Mary and Elizabeth each touching the other's enlarged abdomen as they exchange the news of their pregnancies. But here Mary and Elizabeth have been given amazing abdomens, each having a womb with a view, which serves to make the subject immediately intelligible to the viewer.

While the Middle Ages coveted beauty, there was also an attraction to deviations from the physical norm, in particular to the monstrous and the grotesque. Seemingly mesmerized by things morbid, especially in regard to the human body, medieval artists recorded the grotesque aspects of disease, death and bodily decomposition. Artists appear to have competed to invent ever more horrifying ways to inflict pain on the damned in hell, and to portray the most gruesome tortures imaginable suffered by martyrs. Among the most graphic is a late fifteenth-century bronze statue, made in the Burgundian town of Langres, of its patron saint Mammès, who was martyred by disembowelment; he is shown holding his intestines.[1]

PORTRAYALS OF PAIN/SICKNESS

Pain was a frequent aspect of medieval daily life, since the invention of effective analgesics and anaesthesia was a long way in the future. Yet ailments are turned into amusement in the so-called 'medical set' in Beverley Minster, carved *c.* 1308, which consists of four humorous stone label-stop figures depicting afflictions that remain familiar today: they are said to be stomach ache (although his hand is on his chest rather than on his abdomen), lumbago, sciatica and toothache. These caricatures, located at the end (hence 'stop') of a moulding above an arch (the 'label'), are notable for their earthy humour as well as for the excellent record they provide of medieval life. Earth and heaven combine comfortably – and frequently – in the medieval Church.

Less serious is the condition suffered by a man pulling a thorn from the sole of his foot, a subject seen in many locations. It appears in England in Wells Cathedral on a capital carved in about 1200–10 in the south transept (III.2), the man's facial expression clearly revealing his discomfort. In France, the same subject is seen on a twelfth-century façade corbel at St-Hilaire in Foussais-Payré, the thorn-puller displaying an unusual degree of flexibility. At the church of St-Jean in Grandson, Switzerland, a thorn-puller cries in pain on a mid-twelfth-century capital. The geographical distribution of this subject, as well as the similarity with which it is portrayed in distant locations,

III.2. A thorn-puller: capital, *c.* 1200–10, south transept, Wells Cathedral.

suggest that it may have been more than a genre vignette and may carry additional connotations. Indeed, such images of thorn-pullers have been interpreted as symbolic references to sin. Is the implication that the Church enables the faithful to rid themselves of pain, physical and otherwise? Is the thorn a reminder? 2 Corinthians 1: 7 says, '. . . there was given to me a thorn in the flesh, the messenger of Satan to buffet me, lest I should be exalted above measure'. In considering the validity of these religious interpretations, it should be noted that the same subject is found in the Hellenistic *Spinario*, a statue of a boy removing a thorn from the sole of his foot, which was copied in several versions in antiquity.

Rather than the foot, the head may cause suffering. The problem seems to be epidemic at St-Etienne in Cahors, where several people on the corbels on the north side of the church suffer overtly, two of whom are illustrated here (III.3). High on a once brightly painted wooden roof boss of *c.* 1299, in the cloister of Lincoln Cathedral, a man has long endured pain and he holds his aching head and opens his mouth as if groaning.

More specifically, the pain may be due to a tooth. The many depictions of toothache suggest that this was an especially common problem during the Middle Ages. In the cloister of Lincoln Cathedral, the man just mentioned with the headache can commiserate with his companion with a toothache, whose facial expression reveals his pain as he points

III.3. Two men with headaches: corbels, north side, church of St-Etienne, Cahors.

III.4. A bearded man with toothache: *c.* 1299, roof boss, cloister, Lincoln Cathedral.

to the offending tooth with one hand and pulls his beard to the side with the other (III.4). In the south transept of Wells Cathedral, a capital carved between 1200 and 1210 depicts a man in great pain, wrinkling his forehead as he points to the painful tooth. This capital is associated with Bishop S. William Bytton (d. 1274) whose tomb was thought to cure toothaches miraculously – let us hope there was some justification for this confidence, for there are eleven versions of this subject in Wells Cathedral. Although these images are routinely considered to depict toothaches, might there be additional meaning here?[2]

FACES FIERCE AND FUNNY

Among the many ways to distort one's face, stretching the mouth from side to side by putting the fingers of both hands in the mouth and pulling outward was especially popular in medieval art. Mouth-pullers, usually men, who 'make a face' are found far and wide, as gargoyles, on roof bosses, corbels, capitals, and misericords, and even on church façades. Perhaps they are playing the game of grimacing in which the grimacer makes a face and the person who laughs first becomes the next grimacer, a subject depicted on English choir stalls. Or perhaps this humorous gesture reflects the competitions in 'face-pulling', such as those called *girning*, that were held during the Middle Ages in England and continued long after.[3] The word girn can be used as a noun or verb, meaning a/to grin, growl, snarl, grumble, or yawn.

In England several mouth-pullers appear on the corbels of the parish church of St Wulfram in Grantham, apparently mocking the visitor. Near the men with the headache and toothache on the wooden vault bosses in the cloister of Lincoln Cathedral, just noted, can be seen some self-inflicted pain on the part of a mouth-puller. That on a misericord in Sherborne Abbey looks angry or mocking, his facial expression far from friendly.

In France, in plain view for all to see on the façade of the cathedral of St-Pierre in Poitiers, is a full-length mouth-puller. A bearded mouth-puller is permitted entry into the church of Ste-Menehoulde in Palluau, grimacing with gusto as he stretches his mouth open on a fifteenth-century misericord. That there is more to the meaning of the mouth-pullers than merely mischievous fun is suggested by a person who does the opposite at the basilica of Paray-le-Monial: a capital on a tower portrays a head with the mouth covered by two hands, interpreted to mean *garde le silence, le silence te gardera* (keep silent and the silence will keep you), suggesting that there is danger in opening one's mouth too wide, replacing the silence with many words. Alternatively, the open mouth has been interpreted as a symbol of the sin of gluttony. Both interpretations imply that the closed mouth is preferable, whether to guard against emitting harmful words or ingesting excess food and drink.[4]

Several 'vulgar' gestures may be combined in a single figure, thereby reinforcing the negative connotation of any one. Thus the mouth-puller on a corbel on the apse of St-Pierre in Aulnay-de-Saintonge simultaneously sticks out his tongue, another rude gesture discussed below. Mouth-pulling or stretching is enthusiastically combined with the projecting tongue on a misericord of 1442 in St Peter in Louvain. A mouth-puller on a capital on the south side of St-Hérie in Matha has rubbery arms looped under his knees, resembling a contortionist's pose (II.5); the medieval Church's disapproval of contortionists and other types of performers receives comment below. And a limber mouth-pulling gargoyle on Freiburg Münster has managed to place his right leg over his shoulders (III.6).

III.5. A mouth-puller contortionist: capital, church of St-Hérie, Matha.

III.6. A mouth-puller contortionist: gargoyle, Münster, Freiburg-im-Breisgau. *(Photo: Elliot R. Benton)*

However, rather than pulling one's own mouth (or beard, although beard-pullers are fewer in number in medieval art), the occasional alternative is to pull someone else's mouth, beard, hair, or even snout. For example, two men sit quietly side by side on a corbel without apparent sign of conflict, in spite of the fact that each puts his fingers in the other's mouth. Originally from La Sauve-Majeure, this twelfth-century corbel is now in the Cloisters, New York. Nearby in this museum, gravity-defying gymnastics are performed on another corbel having the same provenance, for a pair of men

simultaneously pull each other's beard and howl. Beards and hair are both pulled on yet another corbel from the same location in a complex composition involving five male contortionists – the meaning of this acrobatic accomplishment correspondingly still more complex. Reduced to only two combatants, beards and hair are pulled on a nave capital at Anzy-le-Duc (III.7). And a crouching man can pull the beards of two men simultaneously without fear of reprisal on a Romanesque capital in the church of Colombiers – for he is clean-shaven. Although the meaning is difficult to decipher, it may be noted that the beard is symbolic of both

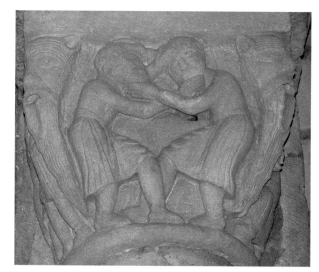

III.7. Two men pulling each other's beard: capital, church of St-Croix-et-Ste-Marie, Anzy-le-Duc.

III.8. A man grasping some animals by their snouts: archivolt of portal, church of St John, Elkstone.

A great many stone heads, human and otherwise, are carved outside and inside medieval churches, seemingly unrelated to the repertoire of biblical subjects usually found here. Some of the faces show concern for one another but more often their attention focuses on the visitor. Monsters on churches are intended to remind the viewer of the nether world filled with horrors that are the destiny of all sinners – most people of the Middle Ages believed in devils, demons, and monsters. Some of the stone heads are fierce and were surely meant to frighten or threaten, perhaps for purposes connected with religious beliefs that involved scaring evil away from the Church and leaving the faithful inside in safety: by using demons to fight demons, these monstrosities protect the church and the congregation within. Bestial heads may reflect the medieval notion that people who are possessed by the devil assume the physiognomies of animals. Based on the premise that physical ugliness is linked to internal moral depravity, monstrous physiognomies thus represent sin or evil.

But to attribute religious significance to every one of the countless examples may be more 'art-historical interpretation' than is justified; the author wonders if the people of the Middle Ages might find some of today's 'scholarship' to be humorous itself in our extensive efforts to explain the inexplicable.

intelligence and virility; to pull another's beard in a fight indicates the sin of Anger and perhaps also that of Pride – each man being proud of his own beard – and of Envy, each jealous of the other's beard. Animals are not exempt from such physical assault for on the portal arch of St John the Evangelist in Elkstone, a little man, in spite of being nearly upside down, firmly grasps each of the wolflike heads on either side of himself by its snout (III.8).

Surely many of the funny faces in medieval art are intended, above all else, to be clever and witty. To create a monster must have been a pleasurable challenge to medieval artists, intent on eliciting a verbal (or visceral) reaction from their viewers. In discussing monsters and grotesques in the margins of medieval manuscripts, Alixe Bovey comments on their 'comic potential' and their ability to be simultaneously shocking and funny, noting that the ability of hybrid monsters to provoke laughter was recognized in antiquity, citing the *Ars Poetica* (*c.* 10 BC) of the ancient Roman author Horace.[5]

Sculpted heads may appear individually but are found more often in their own company. Their interactions entertain – a head pops out on either side of the façade, just below the roofline, on the Romanesque church of San Miniato al Monte, Florence, where the young man on the left, perhaps fearing a reprimand, seems surprised by the appearance of the stern older man (III.9, 10). Stone people may be amused by those of flesh and blood – in the chapter house at York Minster, dated 1270–80, some of the stone attendees at the meetings held here watch intently: one supports his head with one hand and scratches it with the other, although another finds the proceedings to be laughable (III.11, 12).

Identifiable figures are rare. An example is the vivacious, animated, and fashionably attired man on

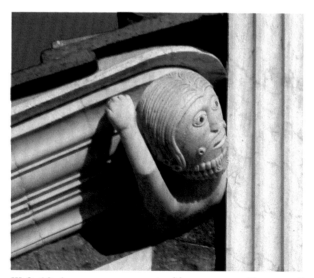
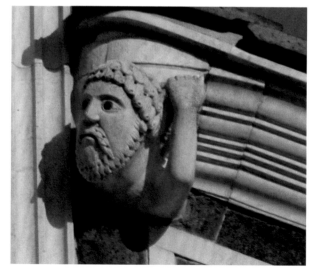

III.9, 10. A young man surprised by an angry older man: façade, church of San Miniato al Monte, Florence.

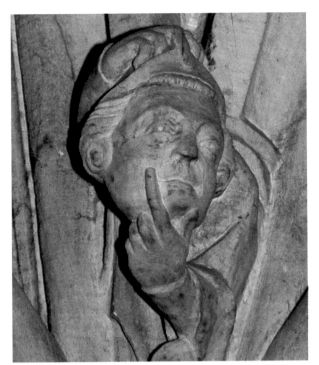 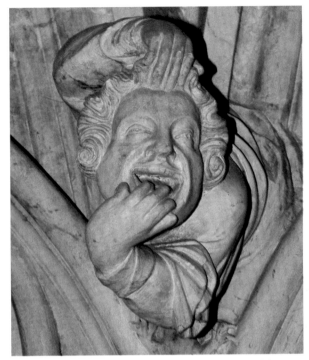

III.11, 12. Perhaps in response to the meetings held here, one person appears thoughtful but another is thoroughly amused: 1270–80, chapter house, York Minster.

the south side of the church of St Peter in Winchcombe, said to portray Ralph Boteler, lord of Sudeley Manor, who completed construction of this church in 1468 (III.13). More frequently, however, the innumerable medieval beings are inventions of ingenious carvers' imaginations. Thus a bearded creature at Lincoln Cathedral laughs at our surprise in finding him perched on top of a buttress (III.14). A great many corbel heads scowl, frown, and howl

at the visitor to the parish church of St Wulfram in Grantham, whereas other faces have friendly smiles, as on a twelfth-century column capital on the north side of the church of St-Pierre in Aulnay-de-Saintonge and those of the fourteenth century on the pulpitum of Southwell Minster.

Animals, real and imaginary, were welcomed into this medieval menagerie of expressive faces. At the church of Sts Mary and David in Kilpeck many of

felines is the cat that seems to express surprise, as if saying, 'Oh!', on an apse corbel at Notre-Dame in Echillais (III.17).

Human emotion, personality, and character may be the artist's focus. A succinct study of our range of emotions is provided by four faces on a single column capital in the cloister of the cathedral of Le Puy Cathedral. From left to right, the first face is frowning sadly, the next is somewhat sullen, then

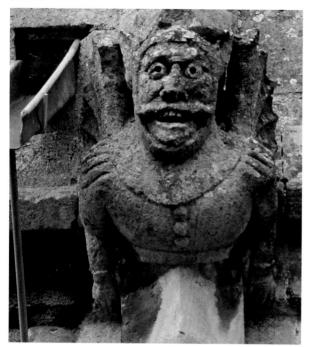

III.13. Ralph Boteler: *c.* 1468, south side, church of St Peter, Winchcombe.

the corbels clearly favour comical physiognomies with exaggerated features and expressions – creatures and caricatures (III.15). The demonic cat head on the nave wall of Gloucester Cathedral (III.16), in spite its of bulging eyes, pointed teeth, and the unfavourable opinion of cats during the Middle Ages (as night prowlers able to see in the dark, cats were linked to Satan) is unlikely to induce fear. And among the most endearing of medieval

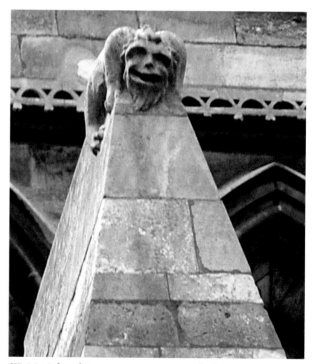

III.14. A laughing creature on top of a buttress: Lincoln Cathedral.

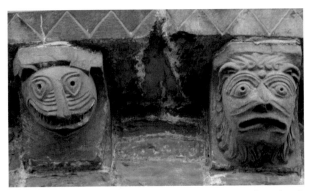

III.15. Caricatured creatures: corbels, *c.* 1145, church of Sts Mary and David, Kilpeck.

contentedly satisfied, and finally smiling happily (III.18, 19, 20, 21).

A study in personality types is found high on the long walls of the Great Hall of the Poor in the Hôtel Dieu in Beaune (mentioned on page 21) where the many carved and brightly painted heads are comical portraits of specific members of the fifteenth-century bourgeois, then living in the city. Each person is juxtaposed with the head of an identifiable animal species that refers to this person's shortcomings,

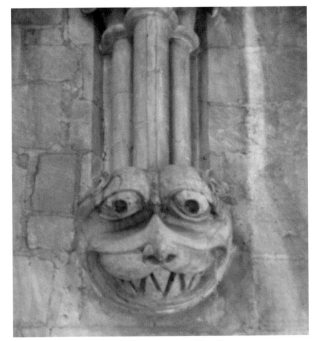

III.16. A demonic cat head: nave wall, Gloucester Cathedral.

III.17. A surprised cat: corbel, church of Notre-Dame, Echillais.

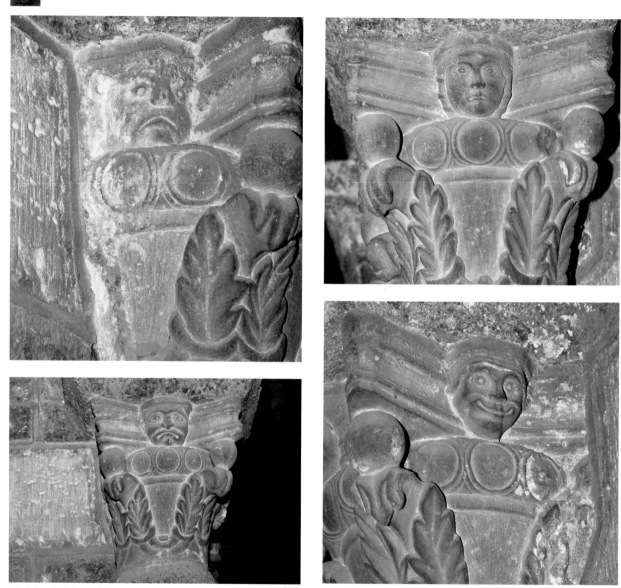

III.18, 19, 20, and 21. Four faces: sad; sullen; satisfied; and smiling: four sides of the same capital, cloister, cathedral, Le Puy-en-Velay. *(Photos: Claudine T. Parisot)*

personality flaws, and principal defects – for everyone to see. Not surprisingly, the animals laugh at the people. Today we continue to characterize people by comparison to animals, using expressions such as 'meek as a lamb', 'sly as a fox', or 'stubborn as an ox'. We might criticize someone as 'a wolf in sheep's clothing'. To tell someone they 'eat like a bird' will produce a very different reaction than to say they 'eat like a pig'. It is hardly complimentary to say someone 'looks like a dog' nor does anyone want to be called 'catty' – or 'mousy'.

CONTORTIONISTS AND ACROBATS

Contortionists, acrobats, tumblers, musicians and other public performers are depicted frequently by medieval artists, their skills displayed on church tympana, capitals, corbels, pilasters, and misericords. Writing in the twelfth century, St Bernard of Clairvaux, best known for his advocacy of extreme austerity in architectural ornament, perhaps surprisingly commented favourably on the physical accomplishments of acrobats and jugglers, saying they were worthy of admiration and that even the spectators up in heaven were delighted by such games. Yet these travelling entertainers and their audiences were held in scorn by many of the clergy and frowned on by medieval society. Physical

distortions were thought to reveal human baseness or our struggle with our physical selves, thus relating to sins of the mind – 'mental contortions'. Yet the popularity of such entertainment performed at fairs is evident, for the profession could not have persisted without an audience.

Given their negative connotation, these figures have been interpreted to be apotropaic, protecting the Church by their ability to repel evil, a medieval application of the principle of fighting like with like. The contorted figures condemn the crude behaviours in which they participate through ridicule. In light of the conflicting opinions on contortions and distortions of the human body, even within the Church, it seems worth wondering if these performers were being publicized or criticized when carved in stone on medieval churches.

An accomplished contortionist on a corbel at the church of St-Hérie in Matha rests on his forearms, his feat being to touch his feet to his head (III.22). The same skill is mastered by a contortionist who simultaneously balances himself on his hands on the acanthus leaves of a late twelfth-century capital in the cloister beside Monreale Cathedral (III.23). A variation that exceeds human capability is seen on a capital of the first half of the twelfth century in the nave of St-Pierre in Aulnay-de-Saintonge – unless

the acrobat's neck is not only flexible but also elastic. An apparently spineless contortionist forms a circle with his body among the signs of the zodiac in the archivolt of the central tympanum in the narthex of Ste-Madeleine in Vézelay, carved in the first half of the twelfth century.

A negative view is suggested by a capital from the end of the eleventh century in the nave of the church of St-Croix-et-Ste-Marie in Anzy-le-Duc on which a nude acrobat performs a backward somersault. One scaly serpent is beneath his feet and another bites his chest as they twine their tails together. This acrobat's body is deformed not only in its pose but also in its proportions, his serpentine shape linking him to the serpents, symbols of the devil, implying that he is

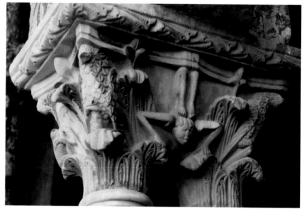

III.23. A contortionist: capital, late twelfth century, cloister, Monreale Cathedral.

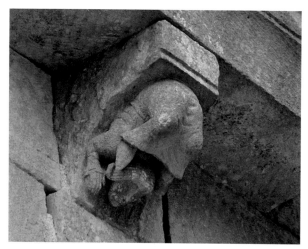

III.22. A contortionist: corbel, church of St-Hérie, Matha.

akin to the devil, who performs seductive tricks (III.24). He deserves comparison with serpentine Salome who does a backward flip when dancing for Herod – which would lead to the beheading of John the Baptist – on the late eleventh-century bronze doors of the west portal of San Zeno, Verona. On the façade archivolt of St-Hilaire in Foussais-Payré acrobats turn flips to the music played for them on a flute on one side, and a viol on the other, combining gymnastics with secular music – the Church disdained both (III.25). At San Martín in Frómista, built between 1066 and 1090 near Burgos on the route to Santiago de Compostela, are contortionists, acrobats, and exhibitionists – perhaps a warning to the pilgrims against unrestrained behaviour that was

at Matha is truly wrapped up in himself (III.27). There are some surprise endings, the bodies of animals concluding in unexpected ways. For example, an amphisbaena, a creature with a head at both ends, on a twelfth-century arch from Narbonne, now in the Cloisters, New York, ties its serpentine body in a knot, evidently angering the rear head which bites the beast on its own back. His spiralling dancing relative, on a fragment of the archivolt of the north doorway at the church of

III.24. A nude acrobat with serpents: capital, nave, end of eleventh century, church of the Assumption, Anzy-le-Duc.

believed to lead them not to sacred Santiago but, instead, directly to hell.

Animals have their fair share of anatomical anomalies in medieval art and are able to outperform humans by tying themselves into knots worthy of medieval macramé. Thus a cat contortionist bites its own tail on a corbel on the east end of Notre-Dame in Vouvant, under the watchful eyes of a great many cats (III.26). A little monster on a corbel of the south façade of St-Hérie

III.25. A musician and a tumbler: archivolt voussoir, façade, church of St-Hilaire, Foussais-Payré.

St-Etienne in Macqueville, goes head-to-head with himself (III.28).

MEDIEVAL MANNERS

Some surprising deviations from what today is deemed proper etiquette are depicted in medieval art – even on and in churches – in a way that seems wholly unholy. In addition to the many examples of people (and even animals) making faces and pulling mouths and beards, noted above, are those whose bad behaviour includes sticking out their tongues or vomiting, and others whose behaviour is still worse, for they appear to defecate publicly.

III.27. A macramé monster: corbel, south side, church of St-Hérie, Matha.

III.26. A cat biting its tail on corbel while many cats watch from above: church of Notre-Dame, Vouvant.

III.28. A coiled cross-legged amphisbaena biting its own tail (head): archivolt of portal, church of St-Etienne, Macqueville. *(Photo: Adriaan de Roover)*

III.29. A unicorn sticking out his tongue: detail of *The Unicorn Crosses the Stream and Tries to Escape*, *c.* 1500, Franco-Flemish, perhaps made in Brussels. *(Photo: © The Metropolitan Museum of Art, Gift of John D. Rockefeller Jr, 1937 (37.80.3))*

BAD BEHAVIOUR

In the tapestry in which a unicorn crosses the
stream and tries to escape in the celebrated tapestry
series in the Cloisters, New York, the unicorn,
surrounded by hunters bearing spears, frowns and
sticks out his tongue at his assailants in an act of
defiance (III.29). Even the gentlest visitors who
glance up at the roof in the cloister of Lincoln
Cathedral will find that on each of two bosses
carved *c.* 1299, a man, unprovoked, sticks his
tongue out at them, although mischievously rather
than maliciously (III.30). In the chapter houses at
both Wells and York, people, fortunately only of
stone, stick out their tongues, as if commenting on
the proceedings of the meetings held there. A

III.31. A demon simultaneously pulling both tail and
tongue: pier capital, nave, cathedral of St-Lazare, Autun.

III.30. A man sticking out his tongue: roof boss, *c.* 1299,
cloister, Lincoln Cathedral.

monster gloats beside the fall of Simon the
Magician, tongue out, on a capital at Autun
Cathedral, where he is accompanied on another
nave capital by a demoralized little demon who
pulls at once on both his very long tongue and his
tail (III.31). On a sixteenth-century misericord in
the church of St-Etienne in Beauvais, the ugliness of
a head with a protruding tongue is compounded by
bumps on the forehead and floppy dog ears. An
antecedent of the Cheshire cat smiles, tongue out,

III.32. A smiling cat with its tongue out: corbel, church of St-Nicholas, Civray. *(Photo: Claudine T. Parisot)*

The open mouth gesture, sometimes combined with the protruding tongue, is characteristic of gargoyles who drain rainwater passively through their mouths, fulfilling their obligation as water spouts. Some, however, take advantage of this function and put it in the service of humour – the entertainment is in the offence, for they appear to vomit. This is seen in the courtyard of the Hostal de los Reyes Católicos, the former Royal Hospital established in 1499 by the Catholic rulers in Santiago de Compostela, where a gargoyle grasps his throat with his hand (III.34). On Freiburg Münster a vomiting gargoyle tries to keep his beard out of harm's way (III.35). In regard to his apparent disgust, it is worth noting that water was not generally consumed as a beverage during the Middle Ages, but was intended instead only for bathing – and was thus little used. In contrast, a gargoyle at Notre-Dame in L'Epine seems to take malicious delight in this activity as he looks down on the passer-by below (III.36). On the façade of fourteenth-century Notre-Dame in Semur-en-Auxois, a man's facial expression indicates his discomfort as he disgorges his water. A late example is seen at Bern Cathedral, where a fool, as indicated by his attire, wails pitifully. The several examples selected for mention here, found in Spain, Germany,

on a façade corbel at St-Nicholas in Civray (III.32). A remarkably inventive variety of implausible tongues, most of which would be difficult to retract into the owner's mouth, are seen on the archivolts of the façade portal of Lincoln Cathedral (III.33), relatives of the popular beak heads seen, for example, at St Ebbe in Oxford.

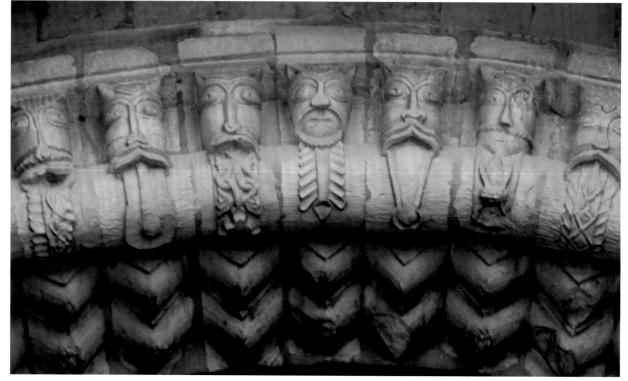

III.33. Monstrous heads with various types of fantastic tongues: archivolts of façade portal, Lincoln Cathedral.

France, and Switzerland, indicate the range of this motif's popularity.

Is there meaning to the gesture of the open mouth with the tongue protruding, or that suggests vomiting? The medieval predilection for instructive symbolism, combined with the art historian's genetic predisposition to analyse anything unable to move, obliges the author to exert an effort to decipher what is sometimes indecipherable, risking the possibility of imposing a modern interpretation on a medieval work of art. However, given that in some examples the open mouth and protruding tongue are amusing, while in others menacing, no single interpretation can accommodate every example. Those that menace were perhaps, like other examples of rude gestures, intended to be

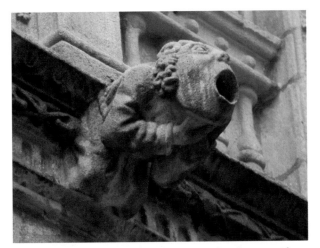

III.34. An open-mouthed man grasping his throat as if vomiting: gargoyle, courtyard, Hostal de los Reyes Católicos (former Royal Hospital, established 1499), Santiago de Compostela.

III.36. An open-mouthed hooded man with his hand on his chest: gargoyle, church of Notre-Dame, L'Epine.

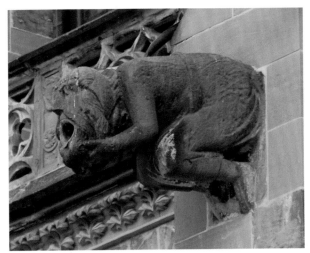

III.35. An open-mouthed man holding his bearded chin: gargoyle, Münster, Freiburg-im-Breisgau.

apotropaic in purpose, protecting people within the church from evils. To stick out the tongue is considered an insult in the Bible (Isaiah 57: 4). Artists often include this in depictions of Jesus's Passion, the gesture directed at Mary or Jesus.[6] But in the case of the vomiting gargoyles, it seems likely

115

that their function as waterspouts has been placed in the service of humour.

WORSE BEHAVIOUR

Rather than using the mouth, several heteroclite gargoyles carved in the form of nude men employ a different orifice for the expulsion of water; these

III.38. A man with his buttocks extended outward, looking over his shoulder: gargoyle, south side, cathedral of St-Lazare, Autun.

III.37. One man holding another with his buttocks projecting: gargoyle, wall surrounding, Musée National du Moyen-Age, Paris.

exhibitionists offer an element of earthy humour when it rains. Centuries of erosion have made the gargoyle on the Angel and Royal Hotel in Grantham somewhat subtler – seen directly from the front, this looks like a face, but the side view reveals that it is a defecating man, his buttocks thrust outward, his hands on his buttocks, and head turned to the right as if to make certain that the visitor is watching. A second glance may be required to decipher a complex gargoyle made up of two figures on the wall surrounding the building that now houses the

III.39. A man with his buttocks extending outward, looking over his shoulder: gargoyle, Münster, Freiburg-im-Breisgau.

Musée National du Moyen-Age in Paris, for a clothed man holds on his shoulders a nude man whose buttocks project out to throw the rainwater clear of the wall – and thus onto the passer-by below (III.37). Perhaps the humour here is enhanced by the fact that this building, constructed between 1485 and 1500, was originally the residence of the abbots of Cluny. Yet this overtly (and appealingly) obscene behaviour is found even on churches: not the slightest hint of restraint is shown by the gargoyle on the south side of twelfth-century Autun Cathedral, buttocks extending outwards, as he glances over his shoulder at the visitor (III.38). The same is true of a gargoyle with an equally inverted posture on the south side of fifteenth-century

Freiburg Münster (III.39). These examples are found in England, France, and Germany; the realm of the defecating gargoyle was evidently extensive. The author knows of no gargoyle that urinates, which would seem to be a more reasonable activity for a gargoyle, whose fundamental architectural role is that of humble waterspout.

Gargoyles did not have a monopoly on this behaviour. In the church of Sts Peter and Paul in Lavenham, a defecating man is carved on a hand-rest of the fourteenth-century oak choirstall, and the same imagery appears on misericords and in manuscript margins. Did the artists intend to offend? Or to amuse with a crude joke? Might there be other interpretations more acceptable to the Church? A little of each explanation may have been involved, for a misericord in St George's Chapel at Windsor Castle demonstrates how readily a religious meaning can be added: as a monk defecates, what he excretes is transformed into a demon, suggesting that his body is thereby purged of sin. If this notion is taken further, the monk may be interpreted as the Church cleansed of evil.

However, if one imagines someone sitting on the sixteenth-century misericord in the church of St-Pierre in Saumur, which Michael Camille calls

III. 40. 'Sniffing the bottom': misericord, church of St-Pierre, Saumur.

'sniffing the bottom'[7] it is difficult for even the most inventive art historian or theologian to devise a redeeming religious symbolism for this mischievous sense of fun (III.40). And a misericord in Aosta Cathedral of 1466–69 depicts a man licking his own anus – the image still more striking if one imagines the misericord with a member of the clergy sitting upon this little seat, his own bottom just above the tongue of the wooden figure! Earthy – in fact irresistibly insolent – humour is certainly a characteristic of the art of the Middle Ages, from which the Church was not exempt.

EXHIBITIONISTS:
MEN AND WOMEN

The numerous depictions of male and female nudes, often crude in their carving and rude in their behaviour, yet located on medieval churches, may surprise today's visitors. Like the defecating gargoyles, these are far from subtle displays or mild indiscretions; rather, they are obvious, intentional, and overt, not content merely to exhibit the body naked but compelled to emphasize especially its

III.42. An exhibiting man crouching: corbel, twelfth century, church of St-Pierre, Champagnolles.

III.41. An exhibiting woman contortionist: corbel, church of Notre-Dame-des-Miracles, Mauriac.

genitalia. Anthony Weir and James Jerman, in their study *Images of Lust: Sexual Carvings on Medieval Churches*, say the depiction of nudes on churches does not seem to predate the eleventh century and reaches its peak of popularity during the twelfth century – around 1150 – although notable examples exist from other periods of the Middle Ages.[8]

The many depictions of exhibiting women found in the British Isles, known as Sheela-na-gigs, meaning

'ugly as sin', such as that at the church of Sts Mary and David in Kilpeck, are simplified and stylized, in a contortionist's pose, the figure displaying her vagina but otherwise not identifiably female. Much has been written about the Sheelas, and they have been accorded various interpretations which tend to overlap in meaning. Thus the Sheelas have been said to be the embodiment of purely coarse humour; fertility goddesses; earth mothers; symbols of lust – and warnings against lust; and didactic images to alert men to the evils of the opposite sex, in keeping with the traditional misogynistic view of women as temptresses held by the Church. Most of the Sheelas are dated to between the thirteenth and seventeenth centuries and are a speciality of the British Isles – Ireland in particular. Although they have some relatives in France, like the impressively flexible exhibiting woman on a corbel on the east end of Notre-Dame-des-Miracles in Mauriac (III.41), or the equally limber little lady in a foliage frieze on the apse of the church of the Visitation of the Virgin in Montberault, and in Spain, like the exhibiting woman who also has her feet up by her ears on the parish church of Cervados, they are not characteristic of continental Europe.

The opposite geographic preference applies to male nudes in medieval art. Although they are not

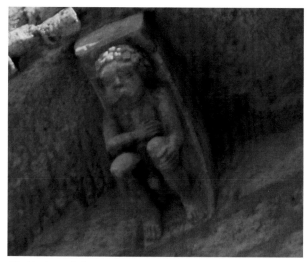

III.43. An exhibiting man sitting: corbel, last third of eleventh century, perhaps *c.* 1085–90, church of San Martin, Frómista.

characteristic of Great Britain, examples are seen on the parish church of St Wulfram in Grantham, on the church of St Mary in Painswick, and another in an unusual pose crawling on elbows and knees on the east exterior wall of the parish church at Abson, near Bristol. But with only a few such exceptions, artists working in the medieval British Isles generally seem to have preferred exhibiting women, in contrast to artists on the continent. Weir and Jerman say there are over seventy exhibiting females in France and approximately forty in Spain, but that there are even more males in each of these countries.[9]

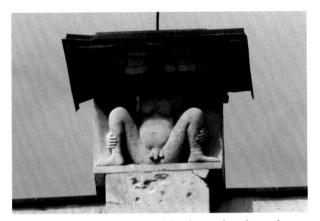

III.44. An exhibiting man with his legs splayed: south side, Modena Cathedral.

If the exhibiting women found in the British Isles are indeed intended to warn men about the evils of women and to discourage them from sexual interest in women, then what is to be made of the many exhibiting men, found especially in France, with equally exaggerated genitalia? Logic suggests that they are intended to warn French women to be wary of the amorous intentions of French men. Perhaps this implies that there were regional differences in sexual morality during the Middle Ages – as, in fact, there are today.

Among the most generously endowed medieval exhibitionists in French sculpture is a crouching man with gigantic genitals on the twelfth-century church of St-Pierre at Champagnolles (III.42).[10]

Because of the specific location of this figure on the church, the only point of view from which the visitor can see him is below – and from here, nothing is hidden. Yet he is neither large in scale nor prominently located – he is up on a corbel, on the north apsidole, in the darkest shadow to be found anywhere on the exterior of this little church. With his sad facial expression and crouching posture, is the implication that the Champagnolles man tries to hide himself from public scrutiny, as if shamed by his condition? Similarly, it can be argued that male and female figures on sequential corbels, who display their genitals and look so unhappy at the church of San Pedro de Tejada, show remorse over their swollen or diseased genitals, the result of their misbehaviour.

Corbels are the favourite haunt for Romanesque exhibiting figures – similarly located is a little megaphallic man who sits solemnly under a corbel at Notre-Dame in Vouvant, high up along the roofline – not down at eye level, not on the sunny south side, and not on the façade. His pose enables him to mimic the shape of the flanking corbels, as if in an effort to camouflage himself. Especially notable are the several exhibiting males on the roof corbels of the church of San Martín in Frómista, carved in the last third of the eleventh century,

perhaps *c*. 1085–90, one of which is illustrated here (III.44). The exhibiting men and women tend to be small in scale and to perform their unusual antics in ancillary areas of the building – high up on corbels, obscured by the shadow cast by the roof, on the back of the church. Yet under the brilliant Italian sun, the shadow actually draws attention to the exhibiting man on the south side of the duomo in Modena (III.44), and there are additional naked men on an apse capital here.

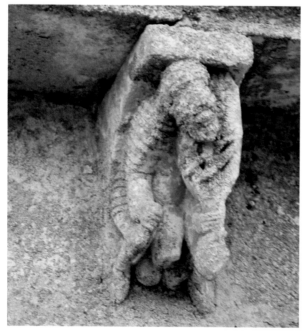

III.45. An exhibiting man playing a musical instrument: corbel, church of St-Christophe, Courpiac.

The exhibiting figures may be assumed to serve an iconographic function having to do with sexual customs encouraged by – or, more often, discouraged by – the medieval Church's 'sermon in stone'. Scenes that may be described today as 'obscene' are likely to have been used to inform the faithful about which sexual activities were acceptable and which were not, and were linked to the medieval Church's beliefs about the specific behaviour required for moral salvation. The exhibiting figures appear to be warnings or admonishments meant to clarify what was considered improper and to promote sexual restraint and avoidance of the sin of Lust. In support of this interpretation, it may be noted that none of the exhibiting men or women seems to enjoy his or her circumstances. Rather than being erotic, enticing, or even attractive, these medieval nudes are more inclined to be offensive or even repulsive. And instead of being anatomically accurate, they are comic caricatures with exaggerated genitalia. Does their ugliness serve to remind the viewer that physical beauty is transient? The message is made clear by an exhibiting man with an unhappy facial expression who squats below a bracket, that supports a devil just above, these sculpted figures located between choir

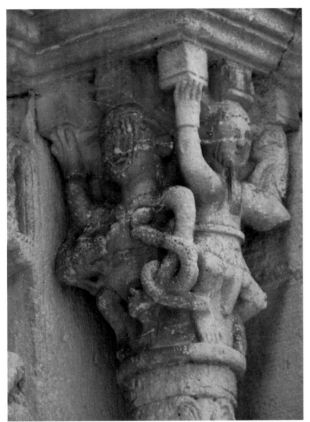

III.46. An exhibiting man with frogs and serpents beside the figure of *luxuria*: capital, façade, church of St-Hilaire, Semur-en-Brionnais.

windows at the church of Notre-Dame in Semur-en-Auxois.

In their book *Images of Lust* mentioned above, Weir and Jerman interpret the nudes as iconographic in function: they are not sacrilegious, nor magic fertility figures, nor idols descended from pre-Christian times, nor remnants of superstitious beliefs. Exhibiting figures are likely to be found on or near pilgrimage routes, and although there are many exceptions, they tend to be on small rural Romanesque churches along the way. These figures are linked to Church sermons against the perceived low moral standards of pilgrims and their entourage.[11] Indeed, to interpret the nudes as sacrilegious would impose a modern mentality on medieval art for, had the medieval Church regarded such figures in this way surely they would have been removed, whereas, instead, many survive today and it is likely that a great many more existed during the Middle Ages.

Exhibitionists tend to appear in the company of other subjects that relate to the sins of flesh, as if the sculptor sought to illustrate several didactic points made in a sermon. On a corbel at the church of St Martín in Frómista one of several exhibiting men plays a stringed musical instrument; the same subject is seen on a corbel at St-Christophe in Courpiac (III.45); and other nudes are found in the company of people making music. Although music was used within the Church as part of the ritual, it was noted above that popular music was believed to encourage lust and lead to sin. The exhibiting man at Courpiac has the

III.47. Four men posed as if urinating: fountain of the *pissaires*, 1399 f., Lacaune.

barrels. Are these the sins/dangers to avoid and against which the Church offers protection? Corbels on the east end of Notre-Dame-des-Miracles in Mauriac include an exhibiting woman, an exhibiting man, a dog with his penis in his mouth, another of a man showing his buttocks while simultaneously fellating himself, and a beard-puller, collectively forming a gallery of so-called 'rude' gestures. Among the corbels in the nave of Ste-Radegonde in Poitiers are an exhibiting man and an exhibiting woman with her prominent breasts revealed. In Spain, the corbels of the parish church of Cervados include an exhibiting woman beside an exhibiting man on the next corbel.

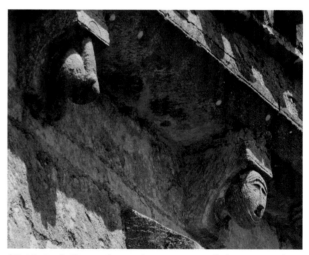

III.48. A phallus and testicles on one corbel, a worried woman wearing a wimple on the next: twelfth century, church, Ste-Columbe.

companionship of other corbel figures engaged in activities condemned by the Church: a couple having anal sex; a man blowing a horn while leaning on an acrobat (copulating?); and several figures with wine

Related images appear side by side not only on corbels. Although small in size, a megaphallic man put to work in the service of the Church like a tiny atlas is directly before the eyes of all who enter the church of St-Hilaire in Semur-en-Brionnais (III.46). The presence of the frog shown head-down above his left arm indicates his association with sin, for Revelation 16: 13–14 mentions '. . . three unclean spirits like frogs. For they are the spirits of demons working signs.' Beside him is a female nude representing *luxuria*, her genitals attacked by serpents and a frog at her breast. Similarly, a nude man and woman are shown to have their genitals bitten by serpents at the Puerta de las Platerías of Santiago de Compostela. There are many medieval examples of the *femme aux serpents* with snakes at the breasts and vaginal area, including that at the church of St-Jouin-de-Marnes, and the horrific one on the south portal of St-Pierre in Moissac.

To find such images on misericords, available only to the eyes of the clergy, like the very flexible nude man of 1484–1522 in the church of St-Marcel who holds his legs up beside his head, clearly displaying his penis and testicles – would seem to counter a didactic interpretation of the exhibiting figures. Yet it is not unlikely that the clergy were also believed to benefit from an occasional reminder.

An unusual example of male nudity in a secular context with positive connotations is offered by a fountain in Lacaune that consists of four naked males, posed as if urinating (III.47). Said to publicize the desirable qualities of the local water by showing its diuretic effect, this fountain is known, without subtlety, as the *pissaires*. The project for the fountain is said to date from 1399, but it remained incomplete until about 1559 (the date is uncertain). Located in the middle of a public square in a small town in southern France, this form of advertising is certain to be noticed and is a prime example of the earthy humour characteristic of the Middle Ages. The marketing message is facilitated by a comic element – a method often used by advertisers today. The activity of the *pissaires* may bring to mind a later sculpture publicaly displayed on a street corner in Brussels known as the *Manneken-Pis*, of 1619, a record of what a lost child was doing when he was found.

Some displays of genitalia are blatant, dealing so directly with the subject that the rest of the body is not depicted. An exceptionally overt example is found on a corbel on the south side of the little rural twelfth-century church of Ste-Columbe, consisting only of a penis and testicles (III.48); when seen in bright sunlight, the shadow repeats

the shape, as if for emphasis. The subject carved on the next corbel to the right seems to be related: a lady wearing a wimple looks noticeably worried. The parish church at Loupiac also has an exterior corbel with a penis and testicles. At the church of St-Just in Pressac a corbel on the north side is carved with a penis (broken) and testicles, yet another example of a man dismembered.

What can the meaning of such sculpture be? The answer may relate to the medieval view that the world was infested by demons intent on tormenting people and from which Church protection was required. Ruth Mellinkoff devotes a chapter of her book *Outcasts: Signs of Otherness in Northern European Art of the Late Middle Ages* to 'Vulgar Gestures and Indecent Exposure'.[12] She explains the exhibiting men and phalluses (as well as evil eyes and rude gestures such as farting and spitting) as apotropaic symbols intended to protect the Church and those within it. Mellinkoff notes that the medieval belief in the protective efficacy of such imagery has ancient origins in early fertility cults and practices, which involved worship of the fertility gods' genitalia. In parts of the ancient world a phallus was used as a defence against the evil eye or bad luck: because the penis is associated with creating life, its depiction can be used symbolically against death.

The ancient Romans used the phallus to ward off evil spirits. Depictions of penises were found inside many British altars in churches built at the time of the Black Death. Weir and Jerman note that as late as the seventeenth century, houses in areas of Wales and Normandy were still protected by phalluses on stairposts and fireplaces.[13] Thus the display of body parts normally hidden from view is interpreted in a positive light as amuletic or talismanic in purpose, offering effective protection against evil.

Deciphering the meaning of these subjects must take into account the artistic style used. Their extremely exaggerated physiognomies, extended beyond those characteristic of Romanesque art to the point of caricature, may suggest that significant humour is intended by the exhibiting figures. Rather than being mutually exclusive or contradictory, these two points of view – apotropaic and amusing – are complementary. An image can be simultaneously instructive and humorous. Comedy may have facilitated the lesson for an audience both illiterate and rural. Earthiness and even coarseness are among the characteristics of medieval art – including that created for the Church. A witty image that amuses can catch and hold a viewer's attention, making the message more easily committed to memory and, consequently, more effective.

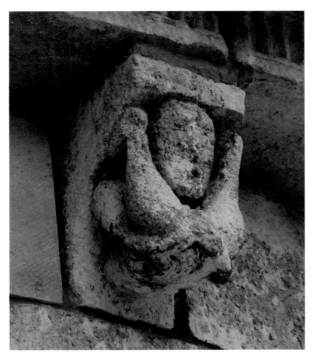

III.49. A surprised man showing his buttocks: corbel, north apsidole, church of St-Pierre, Champagnolles.

However, even with this generous attitude to the display of genitalia, what can be said about an extraordinary and undeniably humorous use of such imagery on medieval pilgrim badges? Two women flank an erect penis above trousers (battle for the breeches?) on one pilgrim badge. On another, a vagina on little legs is dressed as a pilgrim, fully equipped with a hat, a rosary in one hand, and a phallus as a walking stick in the other. A vagina walking on stilts, as if performing at a fair, crowned with three little erect penises, is the subject of yet another pilgrim badge. And the ultimate in the bizarre (and sacrilegious?) is perhaps the pilgrim badge that mimics the custom of carrying a statue of the Virgin Mary in procession, borne on a litter carried on the shoulders of men – now performed by a crowned vagina carried on a litter by three penises who have small tails, arms, and legs on which they walk upright. These examples were found in various locations in Belgium and The Netherlands, and date between 1375 and 1450.[14]

Pilgrim badges were customarily sewn to the travellers' garments as mementoes of places visited; one can only wonder about the use (and the owners) of these genitalia badges. Were they actually worn and, if so, on what occasion? Were pilgrim badges with customary subjects displayed proudly on outer garments, whereas others might be sewn into the lining, to be revealed only to select friends? Were they collected rather than worn? Were these dispensed by certain secular establishments as mementoes of a non-religious experience available to pilgrims? Could the interpretation of such imagery as apotropaic apply here, in that these badges shock by the overt display of genitalia, thereby repelling evil? Or does the comic element

of the medieval pilgrim badges, coupled with the pilgrims' reputation for indulgent behaviour, counter this interpretation? Perhaps not, for laughter was also an ancient device against evil. Would it be too forgiving an interpretation to suggest that these medieval badges might combine both aspects, thereby simultaneously protecting and amusing the pilgrim on his or her journey?

Rather than being seen from the front and displaying their penises, other male figures turn their backs and exhibit their buttocks – including the defecating gargoyles discussed above. At the church of St-Pierre in Champagnolles a corbel figure on the north apsidole seems to express surprise at finding himself in this predicament (III.49). On a corbel in the nave of the cathedral of

III.51. A man showing his buttocks, head over shoulder: Maison d'Adam, Angers,

III.50. A man showing his buttocks: corbel, courtyard, Hostal de los Reyes Católicos, Santiago de Compostela.

St-Etienne in Metz, a man looks through his legs while displaying his naked bottom. Similarly, on a corbel on the south side of the church of San Sepolcro in Barletta, a man bares his buttocks, his hands on either side. Such figures are found also on misericords, on capitals, in manuscript margins, and elsewhere.

In particular, the subject of men with their pants down, exhibiting their buttocks, appears repeatedly on French stalls. In the cathedral of Notre-Dame in

Rodez a man carved on a fifteenth-century misericord bends over so far that he looks through his legs, pulls down his pants with both hands, and reveals his bare bottom. Another fifteenth-century misericord, on loan at St-Michel in Mauvesin, portrays a contortionist who shows his anus while supporting the misericord seat with his hands and feet. A man with a bare bottom appears on a late fifteenth-century misericord in the collegiate church of St-Sylvain in Levroux. A little man on a stall armrest at the church of St-Martin-la-Butte in Troô from the end of the fifteenth century appears to defecate! Dressed as a fool, an exhibitionist with legs raised is seen on a sixteenth-century misericord in the church of Notre-Dame in Lorris. A rare example of a female anus exhibitionist is found at the church of St-Pierre in Concressault.[15]

In the chronic battle against evil waged by the medieval Church, these offensive gestures and postures may have been used to frighten away demons, thereby protecting the Church and all those within. The best defence was believed to be a good offence, essentially fighting fire with fire. The apotropaic interpretation is supported by a man carved on the stalls of 1535 in St-Bertrand de Comminges, who thrusts out his bare buttocks while being steadied in his precarious position by another man in ecclesiastical garb.

Just as the scatological images carved on the exteriors and interiors of churches are intended to turn away demons from the church, the obscene imagery drawn in the margins of manuscripts are intended to protect the sacred words therein.[16] Manuscript margins include many figures showing their buttocks and/or defecating, what Lilian Randall calls obscaena, some involving humans, others involving apes.[17]

Given that such imagery is used on churches, there should be no surprise in finding it on secular buildings. For example, the series of corbels in one of the four courtyards of the former Royal Hospital in Santiago de Compostela are said to depict the ailments people suffered on their long journeys here, for the cathedral was the ultimate goal of many medieval pilgrims. Several corbel figures display their naked buttocks (III.50); perhaps they are 'saddle sore'. Yet if this interpretation is correct, one might ask where is the pilgrim with the sore throat or the sprained ankle?[18] Further, much the same pose is seen on a corbel on the north side of the church of St-Etienne in Cahors.

Overt in pose and location is the exhibiting man on the side of the Maison d'Adam in Angers (III.51).

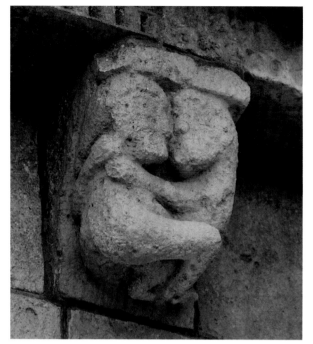

III.52. A copulating couple, kissing: corbel, church of St-Pierre, Champagnoles.

Seen from behind, he blatantly, even defiantly, exposes his private parts while glancing over his shoulder to make certain he has an audience. Surely there is no indication of embarrassment – at least on *his* part. In fact, there is an element of a prank here, as the viewer is 'mooned' by this immodest medieval man. Given his arrogant posture and his location on a wealthy private home from the late fifteenth century, he supports the belief of Weir and Jerman

that anal exhibitionists are a sub-theme of *luxuria*.[19] Has he been caught, literally with his pants down, fleeing from a bedroom window? Other people scamper up and down the timbers here, including the man in ill. I.15 above.

A man, carved and polychromed on a corbel, has displayed his buttocks since 1494 on the exterior of a stone building originally owned by the cloth-cutters' guild, now the Hotel Kaiserworth, in the

III.53. A copulating couple, surprised: twelfth century, church of St-Cybard, Vérac.

III.54. A copulating couple on one capital, a horrified person on the next: twelfth century, church of Notre-Dame, Payroux.

marketplace of Goslar. Wearing only a hat, this caricature turns his back to the viewer, places his hand on his buttocks as if to direct the viewer's attention there, and defecates gold coins! Known as *Dukatenkakker* or 'Goldshitter', Grössinger says he may depict the German proverb, 'Money doesn't fall out of my arse', or that this may be 'wishful thinking'.[20] Mellinkoff says this sculpture is believed to be protective and to bring good luck, relating the story that in medieval times people who did not pay their debts were 'exposed bare-bottomed in the marketplace . . .', but says this figure's gesture is, instead, both apotropaic *and* insulting, noting that in other contexts the same gesture is malevolent and

mocking.[21] The image of a man defecating coins appears elsewhere, ranging from a misericord in the Oude Kerk in Amsterdam to a painting by Hieronymus Bosch – his *Garden of Earthly Delights* triptych, mentioned above, includes a depiction of the miser, condemned to hell, defecating gold coins into a sewer, presumably a commentary on the true value of money and material possessions.

Even cheekier than *Dukatenkakker*, rendered with the photographic detail characteristic of Flemish painting, is a diptych (dated to about 1520) now in the Collections Artistiques of the University of Liège. On the outside the anonymous artist warns the viewer in writing not to open the diptych – an irresistible challenge. Inside, on the left panel the viewer is faced with a highly realistic bare bottom thrust outward, together with a painfully placed thistle. On the right panel of this satire a man makes a mocking face, pulling his eyes and mouth with both hands and sticking out his tongue, as if to say impudently 'I told you so!'

Although nude figures usually appear individually, male-female couples are occasionally seen on and in churches, especially during the Romanesque era. At the church of St-Pierre in Champagnolles there is a little couple, hand on genitals, on the east wall of the south transept, as well as a copulating couple on

a corbel on the north apsidole (III.53). At the twelfth-century church of St-Cybard in Vérac a coital pair look embarrassed to find themselves exposed when the shadows move (III.54). At the church of St-Christophe in Courpiac a couple is discovered on a twelfth-century capital inside the apse. Lovers with rubbery little extremities and large heads, also twelfth-century, are seen on an apse corbel at the church of St-Sulpice in Marignac. The Church's attitude is made obvious on twelfth-century capitals at Notre-Dame in Payroux where in plain view of everyone who enters the church, in the middle of the length of the nave, is a clearly carved man and woman engaged in sexual intercourse, the woman smiling, while, just to the right, another person expresses horror at their activity (III.55). A similar depiction of a couple copulating 'while an admonishing cleric looks on' carved on an interior capital at Carennac is mentioned by Weir and Jerman.[22]

Sexual intercourse is depicted by the Church as repugnant behaviour rather than as appealing romance. However, the artist's image does not intend to offend but to convey a moralizing message. Such portrayals are negative exempla, showing how one was *not* to behave. The medieval Church taught that celibacy was the ideal, but that intercourse was acceptable within marriage because it created more souls. Physical lust, however, was one of the seven deadly sins that would surely condemn a person to hell. Like the more frequently found exhibiting individuals discussed above, the depictions of couples are artistic admonishments, warnings meant to encourage sexual restraint and to discourage lust.

While religious personages, particularly Mary and Jesus, are depicted as physically beautiful in medieval art, the nude human body usually is shown, by contrast, as physically unappealing in the didactic examples discussed here. However, had the *people* of the Middle Ages actually felt that the human body was not enticing and alluring, there would have been no need for the Church's warnings.

The story of Lady Godiva illustrates the enduring and widespread aesthetic of the female body as sensual and seductive and the medieval ascetic belief that, for this reason, it should be hidden from view. This eleventh-century English woman's horse-ride through Coventry provides the ultimate example of travelling light and expands the definition of 'riding bareback'. Lady Godiva is reputed to have pleaded at length with her husband Leofric, earl of Mercia, to lift certain of the heavy taxes imposed upon the people of Coventry. Finally he countered with the

offer that if she would ride naked through the market there, he would do as she asked. The citizens of Coventry were forbidden to look upon Lady Godiva's nakedness, hidden only by her long hair; one person looked and was struck blind. As to the historical basis of this legend, it may be noted that the earliest written version is that of 1237 by Roger of Wendover, more than a century and a half after the reputed ride. Yet had the sight of a nude female body not been regarded as both tantalizing and forbidden, there would have been nothing notable about Lady Godiva's travel wardrobe.

Conclusion

Witty imagery has existed through the ages, evidently appealing to something fundamental within us. The fact that similar images appear in geographically diverse locations and in different centuries suggests that there is a degree of universality in what amuses people, no matter where or when they live. The enjoyment provided by wit and humour is not restricted to the viewers, for there is a sense that the artists who created these images enjoyed their own cleverness and presumably entertained themselves and their fellow workers as they created the examples studied in this book.

Chapter I focused on images intended to amuse. Many may be described as 'site specific', for they are clever only when seen in context and would be considered 'sight gags' today. For example, the figures who lean out of the windows on the façade of the palace of Jacques Coeur in Bourges (I.8, 9) would lose the element of trickery and the consequent humour if removed from their architectural location. In such cases, an unexpected interplay is created by the sculptor – not only with the architecture but also with the viewer. More often subtle than overt, many of these witty images are easily overlooked. When these examples of medieval mischief are discovered, the element of surprise and even of momentary disbelief engages and entertains. Equally amusing for the incongruity of medium are the knotted columns, the solid nature of stone defied, its false flexibility implied. And visual puns and rebuses test the viewer's ability to solve a problem.

Chapter II dealt with medieval artists' aptitude to use wit and humour to instruct. Examined here were ethical issues of great importance to the medieval Church, summed up in the seven deadly sins and their punishments. The *inversus mundi* theme was seen in the many instances of medieval art in which what we expect is not what we get. These two ideas may combine, for example in the depiction of a sinful man who hunted illegally in the grounds of

the abbey of Ste-Foy in Conques, now roasted like a rabbit on a spit over an open fire, by his quarry (II.17). Depictions of the 'war of the sexes' prove that there was no sexual *détente* during the Middle Ages. The portraits of artists and patrons provide evidence that the desire to be remembered was given visual form prior to the exaltation of the individual in Renaissance portraiture.

Finally, chapter III was concerned with depictions of the human body that may surprise, amaze, or offend, whether by suffering the discomfort of a physical ailment, or by a self-induced distortion such as the many mouth-pullers, or by contortion of the body into positions that would seem to defy the constraints imposed by a rigid skeleton. Also examined were certain forms of medieval behaviour that appeared in public presumably only when portrayed by artists, for example, men displaying their bare buttocks, like that at Autun Cathedral (III.38). Nude men and women are portrayed on the exteriors and interiors of medieval churches, perhaps to the surprise of today's viewers, not only at the use of such imagery by the Church but also because, differing from the depiction of the nude in virtually all other eras, medieval artists intentionally eschewed the body's natural beauty.

Has our 'sense of humour' remained essentially unchanged over the years or has it gradually evolved? Are there cultural and regional differences as to what is regarded as amusing? Certainly there are personal variations: what makes one person laugh may do nothing for another. While there are no absolutes, some observations may be made. Humorous imagery neither peaks nor disappears at any one specific time during the Middle Ages, but there are obvious preferences for different types of medieval mischief at different times that accord with the then-current artistic style.

The efforts of Romanesque sculptors focus on capitals, corbels, and tympana, often used by the Church for didactic purposes, as the tympanum of Ste-Foy in Conques (II.15), or for apotropaic purposes, like the corbels at Kilpeck (III.15). Romanesque artistic style is characterized by a charming and superficially naive quality but is, in fact, highly sophisticated, the exaggerations of the cartoon-like caricatures especially useful in conveying moral messages. Gothic sculptors seem to show a preference for visual puns dependent upon context, such as the monster heads devouring vault ribs at Wells Cathedral (I.40), or on a level of realism to deceive the viewers' eyes, like emperor Charles IV addressing his subjects in Mühlhausen (I.1).

Examples that depend upon temporarily tricking the viewer into believing, if only for an instant, that a sculpted figure is alive are characteristic of the later years of the Gothic era, for only then was a style of sufficient realism developed to permit the possibility of deception. The result is a private moment between sculptor and viewer, as the sculptor's creation actively returns the viewer's gaze. Success – that is, the degree to which the stone figure approximates real life – is gauged by the viewer's reaction.

In regard to the development and spread of humorous images, it may be worth noting that certain subjects recur, and are found grouped with certain other subjects, while related ideas are likely to be seen on nearby churches depicted in a similar style, suggesting that itinerant sculptors disseminated both their subjects and their styles. Thus although each medieval church has its own 'character' or 'temperament' or 'personality', if one of the subjects discussed in this study is sighted, the curious viewer is advised to look for more as there are likely to be several here.

While some images are immediately intelligible, the complexity of iconographic interpretation is often further compounded by the medieval affection for ambiguity. A multiplicity of meanings for a single image was acceptable, if not preferable, to simplicity – many shades of grey were enjoyed as much, if not more, than black and white. The various meanings and conflicting opinions about these works of art go back to the Middle Ages. Not all churchmen were receptive to these images, as evidenced by the famous objection in the twelfth century of St Bernard of Clairvaux, who found certain images created by artists to be distractions rather than aids to devotion. Yet an image can be simultaneously didactic and diverting, able at once to instruct and entertain, depending upon the individual viewer. Kenaan-Kedar is correct in saying that the corbels 'held different meanings for different audiences'.[1] Further, the corbels probably held more than one meaning to all audiences, in accord with the medieval attraction to layered symbolism. It may be suggested that these witty inclusions were meant to have much the same effect during the Middle Ages as they have today, attracting our attention and curiosity by their cleverness and ingenuity, enhancing a visit to church. This would accord with religious practices that became progressively more popular, appealing overtly to the medieval public, in an effort to maximize engagement in the activities of the Church.

The various works studied here raise the issue of audience, for all were not created for the same eyes.

IV.1. The tomb of Bishop Thomas Bekynton: south aisle, 1450, choir, Wells Cathedral.

The copulating couple seen on the column capitals in the middle of the nave at Payroux (III.54) could be more prominent in their location – and what they are doing is neither disguised nor subtle, but rather emphatic and obvious. Similarly, the penis and testicles carved on a corbel in the centre of the exterior south wall of Ste-Columbe are blatantly obvious (III.48). Such images are not hidden in the shadows nor tucked away in the corners or on the back of the church in visually inaccessible locations; instead, we may assume that they were meant not only to shock but also to teach and/or protect the congregation.

Other works, sometimes smaller in scale and in less visible locations, targeted smaller audiences. Examples in obscure, even hidden locations cannot have been effective teaching tools: these are more likely to be visual puns, surprises, or jokes. The viewer must look carefully, and these tidbits entice, for where one is discovered there may be more. Such is the case when looking up and under the south transept archivolts at St-Pierre in Aulnay to see the small figures supporting the architecture there (I.57) or down at the bases of the columns in the cloister of Monreale Cathedral to see the little monsters devouring the mouldings (I.37). When seemingly irreverent activity is discovered in places that can only be appreciated today with field glasses or a zoom lens, such as certain gargoyles and ceiling bosses, the artists' satire cannot have been meant for the general public. In such peripheral places artists could experiment, amuse themselves, and amuse others – some may have been intended for the enjoyment only of the individual artist and his fellow workers. When creating art destined for ancillary areas, medieval artists seem to have felt free to indulge their penchant for the peculiar. Such works of art evidently were not bound by the customary conventions that control much of medieval art. Rather, these sculptures reveal medieval artists'

unfettered and individualistic creativity, offering rare glimpses of their personal proclivities and of the value accorded to visual variety.

Some of the art examined here is of the type that has recently been described as 'marginal' or 'low art', as opposed to 'official' or 'high art', by several art historians, and analysed from this point of view. Aspects of this type of non-traditional subject matter in medieval art are discussed by Kenaan-Kedar and Michael Camille. This opinion is based upon the assumption that there was a difference *during the Middle Ages* between what are today being contrasted as 'central and peripheral' art, which justifies making distinctions between sacred elite art as opposed to worldly popular art.

Caution is necessary, however, to avoid seeing medieval art from a modern perspective, for if we are repeatedly surprised today by images we find arresting or even shocking on medieval churches, perhaps this is because the people of the Middle Ages did not view these images in the same way we do. It has been suggested that some of these images were meant to be subversive and were carved in resistance to the Church. If this were so, however, there would not be so very many, over so large a geographic area, made over so many years. Had these images been unwelcome, surely they

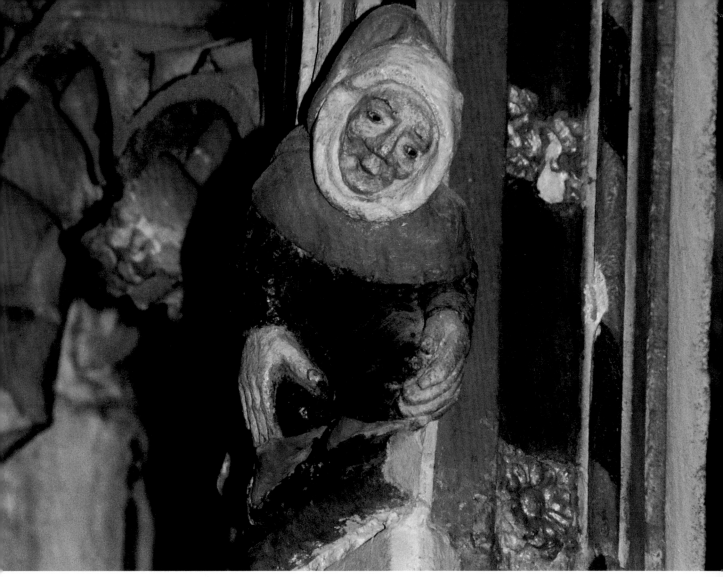

IV.2. Bekynton's jester.

would have been removed long ago. Certainly the clergy were fully aware of the use of satirical and grotesque imagery outside and even inside the Church. Indeed, they even sat on it when they utilized the misericords – which they commissioned.

THE LAST LAUGH

In Wells Cathedral, in the south aisle of the choir, is the tomb of Thomas Bekynton (d. 1465), chancellor of England, secretary to Henry VI, and later Keeper of the Privy Seal, as well as bishop of Bath and Wells from 1443 to 1465 (IV.1). Bekynton had his tomb constructed in 1450, many years before his death, in acceptance of his mortality, with a cadaver below and an alabaster effigy in ecclesiastical vestments above. Unlike other medieval funeral effigies, however, Bekynton's *smiles* – and rightly so. Bekynton, a good bishop who actively improved the cathedral and city of Wells, was known for his happy disposition, but faced disappointment when his request to have his jester buried near him in the cathedral was refused by the Dean and Chapter. Bekynton and his jester had the last laugh, however, for Bekynton had his tomb built with a 6-inch stone figurine of his jester placed on the top left corner – closer to the altar than his own effigy – which will continue to smile for eternity, the pleasure provided by humour undiminished (IV.2).

Finally, a deduction may be made. Given that a bishop such as Bekynton, and even a saint such as Dunstan (see II.1 above), had a sense of humour, and given that some of the humorous imagery is located so that it can only be seen by God, who was believed to be everywhere and to see everything, then God, too, may have a sense of humour.

Notes

INTRODUCTION

1. I am grateful to Revd Walker for generously providing me with the text of his Perkins Seminary workshop, presented in 1999.
2. The bibliography includes Mikhail Bakhtin, *Rabelais and His World*, trans. Hélène Iswolsky, Bloomington, Indiana University Press, 1984; Martha Bayless, *Parody in the Middle Ages*, Ann Arbor, University of Michigan Press, 1996; *Chaucer's Humor: Critical Essays*, ed. Jean E. Jost, vol. 5, Garland Studies in Humor, Hamden, CT, Garland Publishing, 1994; M. Corti, 'Models and Antimodels in Medieval Culture', *New Literary History*, X (1978), pp. 357–64; Melissa Furrow, *Ten Fifteenth-Century Comic Poems*, Hamden, CT, Garland Publishing, 1985; Kathryn Gravdal, *Vilain and Courtois, Transgressive Parody in French Literature of the Twelfth and Thirteenth Centuries*, Lincoln, University of Nebraska Press, 1989; *Humour in Anglo-Saxon Literature*, ed. Jonathan Wilcox, Woodbridge, Boydell and Brewer, 2001; *Humour, History, and Politics in Late Antiquity and the Early Middle Ages*, ed. Guy Halsall, Cambridge, Cambridge University Press, 2002; *Medieval Comic Tales*, ed. Derek Brewer, Woodbridge, Boydell and Brewer, 1996; Philippe Menard, *Le rire et le sourire dans le roman courtois en France au Moyen-Age*, Geneva, Droz, 1969, pp. 156–62; Lisa Perfetti, *Women and Laughter in Medieval Comic Literature*, Ann Arbor, University of Michigan Press, 2003; and Mary Jane Stearns Schenck, *The Fabliaux: Tales of Wit and Deception*, Philadelphia, John Benjamins, 1987.
3. Christa Grössinger, *The World Upside-Down: English Misericords*, London, Harvey Miller Publishers, 1997, p. 112, comments on '. . . how closely fear and humour were linked'.

CHAPTER I. THE AMUSING

1. Nurith Kenaan-Kedar, *Marginal Sculpture in Medieval France: Towards the Deciphering of an Enigmatic Pictorial Language*, Aldershot, Hants, Scolar Press, 1995, pp. 98–99, links this figure and others here to the story of the Holy Grail, with this man identified as Perceval.
2. Kenaan-Kedar, *Marginal Sculpture*, pp. 72–73.
3. '. . . only about 4.5 per cent of Britain's almost 8,600 surviving centrepieces and supporters have primarily religious significance . . .', writes Marshall Laird, *English Misericords*, London, John Murray, 1986, p.10.
4. New York, Metropolitan Museum of Art, Cloisters Collection, f. 82v.
5. Barbara D. Palmer, *The Early Art of the West Riding of Yorkshire*, Early Drama, Art, and Music, Reference Series 6, Kalamazoo, Medieval Institute Publications, 1990, p. 39.
6. Baltimore, Walters Art Gallery, MS. 143, f. 72v.
7. Chantilly, château, Musée Condé, f. 2r.

CHAPTER II. THE INSTRUCTIVE

1. If the number of deadly sins is limited to a mere seven, the author wonders if *all* human foibles and failings can be taken into account. What is considered sinful tends to vary by time and place. Thus if an eighth deadly sin were to be added to the list to bring it up to date for today's way of life, what would it be? Perhaps some medieval sins would now be stricken from the list, for certain types of behaviour once believed to lead to eternal damnation, such as *libido / luxuria*, are encouraged now as a mandatory

component of a desirable 'lifestyle', and a healthy dose of *invidia* is admissible to spur that coveted competitive edge.

2. That this was, therefore, the first cartoon 'strip' was suggested to the author by the elderly steward of Ludlow church, the aptly named Mr Leslie Sharp.

3. François Boucher, *20,000 Years of Fashion: The History of Costume and Personal Adornment*, New York, Harry N. Abrams, 1987, p. 200.

4. However, a headdress almost identical to that at Ludlow is seen on another English misericord in the church of Tansor (Norhants) where the lady shown is young and attractive, and flanked not by heckling boys on the supporters but by busts of fashionably attired ladies; evidently the style had its supporters.

5. Michael and Ariane Batterberry, *Fashion: The Mirror of History*, New York, Greenwich House/Crown Publishers, 1982, pp. 87–88.

6. Oxford, Bodleian Library, MS Douce 366, f. 128r.

7. Apes frequently appear in human roles in the margins of manuscripts; Lilian Randall, *Images in the Margins of Gothic Manuscripts*, Berkeley, University of California Press, 1966, illustrates approximately sixty examples.

8. See David A. Sprunger, 'Parodic Animal Physicians from the Margins of Medieval Manuscripts', in Nona C. Flores (ed.), *Animals in the Middle Ages*, New York, Garland Publishing, 1996, pp. 67–81.

9. Chantilly, château, Musée Condé, MS 62, f. 36v; Randall, *Images*, fig. 36. On the north transept portal of Rouen Cathedral, a late thirteenth-century quatrefoil relief depicts the vile vial again raised for inspection, now held by a human-headed monster who makes his medical diagnosis.

10. London, British Library, Royal 10.E.IV, f. 96r.

11. Cambridge, Trinity College, MS B.11.22, f. 4.

12. London, British Library, Add. MS 36684, f. 125r.

13. Laird, *English Misericords*, p. 9, fig. 98.

14. New York, Pierpont Morgan Library. Illustrated in *Monsters, Gargoyles, and Dragons: Animals in the Middle Ages*, exhibition catalogue, Mount Holyoke, MA, 1977, fig. 20.

15. See Randall, *Images*, figs. 196, 197, 199, 202, 203.

16. Stephen Lamia, 'The Beasts in the Band: An Inquiry into the Iconography of Music-Making Animals in Romanesque Art', unpublished paper presented at 24th International Congress on Medieval Studies, Western Michigan University, Kalamazoo, 1989.

17. Jacques de Longuyon, *Voeux du Paon* (incomplete), collection of William S. Glazier, New York, Pierpont Morgan Library, New York, MS. 24, f. 30v.

18. The subject of the war of the sexes on misericords is discussed by Elaine C. Block in several articles in *The Profane Arts in the Middle Ages*, Misericordia International, especially vol. VIII, no. 2, spring 1999, pp. 90–99. See Pierre Bureau, 'Le Combat pour la culotte: variations littéraires et iconographiques d'un thème profane XIIIe-XVIe siècles', *Le Mirror des miséricordes*, Les Cahiers de Conques II, pp. 95–120.

19. New York, Metropolitan Museum of Art, Cloisters Collection, front panel, 1988.1.6.

20. New York, Metropolitan Museum of Art, Robert Lehman Collection, 1975.1.1416.

21. See Randall, *Images*, figs. 554, 555, 557.

22. Whether Disa or Marcolf is depicted in a work of art is not always obvious. See Malcolm Jones, 'Marcolf as *kluge Bauerntochter* in English Medieval Art', in *The Profane Arts of the Middle Ages*, vol IV, no. 2, autumn 1995, pp.100–06, including Elaine C. Block's reply.

CHAPTER III. THE SURPRISING, AMAZING OR OFFENSIVE

1. New York, Metropolitan Museum of Art, 64.101.1497.

2. Lawrence Stone, *Sculpture in Britain: The Middle Ages*, Baltimore, Penguin Books, 1972, says the subjects of the Wells capitals 'would seem to have been left largely to the masons', p. 103, and that the Wells toothache and thorn-puller capitals are 'both entirely without didactic purpose', p. 104.

3. R.N. Trubshaw, *Gargoyles and Grotesque Carvings in Leicestershire and Rutland*, Wymeswold, England, Heart of Albion Press, 1995, p. 3.

4. Anthony Weir and James Jerman, *Images of Lust: Sexual Carvings on Medieval Churches*, London, B.T. Batsford Ltd., 1993, pp. 104–08. Weir and Jerman find sexual symbolism in mouth-pullers, comparing the mouth-pulling gesture to the sheela figures discussed below. Ruth Mellinkoff, *Outcasts: Signs of Otherness in Northern European Art of the Late Middle Ages*, 2 vols., Berkeley, University of California Press, 1993, p. 199, finds sexual connotations in putting one or more fingers in the mouth, noting that, depending on context, this gesture is not meant to be abusive but instead to show someone, such as a peasant, to be crude or vulgar.

5. Alixe Bovey, *Monsters and Grotesques in Medieval Manuscripts*, Toronto, University of Toronto Press, 2002, pp. 40–41.

6. See Mellinkoff, *Outcasts*, Chapter 10, especially p. 198. Mellinkoff, additionally, considers sticking out the tongue to have sexual connotations.

7. Michael Camille, *Image on the Edge*, p. 94.

8. Weir and Jerman, *Images of Lust*, p. 21. Exhibiting figures are said to develop from Classical prototypes, p. 15.

9. Weir and Jerman, *Images of Lust*, p. 17.

10. This figure, and others like it, appear to be eating a flat object, which, according to Weir and Jerman, *Images of Lust*, p. 92, suggests that they are symbolic of 'blasphemers or those who receive the sacraments with lechery in their hearts . . . seemingly combining lechery with gluttony'. However, the object is of a rectangular shape similar to the lock on the mouth of the misericord gossiper seen in II.14.

11. Weir and Jerman, *Images of Lust*, p. 141.

12. Mellinkoff also presented a paper at the International Congress on Medieval Studies, Western Michigan University, Kalamazoo, 1994, on this subject.

13. Weir and Jerman, *Images of Lust*, pp. 10, 146.

14. See Timothy Hyman and Roger Malbert, *Carnivalesque*, exhibition catalogue, London, Hayward Gallery Publishing, 2000, ills. on pp. 28, 98, 100, 101.

15. For these examples and others, see Elaine C. Block, *Corpus of Medieval Misericords in France XIII – XVI Century*, Tournhout, Brepols Publishers, 2003.

16. In addition to being protective, the same gestures and exposures in a different context can also have purely negative meaning. Sexual or scatological images in medieval art are often directed at a specific person as an insult. To show the buttocks (modern parlance uses 'mooning') is a form of mockery – in fact, merely to turn one's back on someone has long been regarded as disrespectful, hence people of lower rank being obliged to back away from those of higher rank as a sign of deference.

17. See Randall, *Images in the Margins*, figs. 527–43; also Bovey, *Monsters*, pp. 53–55.

18. On the Santiago corbels, see Karl P. Wentersdorf, 'The Symbolic Significance & Figurae Scatologicae in Gothic Manuscripts', in Clifford Davidson (ed.), *Word, Picture and Spectacle*, Kalamazoo, Medieval Institute Publications, Western Michigan Unviersity, 1984, pp. 1–20.

19. Weir and Jerman, *Images of Lust*, p. 100.

20. Christa Grössinger, *Humour and Folly in Secular and Profane Prints of Northern Europe 1430–1540*, London, Harvey Miller Publishers, 2002, pp. 1–2.

21. Mellinkoff, *Outcasts*, p. 205, pl. X.28.

22. Weir and Jerman, *Images of Lust*, p. 89.

CONCLUSION

1. Kenaan-Kedar, 'The Margins of Society in Marginal Romanesque Scultpure', *Gesta*, XXXI/I, 1992, p. 18.

Suggested Reading

Adolf, Helen, 'On Medieval Laughter', *Speculum*, 22 (1947), 251–3

Andersen, Jorgen, *The Witch on the Wall: Medieval Erotic Sculpture in the British Isles*, London, Allen & Unwin, 1977

Anderson, M.D., *Animal Carvings in British Churches*, Cambridge, Cambridge University Press, 1938

——, *Misericords: Medieval Life in English Woodcarving*, Harmondsworth, Middlesex, Penguin, 1954

Armi, C. Edson, *Masons and Sculptors in Romanesque Burgundy*, University Park, Pennsylvania State University Press, 1983

Babcock, Barbara A., *The Reversible World: Symbolic Inversion in Art and Society*, Ithaca, New York, Cornell University Press, 1978

Baltrusaitis, Jurgis, *Le Moyen Age Fantastique*, Paris, Flammarion, 1993

Barasch, Mosche, *Gestures of Despair in Medieval and Early Renaissance Art*, New York, New York University Press, 1976

Barolsky, Paul, *Infinite Jest: Wit and Humor in Italian Renaissance Art*, Columbia, University of Missouri Press, 1978

Benton, Janetta Rebold, *Art of the Middle Ages*, London, World of Art, Thames & Hudson, 2002

——, 'Gargoyles: Animal Imagery and Artistic Individuality', in Nona C. Flores (ed.), *Animals in the Middle Ages*, New York, Garland Press, 1996

——, *Holy Terrors: Gargoyles on Medieval Buildings*, New York, Abbeville Press, 1997

——, *Medieval Menagerie: Animals in the Art of the Middle Ages*, New York, Abbeville Press, 1992

——, *Medieval Monsters: Dragons and Fantastic Creatures*, exhibition catalogue, Katonah, NY, Katonah Museum of Art, 1995

—— and Robert DiYanni, *Arts and Culture: An Introduction to the Humanities*, 2 vols., Upper Saddle River, NJ, 2nd edn, 2004, chapters 11 and 12.

Berlioz, Jacques, and Polo, Marie Anne, *L'animal exemplaire au moyen âge (Ve-VXe siècle)*, Rennes, Presses Universitaires de Rennes, 1999

Bettey, Joseph H., and Taylor, C.W.G., *Sacred and Satiric: Medieval Stone Carving in the West Country*, Tiverton, Redcliffe Press, 1982

Block, Elaine C., *Corpus of Medieval Misericords in France XIII–XVI Century*, Tournhout, Brepols Publishers, 2003

Böhmer, G., *The Topsy-Turvy World*, exhibition catalogue, Amsterdam, 1985

Bovey, Alixe, *Monsters and Grotesques in Medieval Manuscripts*, Toronto, University of Toronto Press, 2002

Brighton, Christopher, *Lincoln Cathedral Cloister Bosses*, Lincoln, Honywood Press, 1985

Brown, Pamela Allen, *Better a Shrew than a Sheep: Women, Drama, and the Culture of Jest in Early Modern England*, Ithaca, Cornell University Press, 2003

Camille, Michael, *Image on the Edge: The Margins of Medieval Art*, Cambridge, Massachusetts, Harvard University Press, 1992

Challis, Margaret G., *Life in Medieval England as Portrayed on Church Misericords and Bench Ends*, Henley-on-Thames, Teamband Ltd, 1998

Evans, Edward P., *Animal Symbolism in Ecclesiastical Architecture*, London, William Heinemann, 1896

Friedman, John B., *The Monstrous Races in Medieval Art and Thought*, Cambridge, Massachusetts, Harvard University Press, 1981

Gaignebet, Claude, and Lajoux, Dominique, J., *Art profane et religion populaire au moyen âge*, Paris, Presses Universitaires de France, 1985

Grössinger, Christa, *The World Upside-Down: English Misericords*, London, Harvey Miller Publishers, 1997

——, *Humour and Folly in Secular and Profane Prints of Northern Europe 1430–1540*, London, Harvey Miller Publishers, 2002

Gurevich, Aron, *Medieval Popular Culture: Problems of Belief and Perception*, Cambridge, Cambridge University Press, 1988

Hyman, Timothy, and Malbert, Roger, *Carnivalesque*, exhibition catalogue, London, Hayward Gallery Publishing, 2000

Janson, Horst W., *Apes and Ape-Lore in the Middle Ages and the Renaissance*, London, Warburg Institute, 1952

Jones, Malcolm, 'Marcolf as *kluge Bauerntochter* in English Medieval Art', in *The Profane Arts of the Middle Ages*, vol. IV, no. 2 (autumn 1995)

Kelly, Eamonn P., *Sheela-na-Gigs: Origins and Functions*, Dublin, Country House, 1996

Kenaan-Kedar, Nurith, *Marginal Sculpture in Medieval France: Towards the Deciphering of an Enigmatic Pictorial Language*, Aldershot (Hants), Scolar Press, 1995

——, 'The Margins of Society in Marginal Romanesque Sculpture', *Gesta*, vol. XXXI/1 (1992) 15–24

——, 'Les modillons de Saintonge et du Poitou comme manifestation de la culture laïque', *Cahiers de Civilisation Médiévale*, XXIX (1986), 311–30

——, 'Unnoticed Self-Representations of Romanesque Sculptors in Twelfth-Century France', in Irving Lavin (ed.), *World Art, Themes of Unity in Diversity*, vol. II, University Park, Pennsylvania State Press (1989), 487–93

Kraus, Dorothy, and Henry, *The Gothic Choirstalls of Spain*, London, Routledge & Kegan Paul, 1986

——, *The Hidden World of Misericords*, New York, Braziller, 1975

Kris, E., 'Ego Development and the Comic', in *Psychoanalytic Explorations in Art*, New York, International Universities Press (1974), 204–16

Kunzle, David, 'World Upside Down: The Iconography of a European Broadsheet Type' in Barbara Babcock (ed.), *The Reversible World: Essays in Symbolic Inversion*, Ithaca, New York, Cornell University Press, 1978

Laird, Marshall, *English Misericords*, London, John Murray, 1986

Lehmann, Paul, *Die Parodie im Mittelalter*, Stuttgart, Hiersemann, 1963

MacColl, D.S., 'Grania in Church: or the Clever Daughter', *Burlington Magazine*, VIII (1905), 80–87

Maeterlinck, L., *Le genre satirique dans la peinture Flamande*, Brussels, Van Oest, 1907

——, *Le genre satirique, fantastique et licencieux dans la sculpture Flamande et Wallonne*, Paris, Librairie Jean Schemit, 1910

Mellinkoff, Ruth, *Outcasts: Signs of Otherness in Northern European Art of the Late Middle Ages*, 2 vols., Berkeley, University of California Press, 1993, especially chapter 10, 'Vulgar Gestures and Indecent Exposure'

Nichols, John, 'Female Nudity and Sexuality in Medieval Art' in Edelgard DuBruck (ed.), *New Images of Medieval Women*, Lewiston, Edwin Mellen Press, 1989, 165 f.

Nordenfalk, Carl, 'Drolleries', *Burlington Magazine*, CIX (1967), 418–21

Otto, Beatrice K., *Fools are Everywhere: The Court Jester around the World*, Chicago, University of Chicago Press, 2001

Randall, Lilian M.C., *Images in the Margins of Gothic Manuscripts*, Berkeley, University of California Press, 1966

——, 'Humour and Fantasy in the Margins of an English Book of Hours', *Apollo*, LXXXIV (1966), 482–88

Remnant, G.L., *A Catalogue of Misericords in Great Britain*, Oxford University Press, 1998, with a chapter by M.D. Anderson on iconography

Roberts, Jack, *The Sheela-na-gigs of Britain and Ireland – an Illustrated Guide*, Dublin, Bandia Publishing, 1997

Rogers, Katherine M., *The Troublesome Helpmate: A History of Misogyny in Literature*, Seattle, University of Washington Press, 1966

Rose, Martial, and Hedgecoe, Julia, *Stories in Stone: The Medieval Roof Carvings of Norwich Cathedral*, New York, W.W. Norton, 1997

145

Rouse, E.C., and Varty, Kenneth, 'Medieval Paintings of Reynard the Fox in Gloucester Cathedral and Some Other Related Examples', *The Archaeological Journal*, 133 (1976), 104–17

Sekules, Veronica, *Medieval Art*, Oxford, Oxford University Press, 2001, especially 168–89

Schapiro, Meyer, 'Marginal Images and Drolerie', *Late Antique, Early Christian and Medieval Art: Selected Papers*, New York, George Braziller (reprint edition), 1993, 196–98

Sheridan, Ronald and Ross, Anne, *Gargoyles and Grotesques: Paganism in the Medieval Church*, Boston, New York Graphic Society, 1975

Sprunger, David A., 'Parodic Animal Physicians from the Margins of Medieval Manuscripts' in Nona C. Flores (ed.), *Animals in the Middle Ages*, New York, Garland Publishing, 1996, 67–81

Swain, Barbara, *Fools and Folly during the Middle Ages and the Renaissance*, New York, Folcroft Library Editions, 1932

Tatlock, J.S., 'Medieval Laughter', *Speculum*, XXI (1946), 289–94

The Topsy-Turvy World, exhibition catalogue, Amsterdam, Paris, London, New York, Goethe Institute, 1985

Tracy, Charles, *English Gothic Choir Stalls, 1200–1400*, Woodbridge, Suffolk, Boydell and Brewer, 1987

——, *English Gothic Choir Stalls*, 1400–1540, Woodbridge, Suffolk, Boydell and Brewer, 1990

Trubshaw, Robert N., *Gargoyles and Grotesque Carvings of Leicestershire and Rutland*, Wymeswold, Loughborough, Heart of Albion Press, 1995

Varty, Kenneth, 'Reynard the Fox and the Smithfield Decretals', *Journal of the Warburg and Courtauld Institutes*, 26 (1963)

——, 'The Pursuit of Reynard in Medieval English Literature and Art', *Nottingham Medieval Studies*, 8 (1964)

——, *Reynard the Fox: A Study of the Fox in English Medieval Art*, Leicester, Leicester University Press, 1967

Vaux, J.H., *The Canterbury Monsters*, Sittingbourne, Meresborough Books, 1989

Verberckmoes, Johan, *Laughter, Jestbooks and Society in the Spanish Netherlands*, Basingstoke, St Martin's Press, 1999

Weir, Anthony, and Jerman, James, *Images of Lust: Sexual Carvings on Medieval Churches*, London, B.T. Batsford Ltd, 1993

Wentersdorf, Karl P., 'The Symbolic Significance of *Figurae Scatologicae* in Gothic Manuscripts', in Clifford Davidson (ed.), *Word, Picture and Spectacle*, Kalamazoo, Medieval Institute Publications, Western Michigan University, 1984, 1–20

Wildridge, T. Tindall, *Animals of the Church, in Wood, Stone, and Bronze*, Wymeswold, Loughborough, Heart of Albion Press, first published 1898, reprinted 1991

——, *The Grotesque in Church Art*, London, W. Andrews, 1899

Wright, Thomas, *A History of Caricature and Grotesque in Literature and Art*, London, Chatto & Windus, Piccadilly, 1865

Zarnecki, George, *English Romanesque Sculpture 1066–1140*, London, Alec Tiranti Ltd, 1951

——, *Later English Romanesque Sculpture*, London, Alec Tiranti Ltd, 1953

Locations of Works of Art

AUSTRIA

Millstatt (Kärnten), Benedictine monastery, cloister, columns come out of animal's mouth

Vienna (Vienna), cathedral of St Stephen/Stephansdom, self-portrait of Anton Pilgram in base of Gothic pulpit; self-portrait of Anton Pilgram in organ base

BELGIUM

Bruges (West-Vlaanderen), Gruuthusemuseum, fireplace with horn-blowing men in crenellations; woman with mouth padlocked

Bruges, Porters' Guild, supporting figure on façade

Bruges, Town Hall, woman flirting with man

Hoogstraten (Antwerpen), collegiate church of St Catherine, misericords with battle over trousers, husband in wheelbarrow; elbow rest with monkey playing fife and drum

Huy (Liège), collegiate church of Notre-Dame, figure supporting corbel at entry

Louvain/Leuven (Brabant), church of St Peter, misericord with mouth-puller sticking out tongue

Liège (Liège), University, satirical painted diptych, Flemish

CZECH REPUBLIC

Osek (Severoceský), Cistercian monastery, chapter house, knotted columns

Prague (Stredoceský), Hradschin, Wladyslaw Hall, portal to Landoechsstube, twisting piers

ENGLAND

Abson (Somerset), parish church, exhibiting man on exterior east wall

Barfreston (Kent), church, animals eating tracery on wheel window

Beverley (East Yorkshire) Minster, 'Medical Set' of four labelstops representing stomach ache, toothache, lumbago, and sciatica; misericords of 'putting the cart before the horse', monkey playing catlike bagpipe, fox preaching to geese, barbary ape examining urine bottle like doctor, monkey thief, sow playing bagpipe, sow playing harp; elbow rest with cat playing fiddle as mice dance

Beverley, church of St Mary, misericords with ape holding up urine flask, monkey thief, 'clever Disa', fox preaching

Blythburgh (Suffolk), church of the Holy Trinity, misericord with Sloth

Boston (Lincolnshire), church of St Botolph, misericords with ape doctor, fox preaching

Bristol (Bristol), cathedral, misericords with 'urging on a slow horse' as a snail with a package on its back, monkey thief, monkey doctor, fox preaching, fox hung by geese, war of the sexes, unchaste woman

Cambridge (Cambridgeshire), Trinity College, ape-bishop in book of hours, MS B.11.22, f. 4

Canterbury (Kent), cathedral, cloister vault boss with monkey wearing monk's cowl; crypt, St Gabriel's chapel, capital with music-making animals, columns with unusual fluting

Chichester (West Sussex), cathedral, misericord with musician kissing woman

Cirencester (Gloucester), church of St John the Baptist, man supporting column on head

Elkstone (Gloucestershire), church of St John the Evangelist, on portal man grasping animals' snouts

Ely (Cambridgeshire), cathedral, chantry, Bishop Alcock represented by cocks; misericords with two women gossiping, fox preaching, war of the sexes

Etchingham (East Sussex), Benedictine church, misericord with fox dressed as Franciscan priest preaching to geese

Exeter (Devonshire), cathedral, figures in crenellations on façade; misericords with hands holding up seat, 'strongman'

Fairford (Gloucestershire), church of St Mary, man clings to moulding, smiling dog on moulding; misericords with man and woman drinking, fox preaching, war of the sexes

Gloucester (Gloucestershire), cathedral, demonic cat on nave wall; misericord with monster swallowing person

Grantham (Lincolnshire), Angel and Royal Hotel, gargoyle defecating

Grantham (Lincolnshire), parish church of St Wulfram, exhibiting man; corbel heads

Halifax (West Yorkshire), Shibden Hall, Satan carrying a soul depicted as a dead sole fish to the frying pan

Heckington (Lincolnshire), church of St Andrew, man on moulding

Hereford (Herefordshire), cathedral church, pair of misericords with war of the sexes

Hessett (Suffolk), church of St Ethelbert, seven deadly sins

Kilpeck (Herefordshire), church of Sts Mary and David, corbels with sheela-na-gig, pig eating person, person struggling in bird's beak, comical faces

Lavenham (Suffolk), church of Sts Peter and Paul, misericords with man playing pig like bagpipe, music-making monsters; choir stall handrest with man defecating

Lincoln (Lincolnshire), cathedral, choir stall with fox preaching; misericord with war of the sexes; cloister roof bosses with man sticking out tongue, toothache, mouth-puller; man supporting column on head in nave; Lincoln imp; laughing creature atop buttress; façade portal with heads with protruding tongues

London (Greater London), British Library, ape-bishop in *Smithfield Decretals*, Royal 10.E.IV, f. 96r; monkey monks in book of hours, French, Add. MS 36684, f. 125r

London, Westminster Abbey, misericords with war of the sexes, old man and young woman with pig playing flute (supporter); figures on buttresses of chapel of Henry VII; figure struggling with pier on south side

London, Stepney, Royal Foundation of St Katherine, misericord with gossiping women

Ludlow (Shropshire), parish church of St Laurence, misericords with false-measuring ale-wife, lady wearing horned headdress, drunken tapster, fox preaching to geese; bench end with boy bishop

Manchester (Greater Manchester), cathedral, misericords with apes robbing pedlar, monkey doctor, pig playing bagpipe

Minster-in-Thanet (Kent), church of St Mary, misericord with woman wearing horned headdress (devil between the horns)

Nantwich (Cheshire), church, misericord with fox preaching

Norwich (Norfolk), cathedral, misericords with ape playing dog like bagpipe, 'clever Disa'

Oxford (Oxfordshire), Christ Church Cathedral, Lucy Chapel, monster with lady's head on tail

Oxford, church of St Ebbe, portal with heads having protruding tongues

Oxford, Bodleian Library, two armed rabbits attacking a dog at bottom of St George and the Dragon, manuscript Douce 366, f.128r

Painswick (Gloucestershire), church of St Mary, exhibiting man

Ripon (North Yorkshire), cathedral, misericords with fox preaching from the pulpit, drunk woman in wheel barrow, pig playing bagpipe

Sherborne (Dorset), abbey, misericords with hands pulling mouth, fox preaching

Southwell (Nottinghamshire), minster, pulpitum with heads and man sitting on column; bull head eating column, head with colonettes in mouth

Stonyhurst (Lancashire), Stonyhurst College, Stonyhurst chasuble, St Dunstan tweaking the Devil's nose with his tongs, English, silk, gold, and silver thread on velvet

Tewkesbury (Gloucestershire), abbey, misericord with war of the sexes

Thaxted (Essex), church of St John the Baptist, figures climbing on exterior

Wells (Somerset), cathedral, dragons gnawing on column bases; misericords with fox preaching to geese, three examples of people holding up seats, ape mimicking pedlar, cat playing fiddle; gargoyle with barrel on shoulder on Chain Gate; Harewell's effigy; Bekynton's effigy and jester; capitals with story of grape stealers, thorn puller, man with tooth ache; portrait of master mason Adam Lock; portrait of worker disliked by stone masons; angel whispering in bishop's ear; monsters eating ribs in retrochoir; monk supporting column on stairs to chapter house; chapter house, man with tongue out

Winchcombe (Gloucestershire), church of St Peter, portrait of Ralph Boteler; doglike animal

Winchester (Hampshire), cathedral, lion climbing on moulding; benches with 'Nine Men's Morris'; ceiling bosses with three figures reading from a book (one is a fox); misericord supporters with sow playing double flute and boar playing viol; emblems of bishops Silkstede and Langton

Windsor (Berkshire), castle, St George's chapel, misericords with gambling leading to fighting, fox steering monks in wheelbarrow, defecating monk

Worcester (Worcestershire), cathedral, misericords with hare riding hound, 'clever Disa'

York (North Yorkshire), Monk's Bar, soldiers; Bootham Bar, soldiers

York (North Yorkshire), minster, two sculptures in left aisle of Phyllis riding on Aristotle's back and of a man riding on a woman's back; chapter house, laughing heads, man with tongue out; frightened felines on chapter house

FRANCE

Angers (Maine-et-Loire), Maison d'Adam, climbing man; exhibiting man; monster biting wooden beam

Angers (Maine-et-Loire), former abbey of St-Aubin, supporting figure on capital

Anzy-le-Duc (Saône-et-Loire), church of St-Croix-et-Ste-Marie, figure supporting capital at entry; capitals with acrobats, beard and hair pullers

Aulnay-de-Saintonge (Charente-Maritime), church of St-Pierre, south portal with many supporting figures, ass playing lyre; capitals with acrobat, contortionist mouth-puller sticking out tongue, smiling head

Autun (Saône-et-Loire), cathedral of St-Lazare, tympanum with angel and devil cheating at weighing of the souls; gargoyle defecating; monsters biting beams; capitals with creature pulling tongue and tail, devil of Simon Magus with tongue out

Auxerre (Yonne), cathedral of St-Etienne, capital with fight over trousers

Avénières (Maine), church of Notre-Dame, capital consumes column

Bayeux (Calvados), cathedral, relief of buffoon with monkey

Beaulieu-sur-Dordogne (Corrèze), church of St-Pierre, trumeau with atlas

Beaune (Côte-d'Or), church of Notre-Dame, capital with music-making animals

Beaune, Hôtel-Dieu, monsters biting beams; animals paired with humans

Beaune, palace of the dukes of Burgundy, monsters biting beams

Beauvais (Oise), church of St-Etienne, misericord with tongue out

Bletterans (Jura), church, misericord with fox preaching

Bois-Ste-Marie (Saône-et-Loire), church, capital with demon pulling out man's tongue with pliers

Bourges (Cher), palace of Jacques Coeur, figures looking out façade windows; figures on fireplaces

Bourges, cathedral of St-Etienne, stained glass of weighing of souls

Brioude (Haute-Loire), church of St-Julien, donkey duet

Cahors (Lot), church of St-Etienne, corbels with men with headaches, man winking at couple kissing on next corbel, man exhibiting buttocks; monk sitting on façade moulding; figures in holes on north side of church; cloister, monk with fist through pier

Carennac (Lot), church, capital with couple copulating while an admonishing cleric looks on

Chadenac (Charentes), church, column-biter

Champagnolles (Charente-Maritime), church of St-Pierre, corbels with exhibiting man, masturbating man, couple with hand on genitals, copulating couple, man displaying buttocks

Champeaux (Seine-et-Marne), former church of St-Martin, misericord with fox preaching

Chantilly (Oise), château, Musée Condé, 'January' in *Les très riches heures du duc de Berry*, f. 2r; ape doctor, book of hours, MS 62 f. 36v

Château l'Hermitage (Sarthe), chapel, misericord with fox preaching

Civray (Vienne), church of St-Nicholas, column-biter; 'right hand man'; corbel with cat with tongue out

Colombiers (Saintonge), church, capital with one man pulling beards of two others

Concressault (Cher), church of St-Pierre, misericord with woman displaying buttocks

Conques (Aveyron), church of Ste-Foy (Foi), Last Judgement tympanum; tiny people peering over archivolt moulding; weighing of the souls; rabbit roasts poacher; cloister capital with monks as masons

Coulanges (Loir-et-Cher), church of St-Denis, misericord with dog (Sloth)

Courpiac (Gironde), church of St-Christophe, corbels with exhibiting man playing musical instrument, with various 'sins'; capital with coital couple

Echillais (Charente-Maritime), church of Notre-Dame, column-biter; corbels with surprised cat, monster with hand in mouth

Embrun (Hautes-Alpes), former cathedral of Notre-Dame, beam-biter; engaged capital supported by several nudes; porch with knotted columns, small column-climbers; figures supporting porch columns

Evreux (Eure), Musée (Municipal Museum), misericord with fox preaching

Foussais-Payré (Vendée), church of St-Hilaire, man pulling cord to ring church bell; façade archivolts with tumblers and musicians; corbels with thorn-puller, man drinking from barrel

Hastingues-Arthous (Landes), former Chartreuse Notre-Dame, corbel with man drinking from barrel

Honfleur (Calvados), church of St-Catherine, monsters biting beams

Lacaune (Tarn), public square, fountain of the *pissaires*

La Plaisance-sur-Gartempe (Vienne), church, corbel with ass playing lyre

L'Epine (Marne), church of Notre-Dame, gargoyles with man holding pitcher and cup, man vomiting with hand on chest; sculptures with sow playing harp, monkey playing bagpipe; various figures supporting piers

Le Puy-en-Velay (Haute-Loire), cathedral, back porch, supporting hand, tiny atlas supporting arch; rear bell tower, sentinels; cloister, capitals with nun and monk fighting over crozier, four moods, stone rope, lions on leash

Le Puy-en-Velay, chapel of St-Michel d'Aiguilhe, hands on façade corbels holding up arches

Les Andelys (Eure), church of Notre-Dame des Grand Andelys, misericord with dog (Sloth)

Les-Ponts-de-Cé (Maine-et-Loire), church of St-Maurille, misericord with woman with lock on mouth; handrest with monkey-monk

Levroux (Indre), collegiate church of St-Sylvan, misericord with man displaying buttocks

Lorris (Loiret), church of Notre-Dame, misericord with fool displaying buttocks

Loupiac (Gironde), parish church, corbel with penis and testicles

Macqueville (Charente-Maritime), church of St-Etienne, archivolt with amphisbaena

Marignac (Charente-Maritime), church of St-Supice, corbel with copulating couple

Matha (Charente-Maritime), church of St-Hérie, capital with mouth-puller contortionist; corbels with contortionist, animal tied in knot

Mauriac (Cantal), church of Notre-Dame-des-Miracles, corbels with exhibiting man, exhibiting woman, man displaying buttocks with penis in mouth, various other 'sins'

Mauvesin (Gers), church of St-Michel, misericord with man displaying buttocks

Metz (Moselle), cathedral of St-Etienne, corbel with man displaying buttocks

Moissac (Tarn-et-Garonne), church of St-Pierre, south portal, *femme aux serpents*

Montbenoît (Doubs), former abbey of Notre-Dame, choir stall panel with Phyllis and Aristotle

Montberault (Aisne), church of the Visitation of the Virgin, apse frieze with exhibiting woman

Mont Sainte-Odile (Alsace), abbey church, chapel of the Holy Cross, four pairs of hands on base of column

Oloron-Ste-Marie (Pyrénées-Atlantique), church of Ste-Marie, figures supporting arch

Palluau (Indre), church of Ste-Menehoulde, misericord with mouth-puller

Paray-le-Monial (Saône-et-Loire), church, capital with hands over mouth

Paris (Paris), cathedral of Notre-Dame, west façade's central tympanum, angels peering over archivolt moulding (largely restored)

Paris, Musée du Louvre, two twisting columns, from Benedictive abbey of Coulombs (Eure-et-Loire), (R.F. 1375 and R.F. 1376); Hieronymus Bosch, *The Ship of Fools*; Parement of Narbonne

Paris, Musée National du Moyen-Age (former Musée de Cluny), gargoyle defecating; misericords with fox preaching, drunk husband in wheelbarrow, war of the sexes

Parthenay-le-Vieux (Deux-Sèvres), church of St-Pierre, corbel with supporting figure

Payroux (Vienne), church of Notre-Dame, capitals with copulating couple and person to right expressing horror

Plescop (Morbihan), chapel of Lezurgan, beam-biters

Poitiers (Vienne), cathedral of St-Pierre, gargoyles vomiting; mouth-puller

Poitiers, church of Ste-Radegonde, corbels with exhibiting man, exhibiting woman

Pressac (Vienne), church of St-Just, corbels with barrel-drinker, penis and testicles

Rodez (Aveyron), cathedral of Notre-Dame, misericord with man exhibiting buttocks

Rouen (Seine-et-Marne), cathedral of Notre-Dame, north portal relief of monster holding urine flask; misericords with war of the sexes, Aristotle and Phyllis

Roure (Alpes-Maritime), chapel of St Bernard, lustful priest

St-Bertrand-de-Comminges (Haute-Garonne), cathedral, carving on choir stall of man displaying buttocks while being steadied by cleric

St-Claude (Jura), church, choir stall with self-portrait of sculptor Jean de Vitry kneeling before St-Claude; misericord with fox preaching

Ste-Columbe (Charente), church, corbel with penis and testicles

St-Denis (Seine-St-Denis), basilica of St-Denis, Tree of Jesse window with abbot Suger offering window

St-Jouin-de-Marnes (Deux-Sevres), church, *femme aux serpents*

St-Marcel (Indre), church, misericord with exhibiting man

St-Martin-aux-Bois (Oise), former abbey of the Augustins, misericord with sculptor (God) and devil sculpting a woman

St-Nectaire (Auvergne), church, capital with music-making animal

St-Parize-le-Châtel (Nièvre), capital with ass playing lyre

Saujon (Charente), church, angel pushing devil at Last Judgement

Saumur (Maine-et-Loire), church of St-Pierre, misericord with 'sniffing the bottom'

Semur-en-Auxois (Côte-d'Or), church of Notre-Dame, gargoyle vomiting; hand grasping snail; exhibiting man below

devil; man hanging from bracket; north porch, man sitting on column

Semur-en-Brionnais (Saône-et-Loire), church of St-Hilaire, megaphallic man at entry; corbels with supporting figures at entry, inside on crossing arch

Strasbourg (Bas-Rhin), cathedral, left transept, frieze with man trimming vines; right transept, man on balcony admiring Angels' Pillar; pulpit with preacher's dog

Toul (Meurthe-et-Moselle), church of St-Etienne, cloister, gargoyle with barrel

Troô (Loir-et-Cher), church of St-Martin-la-Butte, armrest with man defecating

Vendôme (Loir-et-Cher), abbey church of La Trinité, two misericords with man holding up seat with both hands; portrait of Régnault

Vérac (Gironde), church of St-Cybard, corbel with copulating couple

Vertheuil (Gironde), former abbey of St-Pierre, two armrests with Aristotle and Phyllis

Vézelay (Yonne), church of Ste-Madeleine, narthex, archivolt with acrobat; nave capital with slanderer's tongue torn out

Vouvant (Vendée), church of Notre-Dame, north portal, many tiny supporting figures on arch; corbels with cat contortionist, exhibiting man, monster swallowing person

Villefranche-de-Rouergue (Aveyron), church, misericord with war of the sexes

Villefranche-sur-Saône (Rhône), church of Notre-Dame des Marais, hands holding vine

GERMANY

Baden-Baden (Baden-Württemberg), parish church, misericord with drunken woman in wheel barrow

Cleves (Kleve) (North Rhine-Westphalia), Stadisches Museum Haus Koekkoek, Arnt van Tricht, towel rack with couple kissing (man as fool)

Emmerich-am-Rhine (North Rhine-Westphalia), church of St Martin, choir stall with horse playing lute

Freiburg-im-Breisgau (Baden-Wurttemberg), münster (cathedral of Our Lady of Love), weighing of the souls at Last Judgement; gargoyles with man defecating, contortionist-mouthpuller, man vomiting

Golstadt (Swabia), parish church, vault ribs look like branches

Goslar (Niedersachsen), Hotel Kaiserworth, *Dukatenkakker*

Hildesheim (Lower Saxony), Cathedral, Adam and Eve Reproached by God for Eating the Forbidden Fruit, panel from bronze doors cast for Bishop Bernward

Mühlhausen (Thuringia), Marienkirche, south transept façade, Charles IV with Blanche de Valois and court

Nuremberg (Bavaria), St Lorenzkirche, self-portrait by Adam Kraft at base of Holy Sacrament House

Nuremberg, St Sebalduskirche, figure supporting column in nave

Pirna (Saxony), St Mary's church, wild men at springers of choir vault

ITALY

Aosta (Valle d'Aosta), cathedral, misericord with man licking anus

Arezzo (Tuscany), Pieve di Sta Maria, knotted columns; column with protruding abdomen

Bari (Apulia), church of San Nicola, marble throne of Abbot Elia

Barletta (Apulia), church of San Sepolcro, corbel with man displaying buttocks

Benevento (Campania), church of Sta Sofia, cloister, knotted columns

Bergamo (Lombardy), church of Sta Maria Maggiore, porch with figures supporting columns

Como (Lombardy), Broletto, knotted columns

Ferrara (Emilia Romagna), cathedral, columns and colonettes tied with stone ribbons

Fidenza (Emilia Romagna), Cistercian abbey of Chiaravalle della Colomba, cloister, knotted columns

Florence (Tuscany), baptistery, supporting figures (mosaic)

Florence, Museo Nazionale del Bargello, ivory casket with
Phyllis and Aristotle
Florence, church of San Miniato al Monte, façade with two
men popping out
Florence, church of Sta Maria Novella, Spanish Chapel, Andrea
da Firenze, detail of *Triumph of the Church* (*domini canes*)
Lucca (Tuscany), duomo, knotted columns
Lucca, church of San Michele in Foro, knotted columns
Modena (Emilia Romagna), cathedral, knotted columns; reliefs
with supporting figures; exhibiting men on south side and on
apse capital
Monreale (Sicily), cathedral, mosaic of Adam and Eve
Reproached by God; two versions of William II offering
model of church (nave mosaic and cloister capital); cloister,
capital with contortionist; monster eating column base
Orcia (Tuscany), church of San Quirico, knotted columns
Padua (Veneto), Arena Chapel, Giotto, Enrico Scrovegni
offering model of chapel
Palermo (Sicily), cathedral, figures watching on south portal;
mosaic of Adam and Eve reproached by God
Parma (Emilia Romagna), cathedral, Benedetto Antelami,
cathedra seat with two atlantes; column-biters on façade;
man and woman in loggia
Parma, baptistery, column-biter
Ravenna, church of San Vitale, Bishop Ecclesius offers model of
church
San Gimignano (Tuscany), cathedral (collegiata), Taddeo di
Bartolo, hell (mural)
Sant'Angelo in Formis (Campania), church, Abbot Desiderius
offering model of church
Tuscania (Latium), church of Sta Maria Maggiore, corseted
column
Venice (Veneto), basilica of San Marco, gargoyle bearing barrel
Verona (Veneto), cathedral, porch, men supporting, dog bites
lion; dragon eats man
Verona, church of San Zeno, bronze doors with Salome
dancing; relief of roosters with captured Reynard; cloister,
knotted columns

THE NETHERLANDS / FLANDERS

Amsterdam, Oude Kerk, misericord with man defecating
coins
Arnhem (Gelderland), Eusebiuskerk, people on flying buttress
's-Hertogenbosch (Den Bosch) (North Brabant), Sint-
Janskathedraal, figures on flying buttresses; relief of man who
spilled pot of beans (Pride)
The Hague (South Holland), Ridderzaal, eavesdroppers
Utrecht (Utrecht), Domkerk, *pandhof*, stone rope

SCOTLAND

Melrose (Borders), abbey, misericord with sow playing bagpipe

SPAIN

Cervados (Palencia), parish church, corbels with exhibiting
woman, exhibiting man
Cuidad Rodrigo (Castilla y León), church, misericords with
three monks having wineskin bodies, pig playing bagpipe
Frómista (Palencia), church of San Martín, several corbels with
exhibiting men, one playing stringed instrument, acrobats,
contortionists
León (Castilla y León), cathedral, misericords with priest and
woman in bath, man suckling wineskin, gamblers, war of the
sexes; cloister, capitals consuming columns
Madrid (Madrid), Museo del Prado, Hieronymus Bosch, seven
deadly sins table top, *The Haywain*, *The Garden of Earthly Delights*
Oviedo (Asturias), cathedral, stall relief with pig playing
bagpipe
Plasencia (Extremadura), cathedral, misericords with drunk
monk, woman suckling pigskin, war of the sexes
Salamanca (Salamanca), new cathedral, chapel of St Barbara,
supporting figures; lion with head stuck through pier
San Pedro de Tejada (Burgos), church, corbels with exhibiting
man, exhibiting woman

Santiago de Compostela (Galicia, La Coruña), cathedral, Porch of Glory, Master Matthew kneeling at base of trumeau; man and woman with serpents at genitals

Santiago de Compostela, Hostal de los Reyes Católicos, former Royal Hospital, gargoyle vomiting; courtyard, corbel figures showing buttocks

Toledo (Castilla-La Mancha), cathedral, misericord with hound and hare

SWITZERLAND

Bern (Bern), cathedral, gargoyle bearing barrel

Geneva (Geneva), cathedral of St-Pierre, man straddling handrest of stalls; gargoyle as wailing fool

Geneva, Maison Tavel, small figures on mouldings

Grandson (Vaud), church of St-Jean, capital with thorn-puller

Lausanne (Vaud), cathedral of Notre-Dame, stalls with Phyllis and Aristotle

UNITED STATES OF AMERICA

Baltimore (Maryland), Walters Art Gallery, Dominicans shown as 'dogs of the lord', in margin of Guillaume de Lorris and Jean de Meun(g), 'Le Roman de la Rose', French, MS 143, f. 72v

Boston (Massachusetts), Museum of Fine Arts, fox in ecclesiastical garb preaching to geese, spoon, Flemish, silver, gilt, niello, enamel (51.2472)

New York City (New York), Metropolitan Museum of Art:
Phyllis riding on the back of Aristotle, aquamanile, Netherlandish, Lehman collection (1975.1.1416)

Visitation with crystals in abdomens of Mary and Elizabeth, German, walnut (1917.190.724)

Woman sitting on man and striking his bare buttocks, plate, copper, south Netherlands, Dinant or Malines

St Mammès holding his intestines, statue, bronze, Burgundian (64.101.1497)

New York City, Metropolitan Museum of Art, the Cloisters:
Amphisbaena, voussoir of arch from Narbonne, French, stone

Apes building table with three legs, window, German, colourless glass and vitreous paint (1900.119.3)

Ass making music, fresco, Spanish, from San Pedro de Arlanza

Dragon with monk in mouth, aquamanile, brass, German, Lower Saxony (?) (47.101.51)

Miser with sack of coins around neck, capital, from cloister, St-Guilhem-le-Desert

Monkeys, beaker, southern Lowlands (?), painted enamel (52.50)

Perils of love, statuette base, north France or Flanders, ivory (1955.55.168)

Phyllis riding on the back of Aristotle, front panel of ivory casket with scenes from romances (1988.1.6), rest of casket gift of J. Pierpont Morgan (17.190.173)

The Unicorn Crosses the Stream and Tries to Escape (detail, unicorn sticking out his tongue), unicorn tapestries, Franco-Flemish (37.80.3).

Three corbels: two men with fingers in each other's mouth (34.21.8); two men pulling each other's beards (34.21.1); five men pulling each other's beards and hair (34.21.2), from La Sauve-Majeure

New York City, J. Pierpont Morgan Library:
Fox preaching to geese, at bottom of Presentation in the Temple, missal, lower Germany, probably Hamburg

War of the sexes, Jacques de Longuyon, *Voeux du Paon* (incomplete), Franco-Flemish, MS 24, f. 30v, collection of William S. Glazier

Index